ARTISTS IN OFFICES

ARTISTS IN OFFICES

An Ethnography of an Academic Art Scene

Judith E. Adler

Transaction Books
New Brunswick, New Jersey

Library of Congress Catalog Number: 78-55941
ISBN: 0-87855-281-2 (cloth)
Printed in the United States of America

The chapter, "Teaching the Unteachable" reprinted by permission of the
Graduate Faculty, New School for Social Research. Originally published
as "Innovative Art and Obsolescent Artists," *Social Research* 42 (Summer
1975).

The chapter "Revolutionary Art and the Art of Revolution" reprinted
from *Theory and Society* 3 (1976): 417-35, with permission of Elsevier
Scientific Publishing Company, Amsterdam.

Library of Congress Cataloging in Publication Data

Adler, Judith E 1944-
 Artists in offices.

 Bibliography: p.
 Includes index.
 1. Arts and society—United States. 2. Arts—Study
and teaching (Higher)—United States. 3. Arts, Modern—
20th century—United States. 4. California Institute of
the Arts. I. Title.
NX180.S6A27 301.5'7 78-55941
ISBN 0-87855-281-2

For Nathan and Elizabeth

CONTENTS

Acknowledgements XI

Introduction XIII

Chapter 1 - *Artists in Offices* 1

 The "Schooling" of Occupational Preparation
 A New Work Setting: The University and the
 Social Integration and Organizational Con-
 centration of Artistic Production
 Sources of Dissatisfaction with the University

Chapter 2 - *Revolutionary Art and The Art of* 23
 Revolution

 Millenarianism and Utopian Communitarianism
 The Ideal Community as the Ideal School
 Art as Revolutionary Practice: Worldly Aestheticism
 Millenarianism and Fetishized Media
 Revolution as Aesthetic Practice
 Aesthetic Radicalism and the Boundaries of Art
 The Institutionalization of Aesthetic Radicalism
 The Cunning of Culture

Chapter 3 - *Founding Fathers and Seed Money* 53

 A Farmer's Market of the Soul

A "Cal Tech" of the Arts
The Elite's Politics and the Organization's Economy
A Death and a Monument
Spending and Managing the Money

Chapter 4 - *Alluring the Artists: The Construction* 63
of an Art Scene

Work in the Arts and Great Expectations
Charming the Money
The "Art" of Administration
"The Center of the Revolution"
Procuring Stars
Bringing Friends
Gold Rush, Strip Mining, and Loose Spending
A Joke in the Social Structure
Transients and Hustlers
An Experiment and an Adventure

Chapter 5 - *Artist's Cockaigne* 93

Art Worlds in Ashes - Art Worlds to Build
A Complete Facility Under Professional Control
"Community of the Arts" and Struggle in the
 Work System
The Work of Teaching and the Ideal Student
Radical Communitarianism and Art as a Way
 of Life
Vision Becomes "Hype": Economic Impera-
 tives and a PR Strategy

Chapter 6 - *Laymen Among Artists* 111

"Real Work" in Studio and Office
Administrative Jobs and Aesthetic Decisions
Patrons and Brokers
Trustee Tasks and Trustee Aesthetics
Performing for the Trustees
Learning Opportunities and Performance Risks
Retreat to Professionalism and the "Real World"

Chapter 7 - *Teaching the Unteachable* 129

Educating the Person and Shaping the
 Instrument
Innovative Art and Obsolescent Artists
Absent Authority and Occupational Nonentity

Chapter 8 - *Conclusion: End of Utopia* 145

Bibliography 151

Subject Index 159

Name Index 163

ACKNOWLEDGEMENTS

One of the things I learned in writing this book is the extent to which all work is inevitably collective, individual authorship being somewhat of a convention. Without the work of the following people, this one would not have been accomplished. Maurice Stein first introduced me to the sociology of culture, then helped to create the institution I was to study, provided me with employment in it, and encouraged me in my fieldwork. Without his patronage and nurturance this book would have been unthinkable. If I had not been inspired by Egon Bittner many years ago I never would have become a sociologist, and without the attentive intellectual and emotional care of Kurt H. Wolff, I might not have remained one. These three people have been protective and faithful friends, shaping me as well as my work. I was lucky to have been at Brandeis University when Everett C. Hughes taught there. Intellectually, he has had an important influence upon me.

Jean Briggs, Leah Schwartz, Susan Tarr, Barrie Thorne and Carla Wolff nourished me with their own writing while I was working on mine. Joseba Zulaika, carpenter, has kept my self in good repair. Together with Margherita Ciacci-Berardi, Juan Corradi, Phyllis Hecker, Donna Huse, Melissa Lee, Juliet and Dean MacCannell, Marguerite MacKenzie, Jeremy Shapiro, Sue and Seung-il Shin, Bea and Sol Cohen, and my family, these people have created a world I have not fallen out of despite frequent residential relocation. Only other academic nomads will know how important this is.

I am indebted to my colleagues at Memorial University of Newfoundland, especially to Clinton Herrick, Robert Hill, Rick Johnstone, Ronald Schwartz and Adrian Tanner, for providing me with stimulating conversation about my research.

The following people offered very welcome encouragement and support at early stages of this work: Bennett Berger, Priscilla P. Clark, Paul DiMaggio, Irving Louis Horowitz, Dell Hymes, Rachel Kahn-Hut, Daniel M. Mendelowitz, Sally Ridgeway, Rosalind Sydie, Harrison White.

Unfortunately, the number of people at the California Institute of the Arts who gave me many hours of their time are so numerous that it would be unfair to single any of them out by name. The ethnographer who finds a tribe of such superior and articulate intelligence is lucky. Most of what I have understood about their life they understood themselves and taught me to see.

But the person who has made the greatest contribution to my work is my colleague of the past ten years, Volker Meja. By now he has joined that category of persons who give the most and are thanked the least. He shared the pain of this book more than its pleasure.

St. John's, Newfoundland
December 1977 JUDITH E. ADLER

INTRODUCTION

In recent assessments of scholarship in the sociology of art some
scholars have argued that more attention should be given to the
organizational settings within which the arts are produced—an approach
which has already proved fertile for the sociology of science.[1] Until lately,
they observe, sociologists have made the mistake of focussing exclusively
upon cultural products while allowing the organizations from which they
flow to remain uninspected.[2] The tardiness with which sociologists have
turned their attention to the work contexts in which the arts are produced
can perhaps be attributed in part to an ideologically determined reluctance
to regard art as work. A well-established philosophical tradition of which
Schiller,[3] Huizinga,[4] and Marcuse[5] are prominent representatives has
characterized art as most true to itself when, in contrast to other human
labors, it flowers as "free" play; and this tradition, both reflecting and
elaborating a mythology of art as an exemplary alternative to toil, has
rested upon the long retention in the arts of preindustrial forms of work
organization and technology. The very social marginality of artistic
activity during the period of industrial transformation marked it as an
idealized object of contemplation for intellectuals nourishing a nostalgic
or utopian perspective, and the romanticization of artists' status as
independent producers obscured the importance of the social networks
upon which they depended. If sociologists are now increasingly ready to
apply concepts developed in the sociology of occupations and
organizations to the study of art—in short, if they are ready to regard
artistic production as comparable to other forms of labor—this may
reflect a growing desacralization of the arts as, subject to corporate,
university, and government patronage, they begin to lose the social
marginality[6] and individualistic organization which made their practice
rife for romanticization.

The past two decades have seen a great expansion of the arts in higher education, with the consequence that artists are increasingly likely to find themselves (at least for some periods in their lives) working as employees of large bureaucratic organizations. The new work setting, by offering an alternative to other sources of patronage and support, raises new hopes but also imposes its own constraints and requires artists to make new accomodations. This book, based upon fieldwork carried out between 1970 and 1972 at the California Institute of the Arts, provides a case study of one group of artists who responded to the changes taking place in their occupations by attempting to found a utopian art academy (an instance of what might be called an "occupational utopia"). While the California Institute of the Arts still exists, the art "scene" with which it was first identified, and whose development and demise I examine, has now been dispersed. Cal Arts is by no means a unique case of an art school's serving as the stage for such a fleeting "scene"—the Bauhaus and Black Mountain College offer comparable examples. And though the tension between the Institute's simultaneous character as an academy and a fluid "scene," as an art colony and an art school was particularly pronounced during its initial semiinstitutionalized phase, I suspect such tensions would prove to be present in any academic art setting attracting professionals who aspire to national and international renown.

I have sometimes thought of this work as a kind of dream analysis; the dream, however, whose production, content, and resolution it analyzes was constructed by an occupational group rather than by an individual. In attending to this collective dream I have sought to show the manner in which the dreamers' phantasy was structured by the work worlds in which they made their way, the aspects of these worlds which their phantasy illuminates, the social processes which first lulled them into dream and then forced them back into wakefulness. Community studies have been viewed as a continuation of the realist tradition of the novel; and one of the strong strains in this tradition has been the impulse to parody romance by examining characters either confused by romantic assumptions about reality or deliberately setting out to confront the world with their dreams. I recognize that one of the central threads of my own study places it squarely within this genre. My ambition, however, has been to offer a sociological rather than a literary examination of a community of dreamers.

In addition to providing an ethnographic description of an aesthetic work organization and examining the ways in which artists accommodate to new opportunities for salaried employment in academic bureaucracy, I have sought to take up from various angles the central problem of the sociology of art: that of identifying the social determinants of aesthetic production—the social aetiology of artistic conventions. I have attempted

to do this by regarding artists as workers and trying to discern the manner in which their production is marked by the social relations in which it is carried out, as well as by showing the ways in which these relations are constrained by the traditional ethos and mythologies which artists bring to them. My central argument might be stated as follows: attention to the work system within which artistic production is embedded—to the routine needs and conflicts of its members, as well as to the strategies they develop for handling them—provides the soundest basis for grounding aesthetics in social structure. Or, stated another way: in coming to understand how artists are forced to adopt the *manners* demanded by a historically specific work setting we may learn how they come to work *in the manner* which is later associated with it.

NOTES

1. See Howard Becker, "Art as Collective Action," *American Sociological Review* 39 (December 1974): 767-76. See also Richard A. Peterson, "The Production of Culture: A Prolegomenon," *American Behavioral Scientist* 19 no. 6 (July-August 1976), and Paul DiMaggio and Paul M. Hirsch, "Production Organizations in the Arts," *American Behavioral Scientist* 19, no. 6 (July-August 1976).
2. DiMaggio and Hirsch, Op. cit., p. 2.
3. Friedrich Schiller, *On the Aesthetic Education of Man* (London: Routledge and Kegan Paul, 1954).
4. Johan Huizinga, *Homo Ludens: A Study of the Play-Element in Culture* (New York: Roy Publishers, 1950).
5. Herbert Marcuse, *Eros and Civilization* (Boston: Beacon Press, 1966).
6. See Michael Useem, "Government Patronage of Science and Art in America," *American Behavioral Scientist* 19, no. 6 (July-August 1976), and Jack Morrison, ed., *The Rise of the Arts on the American Campus* (New York: McGraw-Hill, 1973).

ARTISTS IN OFFICES

Chapter 1

ARTISTS IN OFFICES

The appeal which a "university of the arts" or "aesthetic think-tank" holds for artists can only be understood by first looking at the role universities have begun to play in the arts since the second quarter of this century (as sources both of employment and of professional preparation), and then examining the dissatisfactions which make artists eagerly receptive to suggestions of an institutional alternative.

THE "SCHOOLING" OF OCCUPATIONAL PREPARATION

Academia is a historically new occupational setting for the kinds of professional workers the Institute eventually recruited. Practicing artists have not long been employed in large numbers by academic institutions, nor have aspiring young artists traditionally turned to them for their education. In fact, the "schooling"[1] (or formal institutionalization) of professional education in the arts is still far from complete, as is its ideological elaboration. The ambiguity inevitably accompanying an emergent historical structure helped to make it difficult at Cal Arts to secure any common faith that the institution was providing an important service of long-standing social legitimacy, and thus contributed its share to creating an atmosphere of chronic and demoralizing uncertainty among students and staff. Even before the legitimacy of any particular school was called into question, the legitimacy of all schools was problematic, not simply because higher education had lost some of its credibility in

1

American culture during the late sixties, but more because schools are still a relatively recent arena of occupational socialization in the arts.

Before the end of the nineteenth century, art schools and academies served as important sources of instruction for only a minority of professional artists. For example, in France, while the academies enjoyed a monopoly over the patronage of the court and controlled access to the highest rewards of their respective occupations, the *Ecole des Beaux Arts* molded the education of only the smallest percentage of the country's painters and sculptors, and even these divided their time between the Academy and the private *ateliers* where they served as apprentices.[2] The Paris academy of the nineteenth century:

> was never meant to deal with the whole of the professional education of a young painter or sculptor. He neither painted, nor sculpted nor modeled figures or reliefs during his working hours at the Academy. All this he had to learn in the studio, or as one may safely say, workshop of his master, with whom he still lived and under whom he still worked, in a way almost identical with that of the Middle Ages.[3]

The private drawing master and the private music master, as well as the work settings where a neophyte could effectively apprentice himself to those who had mastered a craft, were the principal sources of education. The painting studios of an earlier day, like many contemporary performing arts groups, would not have been able to function without the "gophers" (as they are now called in theater parlance) who carried out much of the routine dirty work while picking up the skills of their trade. The young apprentices, or *rapins,* of the early nineteenth-century French studios have been described as functioning like domestics—arriving at early hours of the morning to light the fires, clear the rooms, prepare the paints and canvases.[4]

Yet, in the course of the nineteenth century, after the death of the guilds, the ascendancy of the school over the workshop as the locus of occupational preparation in the visual arts—the academization of instruction—was gradually achieved. "The . . . art school as the one and only establishment for the education of the artist [was] a nineteenth-century invention."[5]

By the turn of the century, art schools in the United States were attempting to establish themselves as higher educational institutions by eliminating elementary courses and requiring at least a high school diploma for admission. As has been the case with other occupations attempting to secure a more exalted professional status, the "schooling" or academization of education in the arts has been accompanied by a consistently articulated concern with standardizing curriculum,

establishing a uniform rate of matriculation, and marking the successful completion of a course of study by an awarded degree. A study of American art schools published in 1950 states that "[out of a concern] to raise the art professions above the vocational level and to meet the educational standards of other professions, a definite trend toward uniformity in professional art education has developed."[6] The authors of the study report that of eighty art schools sampled, all had by that date established formal entrance requirements (including high school graduation), employed a credit system for measuring students' advancement, and, with minor exceptions, granted degrees. For purposes of comparison it is interesting that a study of music education published in the same year reports the success of the National Association of Schools of Music, founded in 1927, in helping its member schools to dissect music into various disciplinary studies and to agree upon standardized curricular units and degrees.[7]

But "schooling" as a strategy for professionalization (and especially the stress on the importance of any degree certifying the completion of a formal course of instruction) has its limitations in the arts. There are no legal licensing requirements for the practice of art (at least not since the demise of the medieval guild system), and artists, with little collective control over the market for their services, have no power to make the possession of a degree a prerequisite of occupational participation.[8] Since a formal degree gives only minute competitive advantages to its holder in any marketplace other than that of teaching (the claim to be a "certified sculptor" or a "qualified poet" being fruitless), it is common for art students to drop in and out of school with an indifferent regard for formal graduations.[9] At Cal Arts, while some students were preoccupied with the question of the "meaning of the degree," those acquainted with the conditions of occupational practice cynically regarded it as a sop for naive laymen, primarily for parents footing the educational bill. Only administrators concerned with the sensibilities of parents and trustees were uncomprehending and dismayed when students openly expressed indifference or contempt towards it.

And yet, even if the practice of the arts has not been legally or otherwise strongly linked to the completion of a course of formal instruction, there is some evidence that at least visual artists who sell and exhibit their work nationally do prepare themselves in art schools, even if they later claim that this instruction bore no relation to their achievement.[10] With the end of the private apprenticeship system of the workshop, it became necessary to attend schools not only for instruction, but also for access to those tools of the craft which were more costly than brushes and tubes of paint; and as art teaching in the public and private schools developed into one of the few sources of steady income in the arts, certificates and degrees were sought as passports to this market.[11]

A NEW WORK SETTING: THE UNIVERSITY AND THE SOCIAL INTEGRATION AND ORGANIZATIONAL CONCENTRATION OF ARTISTIC PRODUCTION

During the past few decades liberal arts colleges and universities have assumed a significant role in the arts, not only as sources of instruction but as employers, patrons, curators, and impresarios.[12] University-sponsored concert series, resident professional companies, "artist-in-residence" programs, university museums, and expanding art departments have made the universities rivals of the old cultural capitals as centers of artistic production and heirs of the court and the church as corporate patrons. The university audience has become a mainstay for all performing activity, especially for performances of experimental and innovative work. One study, claiming that 70 percent of the concert activity of professional musicians can be attributed to the college circuit, identifies the college and university audiences as the largest buyers and consumers of serious music in the country;[13] another credits them with an expanded audience interest in modern dance and hence for a profusion of new dance companies.[14]

With growing social and economic pressure upon young people to secure a college degree, art schools without any college affiliation have found it increasingly difficult to attract students. State supported or well-endowed private colleges and universities, having financial resources at their disposal far greater than those available to the smaller independent professional schools, have been in a superior competitive position to attract students and faculty by offering higher salaries and excellent fringe benefits as well as costly equipment and performance facilities. By the mid sixties, college campuses provided performing artists with some of the most elaborately designed and well-equipped theaters in North America. Those artists moving from the use of traditional handicraft to advanced technologies rapidly found that only large institutions were capable of supporting the costs of such production and that they were dependent upon them not only for income, but for access to the very tools of their trade.

Film-making offers a good example of the dependency upon well-funded organizations which a complex and costly technology creates. A film maker working with even the cheapest and most primitive equipment will find himself—compared with a painter or poet—involved in a highly costly art form. A garret film maker, living on thinned soup and creative enthusiasm, is unthinkable as a real possibility; the young artist fascinated by this contemporary medium requires the affluent upper-middle-class income his historical predecessor could afford to scorn.

Once he aspires to meet the standards of professional quality set by the work of the film industry (that is, once he wishes to exploit the possibilities

of his chosen medium to their fullest extent), he will find the necessary equipment beyond the financial means of any individual; it can only be found in the commercial film industry itself—or in university film schools. The following segment of a recorded conversation between three Cal Arts administrators on standards of workmanship nicely illustrates the relationship between costly aesthetic technologies, a certain kind of professionalism, and the artist's need for organizational affiliation:

> *Dean of Art:* "Are your seventy-five advanced students professionals?"

> *Dean of Film:* "If you hyphenate the word professional with 'professional-level-technology' . . . we have seventy-five students able to work with professional-level equipment such as amateurs cannot afford."

> *Dean of Art:* "So you apply the adjective professional only to the equipment and not to persons."

> *Dean of Film:* "That *is* really how I think of it."

> *Dean of Art:* "How do you categorize the film maker whose desire is to go out and make *personal* films budgeted according to what he can con from the world?"

> *Dean of Film:* "An amateur. . . ."

> *Dean of Humanities:* "The capacity to make full use of the equipment is a measure of the . . . professional."

> *Dean of Film:* "And you can't *get* that kind of equipment unless you're a member of an academic institution or you're working for the Yankee dollars." (i.e., the Hollywood Studios, J.A.)

The film maker who does not want to do commercial work is driven to seek one of the scarce university appointments, hoping that once his teaching obligations are met he will be able to use the school facilities for what he calls his "own work." Similarly, a musician or composer who wants to use an electronic synthesizer rather than a piano, or a visual artist more intrigued by the aesthetic possibilities of computer, video, or laser technology than by those of charcoal or ink are as dependent upon

corporate or university backing as a contemporary research scientist whose tools have developed in complexity far beyond those of the eighteenth-century home laboratory. Such artists can as little carry on in a one-man studio as a contemporary biochemist could set himself up at a work table in his basement, and their shifting relations to institutions become the most important contingencies of their careers.[15]

Those at Cal Arts who worked with costly and elaborate equipment seemed never to tire of puns about the problem of finding a way to support their "habit"—referring, of course, to the work to which they were addicted and the access to organizational facilities which it required. The contrast between the employed artist's dependency upon the organization owning the means of his production, and the older occupational image of the artist as a "free" (even if poor) professional—as a self-employed craftsman who could never be locked out of his own workshop through firing, graduation, or other unfortunate contingencies—made this wry metaphor of bondage a favored bit of folk humor. Its didactic repetition helped to define a new collective occupational image and to formulate new shared vulnerabilities.

Artists working with advanced and costly technologies, like earlier workers whose industries came to be based upon machine rather than handicraft methods, no longer own their means of production.[16] They return to a dependency like that of the seventeenth-century organist upon the church which housed his instrument; of the eighteenth-century French history painter upon the Academy which enjoyed an exclusive legal monopoly over the teaching of life drawing and state patronage; or of the twentieth-century Soviet sculptor upon the union holding a legal monopoly on the purchase of his materials.[17] From this perspective the nineteenth and early twentieth centuries represent a brief anomaly in the organizational history of art in the West (a short period during which artistic production was organized in a dispersed rather than a concentrated fashion), and the artist—leaving church, court and academy behind—took his chances as an independent entrepreneur in the cultural marketplace before beginning once more to be drawn under a corporate (and academic) wing. This period gave rise to the image of the artist as a proud, defiant, uncompromising individualist, recompensed for his poverty and social marginality by freedom from the dreary social constraints to which functionaries and employees of all kinds are believed to be forced to submit.

Western culture has idealized and glamorized artists in part because the individualistic and dispersed organization of aesthetic production and the isolated and self-regulated nature of their work has offered an appealing conceptual opposition to the cultural stereotype of the "organization

man." And if, as Lévi-Strauss would argue, cultural constructions of reality depend upon and proceed by way of such oppositions, artists have served a mythic role as important as their more obvious productive one; as a symbol, their occupational image tapped a nostalgia for the disappearing independent craftsman and entrepreneur. Through it an anachronistic bourgeois individualism could continue to be idealized and dramatized in a somewhat altered and disguised form. For however much Bohemia might have developed its imagery and its culture through an inversion of the imagery and culture of the world of business, the heroic image of the artist is homologous to the early bourgeois ideal of the self-made man whose lonely, willful, and ruthless devotion to production triumphs over an indifferent competitive world to result in lasting accomplishment. While on one level the poet, painter, or concert artist [18] has been seen as an outsider manifestly critical of bourgeois culture, on another his image has served as a vehicle for the expressive dramatization of a wider social type long on the wane but still highly, if nostalgically, valued.[19]

This capacity of the artist's image to symbolically convey both the affirmation and the negation of bourgeois values may at least partially explain why both political radicals and conservative patrons can be equally seduced by the prospect of closely associating themselves with it. Industrialists and managers can project their own occupational ego-ideals onto the cultural stereotype of the artist as an ambitious, self-sacrificing, lonely individualist, singlemindedly driven by and obsessed with his work and determined not to countenance any social barriers to its accomplishment. That this fond image might not at other moments prevent their preoccupation with art students' laziness, dirtiness, and bare feet, is no contradiction. Symbols are resonant with multiple meanings which need not be in harmony with one another: we should not be surprised if the same role-image can ambiguously convey both the most shameless transgression of the gospel of work and its purest expression (the ambivalent image of the "dedicated" and "disciplined," or "lazy" and "irresponsible," artist only paralleling, in this regard, that of the "laboring" and "deserving," or "shiftless" and "immoral," poor). In any case, it is exactly the anachronistic, unrepresentative, marginal quality of the (now disappearing) artist's role which has given it central ideological significance.

This image has a strong hold even on artists, and yet it may owe its continuing potency in part to a cognitive lag, to the slowness with which new imagery is developed to reflect the changing conditions of occupational practice—just as some Wall Street lawyers working in large firms may incongruously maintain a conception of themselves as general practitioners and attempt ritually to preserve some of the aura and style of

the earlier occupational role.[20] For the time is coming when few professional artists will be able to say with Marcel Duchamp: "One is a painter because one wants so-called freedom; one doesn't want to go to the office every morning."[21] Instead, they will share the whimsical irony of the Cal Arts teacher who recognized that "If I had known what I know now at the time I chose to become an artist, I wouldn't have *had* to fight with my parents about it. I could have joked with them instead." The "joke" consists of the incongruity between the image of the artists' marginality and the growing reality of their social integration—of the fact that the mature and successful art academic finds himself in a social position not very far from that of the lawyer his parents had wanted him to be.

If a historical perspective reveals an essential continuity in the social integration of the arts and, more importantly, a continuity in the corporate organization of patronage from church, court, and academy, to state, industrial corporation, and university (which was only briefly broken before beginning to be reconstituted again), the often proclaimed "end of the avant garde"[22] appears in a new light. The avant garde, it may be argued, could only have become a significant occupational movement during a period of transition when the arts were not integrated with the dominant social institutions, when their production was organized in a petit entrepreneurial fashion, and when producers found themselves at the mercy of an impersonal mass market.

Without this historical view, the social marginality of the arts (and its attendant occupational ideologies and psychologies) is in danger of being hypostatized as a timeless and inevitable accompaniment of aesthetic activity. In fact, prior to the period of industrialization, the sciences not the arts were deemed essentially useless, playful pursuits, irrelevant to the primary concerns of those who controlled society's wealth and unworthy of large-scale promotion and support. The usefulness of the arts was self-evident to the church, as it was to a monarchy and aristocracy bent upon providing persuasive and enduring sensual testimony to their glory. Only with the Industrial Revolution did the sciences suddenly assume the character of serious and important activities essential to society's most honored projects and to the continuing power of its ruling classes, while the arts fell to science's former status as "useless" pursuits whose claim on limited social resources was of doubtful legitimacy.[23] And with the transition from early to advanced capitalism some arts quickly retrieved their lost instrumentality and respectability as they proved themselves indispensable to the new economic imperative of artifically stimulating commodity consumption through advertising and packaging design.[24] As an administrator of Cooper Union, one of America's oldest art schools, put it:

Today's commercial artist is a responsible member of suburbia. He is in the main stream of contemporary society—the essential expediter of the process of supply and demand—the straight man in the colloquy between buyer and seller, the graphic though silent pitch man in the soft sell game.[25]

Commercial art is not the only art which performs a central role in the contemporary economy. As the "appreciation" (or consumption) of the arts becomes a widespread middle-class leisure activity,[26] even the former distinction between the fine and commercial arts blurs, and the universities, integrating the arts into their programs, rise to the new task of educating culture's "consumers" as well as its producers and professional managers.[27] The university has been explicitly urged to assume the role of socialization on the following grounds:[28]

> . . . the cultural explosion could lower overall quality in the arts. There is no doubt that the practice of democracy can pose a threat to that quality. . . . On the basis of an unselected, or "popular" audience, we have to accept the fact that the wider the audience, the lower the common denominator. . . . There is an eager, receptive audience that wants to learn, but helping them learn requires a serious long-term and sustained effort in audience building and audience education. This is an essential responsibility for higher education. Colleges and universities are the places most able to insist on quality and, as national cultural leaders, to help determine standards.[29]

Including the arts in college and university curricula has been approached by professionals not so much for the purpose of democratizing active participation in the creation of culture, as for the purpose of combating the "plague of amateurism." The traditional elitist preoccupation with the "dangers" of cultural vulgarization, perhaps fueled by the widely reported increase in amateur aesthetic production (especially in the performing arts),[30] contributed its own color to the argument that the universities are elite culture's proper fortress and that the arts would be best "defended"

> by professionalizing them, by basing them as other professions have been based, in advanced university training, and by nourishing their scholarly and intellectual substance to match that of other disciplines.[31]

The arts, however, are difficult to professionalize. If college and university programs are becoming significant channels into the elite

sectors of the art occupations, it is because 1) they provide scenes of activity where the informal collegial networks that guide a career can be formed, and, 2) they increasingly control access to the occupation of academic teaching. High proportions of university educated artists seek academic positions when they graduate, gradually excluding artists without degrees from the academic marketplace and making the possession of academic credentials all the more crucial in the competition for one of the few available sources of secure employment.[32]

Outside the occupation of academic teaching, however, markets over which art workers have limited collective control—and which place a premium upon innovation and change—inevitably sabotage academic attempts to define and maintain standards based on an enduring body of theory and enforced by professional authority. As long as "anyone who makes it is an artist" (a rule of thumb tirelessly, if ironically, repeated at Cal Arts), university-based artists will not be able to extend their influence far beyond their own professional segment and will not, like university law and medical faculty, become the governing elites of their wider occupations. The easiest occupational segments to professionalize are, like academic art teaching, tied to large organizations with a bureaucratic bias towards measurable and standardized criteria of entrance and promotion. In this sense, embedding the arts in bureaucratic work settings will further their conventional professionalization since it will encourage the restriction of positions to persons who have completed a prescribed course of training. Yet as long as the highest incomes and honors go to those people who rise to the top in the cultural marketplace, regardless of whether they are affiliated with large organizations, any bureaucratically defined and protected professional status will be qualified by this other hierarchy of market success; and the professionalized academic art establishment will be widely suspected by its own members to consist of those people who have failed to reach the highest rungs of commercial achievement.[33] (This is more true of an art like painting in which renown can bring riches than of one like poetry which is not munificently rewarding even to its "stars.")

But for the majority of artists who do not become "stars," the university holds one powerful appeal as a source of employment. Beyond offering costly facilities and more security and middle-class status than other sidelines open to the majority of artists who are unable to earn a living through the practice of their craft alone,[34] the university promises professional autonomy—freedom from the tyranny of audience or customer taste. With a university appointment the artist finally gains independence from the lay audience which he must otherwise tolerate as an economic necessity while attempting to minimize its interference in and

influence over his work. Even those artists who feel disturbed by the narrow class distribution of professional cultural services, and who insist on the importance of creating a wider public and making contact with the people, endow this idealized popular audience with a natural sophistication and understanding worthy of true colleagues. (For ultimately it is to worthy colleagues alone, not to the galleries, that they wish to play.)[35]

A salaried position in higher education frees an artist from the despised role of entertainer and offers him the opportunity to engage in what he may himself term "pure research," adopting the vocabulary and identifying with the occupational imagery of today's scientific and technical elites just as his occupational forbears pressed analogies between their own work and that of the more prestigious *literati*.[36] Finally freed from the compulsions of the marketplace, the university artist engaged in his aesthetic research can feel more purely professional than those artists whose projects are compromised by other ways of making a living such as the classical musicians and actors whose repertoire must take audience demand into account, the Hollywood movie director who must suit his producer, the painter who can afford for only a limited time to explore an idea which does not sell.

The effective elimination of a lay audience or the denial that artists should concern themselves with providing any sort of service whatsoever has been proudly taken as a sign of their final ascension to professional seriousness. One prominent critic reports triumphantly:

> . . . art has become as "serious" as science or philosophy, which doesn't have audiences either. . . . In taking art as seriously as scientists take science, artists refuse to play the game of art world fads. They are declining society's role assumption of "showman" . . . the withdrawal of art into itself may be its saving grace. In the same sense that science is for scientists, and philosophy is for philosophers, art is for artists.[37]

This rejection of the assumption that an artist's work is ultimately destined for a lay public is not new. Arnold Schönberg authored one of its more spirited formulations half a century ago:

> I also hold the view that a work doesn't have to live, i.e. be performed, at all costs either, if it means losing parts of it that may even be ugly or faulty, but which it was born with . . . [as for the listener] all I know is that he exists and insofar as he isn't indispensable for acoustic reasons (since music doesn't sound well in an empty hall) he's only a nuisance.[38]

Such a passage should not be taken as a colorful exaggeration of an occupational impulse: artists look to the universities for the opportunity of carrying this impulse quite literally to its conclusion. The aim (to use the folk vocabulary) is to reject "vulgar" aesthetic "production" *for* laymen in favor of "pure research" in aesthetic "process" *with* colleagues.

SOURCES OF DISSATISFACTION WITH THE UNIVERSITY

If the new university setting offers a chance to escape from the compromising demands of other marketplaces, it also imposes new constraints. University entrance requirements, with their heavy emphasis upon high school grade point averages and scholastic aptitude tests, bar many artistically talented students whose craft training may already be advanced but whose grades and test scores do not meet general university standards. The university artist finds his own predelictions in student admissions subordinated to the principles of the university's wider liberal education program. If the teacher is engaged with an art form demanding prolonged bodily discipline which must be commenced at a very early age (such as some forms of dance and musicianship), it will be crucial to him to find students whose professional commitment has already been partially made, even if (as is often the case) their aptitude, interests, and competence outside their craft are quite limited. And yet he will often find that these very students are denied him, while he is forced to "waste his time" with others who have neither talent, inclination, nor youth enough to promise any significant professional achievement.[39] Teachers in the independent professional schools have always had many students who would remain amateurs too, but at least these schools did not discriminate against professionally well-qualified students who had scored low in verbal aptitude tests or who had only a low high school grade-point average in part *because* they had been spending every spare moment doodling or drawing.[40]

Like an athletic coach, a university art teacher is to some extent cast in the role of teaching a recreational skill for leisure time enjoyment. And perhaps the very ambiguity of the boundary between "professional" and "amateur" status in the arts (due to the fact that many professionals are unable to earn a living by the practice of their craft) makes university artists particularly sensitive on this point. That one person's profession might be anothers' recreation can be quite threatening to occupational identity and pride. As a Cal Arts teacher bitterly quipped, "If anybody can be an artist, then an artist is nobody."

Both among my informants and in published discussions of the arts in academia, the notion of an academic teaching job as a leech draining its

victim's creativity, especially when he is not allowed to be extremely selective in his contact with students, is an enduring theme. Typically, the artist-in-residence role, with its limited teaching obligations, is regarded as the appropriate one for an individual whose creativity and productiveness are deservedly a matter of social concern; and against this model most academic jobs are measured and found wanting. Anything less than the offer of institutional patronage and the promise that the sanctuary granted to an artist will be breached only by a deserving and serious minority is seen as a disheartening sign that the recipient's greatness is, depending upon his age, neither respected nor expected.

The idea that significant talent deserves to be supported, that it should not be dissipated by the necessities of working extraneous jobs for a living, is understandably strongly held among artists.[41] On the one hand this simply implies that an artist's work should afford him a living, that he should not be forced to turn his precious time and energy towards other paid employment. But there is also a trace of the sense that artists, like beautiful women, should be protected from the indignity of routine and unworthy work obligations—that the fragile quality of inspiration for which they are valued will be snuffed out if their attention is ensnared by a profane sphere of activity.

The following passages from a text on music education refer specifically to the problems of the "composer-professor," but they are representative of the concerns of artists in other fields as well:

> . . . [his] creative impulses may in time sink into the swamps of academic routine [as he faces the] disheartening task of teaching the simplest principles of harmony to unprepared and uninterested freshmen in large masses.[42]

> . . . [he is] caught in the wheels of the academic machine; [his] mornings spent in crowded classrooms, and [his] afternoons in grading papers and attending committee meetings, [his] evenings in dull exhaustion. . . . Inspiration and academic regimentation are antithetical. Once having begun the lock step of continuous classroom toil, the composer-professor soon grows sour and frustrated, and soon will be less efficient as a teacher than are his colleagues who have never suffered the pangs of single creative urge. Practicing composers who become teachers should not be overloaded with academic chores. They are happiest, and therefore render the most useful service, when they [are] responsible in [their] own way for the sympathetic guidance of only a few advanced students whose technical skill and creative aptitude place them above and beyond the average level of the college student.[43]

The redundancy of the terms "practicing composer" and "practicing artist" is in itself interesting: it is used as a contrast to the academic who, never having practiced his craft professionally or gradually ceasing to practice it as he becomes absorbed by his academic job, is regarded as an artist in name only. The common fear is that the "COMPOSER-professor" will be transformed by academia into a "composer-PROFESSOR," and ultimately into a mere "professor."

In many occupations, career lines may draw people away from the core activities with which their work is symbolically identified.[44] The composer-professor who eventually ceases to compose might be comparable to the engineer who eventually forgets how to use a slide rule after moving "up" to an administrative post. At Cal Arts anyone whose academic teaching role had eclipsed his nonacademic productiveness was discussed with rather triumphant and competitive pity. People watched one another for the signs of such an eclipse with all the vigilance and anticipation with which a fundamentalist community might scrutinize its members for signs of straying from the "spirit." The low esteem in which university-based artists hold art teachers without outside professional connections is probably pretty well suggested by the assumption expressed in the passage quoted above that the composer-professor will be joining "colleagues who have never suffered the pangs of a single creative urge."

While a university post is a boon in many respects, it can be a dangerous seduction as well. University teaching regarded as a sideline is more absorbing than most alternative positions; a profession in itself, it demands greater commitment than a job allowing more of the self to be held in reserve during its performance. While it might seem that here the university artist is only experiencing the conflict between teaching and professional productivity so commonly voiced by other academics, this conflict is exacerbated for artists since a teaching post, even in a prestigious university, brings them little recognition or reward in their nonacademic professional worlds (where achievement is still measured by performances and exhibitions, and by the reviews and publicity they receive).

Even were the university artist able to choose his ideal clientele so that he worked only with talented and well-prepared students, the university's bureaucratic structuring of student activity interferes with the necessary temporal rhythm of serious and disciplined artistic production. The undergraduate student who is required to maintain a minimal level of achievement in a variety of academic subjects is not free to drop all other obligations in order to spend eight hours a day in the painting studios or to work around the clock polishing a string quartet or a theatrical production. His attention is constantly shifted and dispersed as he balances many work obligations: a biology exam may keep him from

rehearsing for days to the disgust of faculty artists who regard exclusive and singleminded concentration, especially during peak periods of production, as the hallmark of a serious artist. The broadly educated human being is an educator's ideal not an artist's, who might well prefer his student to be locked in a closet with his violin for four years if his chances of emerging an "idiot genius" were thereby enhanced. Especially in those arts which require disciplined commitment at a young age, instructors are impatient at having to wait for their students to reach the level of graduate school before securing a relative monopoly on their time and energy.

Even more serious, the university setting inhibits mutual collaboration and influence between different kinds of artists by encouraging rigid definitions and maintenance of disciplinary boundaries. Whereas the university has brought different arts together in a single organization, the promise thus raised of new creative syntheses—of a new *Gesamtkunstwerk*—has not been fulfilled because a bureaucratic work organization has encouraged ever more narrow specialization and rigid demarcation of discrete domains of aesthetic activity.

Not only does the structure of university education create problems for art programs, but their members—as latecomers to academia—are often quite marginal members of the wider university culture. Art department salary scales are frequently lower than those of other disciplines, and their budgets are likely to compare unfavorably with those alloted to the sciences. The new occupational setting can thus give rise to a sense of relative deprivation, even though colleges and universities have afforded more lavish budgets than the smaller independent professional schools ever could. Large budgetary discrepancies are particularly galling for those artists who identify advanced research in the arts with the experimental use of advanced technology for aesthetic purposes. The following complaint by one administrator illustrates the ambitions and consequent frustrations raised by proximity to university scientists:

> One of the archaic things at the University of California was to deal with course support for the arts at about the level of the humanities—based on a watercolor class of 1919! On the Ladies' Drama Society! And we really calculated the needs of the arts—with electronic music, with what art schools need in general—to come much closer to aerospace and biology!

In a milieu which has traditionally valued scholarship (as measured in the volume of publications) above all other activity, the creation of art (in distinction to connoisseurship or art history) has suffered the same taint of vocationalism and faced the same initial difficulty in gaining acceptance as

a legitimate academic pursuit as the laboratory sciences did during the late nineteenth century. Even novelists and poets, whose craft would seem the most easily assimilable by the academic milieu, find themselves to be academic outsiders and experience difficulty in securing regular appointments in departments biased towards hiring people with standardized careers and credentials and narrowly defined expertise. Even within the art departments, artists often find programs dominated by the longer established and more scholarly art historians and theorists. There is a widely recognized and long-standing animosity between practicing artists and these academics whom the former accuse of having as little sympathetic grasp of contemporary aesthetic developments as Archimedes would have of modern engineering. To many artists the art historian, like the critic, is simply another kind of square layman presuming to make authoritative judgments about work which only practioners are equipped to understand and, to make matters even worse, he is likely to be completely out of touch with current problems and issues in the field.

Faced with pressures to adapt to a new milieu, some art educators have argued in favor of emphasizing the role of discipline, intellect, and scholarship in the practice of the arts in order to enhance their academic respectability.[45] Rejecting what they call a vulgar vocational approach, they urge that the period of formal training be lengthened to include both a preparatory liberal education and a graduate professional education, and that art programs be encouraged to grant a doctorate of fine arts proclaiming its holder "capable of creative effort in his specialty [and possessed with] enough formal academic training to allow him to hold his own in the academic community."[46]

The argument is bolstered by the idea that the arts now draw so much upon other branches of knowledge that it is no longer sufficient for an artist to be simply a good craftsman.

Advancing the onset of formal training to the graduate level while emphasizing the scholarly and theoretical grounding of practice is an old strategy for raising an occupation's standing in the world.[47] Elite artists have been accenting the intellectual aspects of their work since the Renaissance. We can trace a continuous line of development in this regard from Michelangelo's insistence that he worked *col cervello*,[48] to the eighteenth-century painters who prided themselves more on their learned grasp of obscure and esoteric mythological and historical themes than on their manual skill to, finally, the Conceptual artists of the 1960s who altogether dispensed with the craft of object-making in order to highlight more clearly the purely conceptual and philosophical side of art.[49]

Attempting to reformulate the artist's role as that of a philosopher and idea man, the so-called Conceptual art movement can partly be

understood as an adaptation to changes in the structure of economic support for the arts. Conceptual art, as one critic observed, "needs patrons rather than collectors,"[50] and though the practitioners of the genre attempted very early to create and sell a new service role for the artist as an idea man or aesthetic consultant for government, industry, and education, the new role is best suited to academia.

From the time of the earliest academies of the Renaissance, the cultivation of theory and criticism, of intellectual over manual dexterity, has been the hallmark of art academicians. The Conceptual art of the sixties—with its treatises and its theses, its substitution of publications for exhibitions, and its redefinition of works *of* art to include esoteric criticism and speculation *about* art[51]—appears to be a genre of academic art finely adapted to the pressures of the new university habitat.

But even with an adaptive academization of the arts, the college and university milieu jars with the mores of the bohemian subculture in which many artists still participate: a subculture which grows out of highly atomized, "loose" occupational structures and exalts qualities of anarchistic individualism (eccentricity, the apostasy and advertisement of personality through flamboyant, spontaneous, and outrageous behavior) confronts the culture and imperatives of a bureaucratic work organization with its stress on certified and universalistic credentials, routinized procedure, formally designated domains of authority and expertise, the subordination of person to office, and the use of formal and hierarchically significant titles. People who may have been drawn to art in the first place because, like Marcel Duchamp, they "did not want to go to the office," now squirm slightly in their university offices like resettled gypsies in a pristine new housing complex. Forced to do some of the despised "paper pushing" in the very opposition to which their occupational identity was formerly defined, they enjoy their new comfort and security while suspecting the new milieu to be incorrigibly sterile both as a setting for the socialization of new occupational generations and for the production of significant new achievement.

Doubts and reservations about the suitability of the university as a center of artistic work and education and hopes for discovering a new solution to their particular problems were being widely articulated by professional spokesmen during the period in which Cal Arts was founded. McNeil Lowry of the Ford Foundation, who later enthusiastically endorsed the Cal Arts project. expressed the following discouraging opinion to the Association of Graduate Schools: "Under the present conditions, the best service you can perform for the potential artist is to throw him out."[52]

And a dean of a university theater school who had benefited more than most from university sponsorship as a result of having been given the

opportunity to create a permanent resident professional company, when asked about the "ideal relationship" between the theater and the university stated:

> The ideal relationship is to remove theater and theater training from the academic and university organization, and establish it in an academy loosely connected to the university, so that it could be financed by the university, visited by members of the university, and could call upon the facilities of the university when necessary. In short, theater or theater training should not be involved in the giving of degrees, or the organization of curriculum in quite that rigid and necessarily inflexible way that one finds oneself falling into just by virtue of the structure of a university situation.[53]

He then continued to speculate about the possibility of creating a university-financed "academy of the arts" which might include music, dance, and film as well as theater. The interview echoes the conviction expressed during an international conference on the professional training of artists that the ideal arrangement would be the creation of "an advanced Institute for artistic research . . . combining the qualities of atelier and university type instruction."[54]

In summary, during the period in which Southern California patrons were studying the possibility of developing a "Cal Tech of the Arts," artists found themselves 1) increasingly looking to the education industry for occupational training and employment, and 2) searching for a way of retaining the financial, organizational, and status advantages of the university work setting, while recouping both the focussed specialization and professionalism of the waning vocational schools and the bohemian culture of a thriving, informally organized art "scene." University artists entertained a mood of what might be described as occupational nationalism or aesthetic separatism: an inclination to define the arts as essentially related, to exclude from this "family" the "poor relations" (fashion design, advertising art, handicrafts) which had been left behind in the vocational schools with the move "up" to the university,[55] and to search for a new institutional alternative—a territory of their own which could be organized to meet the unique demands of their occupational practices and which would be responsive to the ethos of their occupational cultures.

NOTES

1. See Ivan Illich's work on the formal institutionalization of education. Ivan Illich, *Deschooling Society* (New York: Harper and Row, 1970).

2. Jacques Lethève, *La vie quotidienne des artistes au XIX siècle* (Biarritz, France: Librairie Hachette, 1968), p. 11.

3. Nikolaus Pevsner, *Academies of Art: Past and Present* (Cambridge: Cambridge University Press, 1940), pp. 91-92.

4. Lethève, Op. cit., p. 14.

5. Pevsner, Op. cit., p. 14.

6. Elizabeth McCausland, Royal B. Harnum, and Dana P. Vaughn, *Art Professions in the United States* (New York: Cooper Union Art School, 1950), p. 19.

7. Paul S. Carpenter, *Music: An Art and a Business* (Norman, Oklahoma: University of Oklahoma Press, 1950), p. 178.

8. For a discussion of the varying degrees of (weak) collective power held by workers in the arts see the following historical account of the fates of the arts during the Depression years: William F. McDonald, *The Federal Relief Administration and the Arts: The Origins and Administrative History of the Arts Projects of the Works Progress Administration* (Columbus: Ohio State University Press, 1969).

9. Mason Griff refers to the lack of "tight," centralized occupational control in the arts in order to account for their "open" system of recruitment and for the "gentle" practices of many art schools in the United States. See his "Recruitment and Socialization of Artists" in *The Sociology of Art and Literature: A Reader,* edited by Milton C. Albrecht, James H. Barnett, and Mason Griff (New York: Praeger, 1970), p. 147.

10. See John A. Michaels, "Artists' Ideas about Art and Their Use in Education," Final Report, Project #5-8300, *United States Department of Health, Education and Welfare,* 1967. Michaels found that over 96 percent of a sample of "successful" artists (defined as those whose names recur on national exhibition lists) had been prepared in professional art schools. Only half of them, however, felt their education had been of any value in their later work. See also the discussion of artists' experience with formal education in Bernard Rosenberg and Noriss Fliegel, *The Vanguard Artist: Portrait and Self-Portrait* (Chicago: Quadrangle, 1965), pp. 116-22.

11. Stuart McDonald, *The History and Philosophy of Art Education* (London: University of London Press, 1970), p. 255ff.

12. See Jack Morrison, *The Rise of the Arts on the American Campus* (New York: McGraw Hill, 1973); and Morris Risenhoover and Robert T. Blackburn, eds., *Artists as Professors: Conversations with Musicians, Painters, Sculptors* (Urbana: University of Illinois Press, 1976).

13. Cited in Edward L. Mattil, "Teaching the Arts," in *The Arts in Higher Education,* edited by Lawrence Dennis and Renate Jacob (San Francisco: Jossey-Bass Inc., 1968), p. 69.

14. William J. Baumol and William G. Bowen, *Performing Arts: The Economic Dilemma,* A Twentieth-Century Fund Study (Cambridge, Masachusetts: The MIT Press, 1966), pp. 31; 530.

15. See Everett C. Hughes, *Men and Their Work* (Glencoe, Illinois: The Free Press, 1958), p. 131.

16. The parallel between the transformation of other kinds of "free professionals" into salaried employees and the earlier transformation of artisans into industrial proletarians is argued in Serge Mallet's idea of the "new working class." See his *La nouvelle classe ouvrière* (Paris: Editions du Seuil, 1963).

17. See Pevsner, Op. cit., p. 97, and John Berger, *Art and Revolution: Ernst Neizvestny and the Role of the Artist in the U.S.S.R.* (New York: Random House, 1969), p. 79.
18. The romantic stereotype draws only on the soloist's role, not on that of the conscientious member of a symphony or dance company "team."
19. For a comparison of the classic bourgeois industrialist and the creative artist, see Jacques Ellul, *Métamorphose du bourgeois* (Paris: Calmann-Levy, 1967, p. 11:

> A son niveau [le bourgeois] est [un artiste]. Il n'a vu qu'une chose, et fut le seul à la voir, la mise en oeuvre de tout le possible économique, de toutes les richesses poue les créer, les faire reproduire, et lancer par la tous les mouvements économiques. Il est habité par une seule idéologie - celle de son entreprise - à condition de jouer sur ce mot: qu'il a enterpris et cette institution de production qu'il a créée. Parce que ce fut enterpris, tout doit être subordonné à la vie, la marche, le développement de cette institution. L'idéologie de l'entreprise dépasse de tres loin les revenus, les richesses qui seront consommables par ce bourgeois. Il est bien plus prêt à réinvestir qu'à thésauriser ou à vivre dans la lux amolissant. Et c'est la marque de son obsession, mais de son génie. Pour réaliser ce dessein, cette immense mise en branle de tout le processus économique, il fallait une énergie implacable - un caractère inflexible - et que tout ploie devant.

Such an image is no longer constructed of our industrialists, but it continues to be romantically applied to art workers.

20. See Erwin O. Smigel, *The Wall Street Lawyer: Professional Organization Man?* (Bloomington, Indiana: Indiana University Press, 1964), p. 206.
21. Pierre Cabanne, *Dialogues with Marcel Duchamp* (New York: Viking Press, 1971), p. 25.
22. See James Ackerman, "The Demise of the Avant-Garde: Notes on the Sociology of Recent American Art," *Comparative Studies in Society and History* 4 (October 1969), pp. 371-84; Donald Drew Egbert, *Social Radicalism and the Arts* (New York: Alfred Knopf, 1970), pp. 721-22.
23. See the historical comparison between the social status of artists and scientists in Elliot Krause, *The Sociology of Occupations* (Boston: Little Brown and Company, 1971), pp. 256-61.
24. For an analysis of the economic imperatives underlying the rise of advertising art in the 1920s, see Stewart Ewen "Advertising as Social Production," in *Radical America* 3, No. 3 (May-June 1969), pp. 42-56.
25. Fred C. Rochewald and Edward M. Gottshall, *Commercial Art as a Business* (New York: Viking Press, 1971), p. 23.
26. See J.B. Hightower, "Class Art to Mass Art," *Art in America* 58 (Spring 1970), p. 25.
27. In 1972, the University of California opened a Graduate Arts Management Training Program sponsored by the Graduate School of Business Administration and the College of Fine Arts. Arts Administration is an incipient new profession.
28. For an incisive criticism of "professionalized" culture and the "education" of the public to acknowledge its standards and authority, see Jean Dubuffet, *Asphixiante Culture* (Paris: J.J. Pauvert, 1968).
29. Mattil, Op. cit., p. 68.

30. See, for example, William J. Baumol and William G. Bowen, *Performing Arts: The Economic Dilemma* (Cambridge, Massachusetts: The MIT Press, 1966). This study concludes with the observation that not only did amateur activity in the performing arts greatly increase during the early sixties, but also due to the "rising costs of professional performance, amateur activity will tend to drive the trained performer from the field," p. 407.

31. Margaret Mahoney, ed., *The Arts on Campus: The Necessity for Change* (Greenwich, Connecticut: New York Graphic Society, 1970), p. 49.

32. A study prepared for the College Art Association of America in 1966 revealed that between 1957 and 1962 about half of the recipients of M.F.A. degrees in university painting programs wanted to go into university teaching as a career. Andrew Ritchie, *The Visual Arts in Higher Education* (New Haven: Yale University Press, 1966), Table 10.

33. For a discussion of the concept of "comparative failure" in another context, see Robert R. Faulkner, *Hollywood Studio Musicians* (Chicago: Aldine Atherton, 1971), pp. 52-61.

34. For data on median income levels in the arts see Baumol and Bowen, Op. cit, pp. 99-135.

35. Howard Becker's study of jazz musicians pointed this out years ago, and my field work strongly confirms his findings. See Howard Becker, "The Professional Dance Musician and his Audience," *American Journal of Sociology* 57 (September 1951), pp. 136-44.

36. For an example of this new identification, see Gorgoni Müller, *The New Avant-Garde* (New York: Praeger, 1972), p. 6. "Not since da Vinci have artists come so close in their creative thinking process to the discoveries and conclusions of other realms of research such as physics, psychology, linguistics and anthropology. Today's works have replaced vague poetical allusion by a rigorous methodology in experimenting with reality." For an account of the Rennaissance artist's advantageous alliance with the literati of his day, see Arnold Hauser's "The Social Status of the Renaissance Artist," Chapter 3, *The Social History of Art*, Vol. 2 (New York: Vintage, 1951), pp. 52-84.

37. Ursula Meyer, *Conceptual Art* (New York: Dutton, 1972), p. xx.

38. Letter to Alexander van Zemlinsky, February 23, 1918. Quoted in Henry Raynor, *A Social History of Music* (New York: Schocken Books, 1972), p. 9.

39. One study of ballet dancers, for example, reports that female dancers, even those who end up in the less prestigious companies, must begin training before the age of ten, and that few male dancers begin training as *late* as age seventeen. See David Earl Sutherland, "Ballet as a Career," *Society* 14, No. 1 (November-December 1976), pp. 40-41.

40. I remember visiting one Institute musician (who was also on the faculty of a nearby university) just as one of his university students—a string player—was leaving. "I hate that!" he spat out in frustration as soon as the student was out of earshot—meaning, he felt it a waste of his expertise to teach an eighteen-year-old beginner a craft which must be started at the age of four to be done well. He tried to comfort himself by repeating several times that the student was "nice," that it would be nice for her to play music with her boyfriend, but like an aging athlete who had dreamed of training a star and found himself instead with a Sunday gymnastics class of overweight office workers, the very nature of the clientele the university imposed on him was a disappointment and a humiliation.

41. At the Institute, a music student was understood by others to have become the object of "great expectations" when his teacher stated that it would be a crime for him ever to have to work, that "someone like that deserves to be supported."

42. Paul S. Carpenter, *Music: An Art and a Business* (Norman, Oklahoma: University of Oklahoma Press), p. 183.

43. *Ibid.*, p. 188.

44. Everett C. Hughes, *Men and Their Work* (Glencoe, Illinois: The Free Press, 1958), p. 137.

45. See Margaret Mahoney, ed., *The Arts on Campus: The Necessity for Change* (Greenwich, Connecticut: New York Graphic Society, 1970); A. Whitney Griswald, ed., *The Fine Arts and the University* (New York: Macmillan, 1965).

46. F. Curtis Canfield, "The Performing Arts," Griswald, *Ibid.*, p. 44.

47. See, for example, Hughes, Op. cit., p. 134; William E. Moore, *The Professions: Roles and Rules* (New York: Russell Sage, 1970), pp. 60-61; and Eliot Freidson, *The Profession of Medicine* (New York: Dodd, Mead & Co., 1970), pp. 77-84.

48. Hauser, Op. cit., p. 67.

49. See Meyer, Op. cit.; Lucy Lippard, ed., *Six Years: The Dematerialization of the Art Object* (New York: Praeger, 1973); and Donald Karshan, ed., *Conceptual Art and Conceptual Aspects* (New York: New York Cultural Center, 1970). See also Sally Ridgeway, *When Object Becomes Idea: The History of an Avant-Garde Art Movement*, Ph.D. dissertation, Department of Sociology, City University of New York, 1975.

50. Lippard, Op. cit., p. 8.

51. Meyer, Op. cit., pp. 10-13; Tom Wolfe, *The Painted Word* (New York: Farrar, Straus and Giroux, 1975), concurs with this interpretation.

52. Cited in Mattil, Op. cit., p. 71.

53. Robert Brustein, "The Idea of Theater at Yale," *Theater Quarterly* (Winter 1971), p. 74.

54. "Report of the International Conference on the Professional Training of Artists," (London, 1965).

55. Any particular classification of different activities as related "arts" is, of course, historically variable (in the eighteenth century gardening was considered a fine art, akin to poetry, while painting was not); the social classification of a craft as a "fine art" is to some extent the outcome of successful occupational politics. (At Cal Arts, the field of design was the *nouveau arrivé*, and the claim—implicit in their very presence—that designers were 'artists' did not go unchallenged by art's "older families," even if at other moments the latter could afford to profess disdain for their occupational title.) For a discussion of the evolution of an earlier stage in the system of the arts, see Paul Oskar Kristeller, "The Modern System of the Arts: A Study in the History of Aesthetics," *Journal of the History of Ideas* 12 (1951), pp. 496-527; and ibid., 13 (1952), pp. 17-46.

Chapter 2

REVOLUTIONARY ART AND THE
ART OF REVOLUTION

La condition de l'artiste dépend d'abord
du type de société dans laquelle il vit et
des moyens par lesquels s'opèrent la
reconnaissance des oeuvres et leur
commercialisation. Mais ce qui importe,
au moins autant que les données
objectives, pour comprendre la manière
dont les artistes vivent leur condition,
c'est l'idée qu'ils se font d'eux-memes et
de la société, c'est leur idéologie.

Raymonde Moulin, *Le Marché de la
Peinture en France*[1]

Institute students and staff saw themselves as subjects of a utopian
experiment in the reorganization of their education, work, and life. This
was the common understanding which underlay all the talk about whether
"it" could ever have worked, about who had betrayed "it" and where "it"
had gone wrong—conversations which accompanied the life of the
institution from the time it opened and which formed a major collective
pastime. Competent participation in institutional gossip, appreciative

observation of the unfolding institutional drama, comprehension of the community's various hierarchies of moral credibility—in short, membership—required an awareness of this shared understanding that the Institute (like all utopian communities) was a "promise" to be fulfilled, a "difference" to be maintained, a "refuge and a hope."

The school recruited its first members and worked on shaping its public image and its mandate during a period (1967-1970) of unusual millenarian fervor in the Western world. Student revolts, ghetto riots, the events of May-June 1968 in France, the increasing visibility of a distinct youth culture organized around values opposing those of the dominant culture, were widely taken as signs of "The Beginning of the End"—signs which at once proclaimed a millenarian presence and served as supportive evidence for a millenarian orientation. Since the social base of this loosely organized international movement was drawn more along generational than economic or occupational lines, youth, sometimes proclaimed to constitute a new social class,[2] inherited the role formerly assigned to the proletariat as the expected agent of imminent collective salvation.

The Institute was merely one of a host of other communitarian and educational experiments which rode on the wave of this social mood, and an important determinant of its eventual fate (along with the collapse of the boom economy of the early sixties) was the fact that the wave of collective fervor and enthusiasm which had promised to bear it up subsided rather quickly, leaving the school becalmed amidst the period's debris of abandoned hopes and discredited rhetoric.

The nautical metaphor is not my own, but rather one in which the "vessel's crew" lived their experience: when a new administrator was hired he would be "welcomed aboard" by his colleagues and, when the institution was believed to be in trouble, its members alluded in conversation to the "Flying Dutchman" and to "Moby Dick," to captainless and doomed ships which would never complete their charted course. Institutions being less labile than social movements, the costly church spawned during an evanescent religious moment eventually faces the problem of protecting the long-term investments of its backers and functionaries and of sustaining a convincing air of legitimacy once that moment has passed. The Institute can usefully be seen as both a vessel and a church; the pages which follow explore the composition of the spirit which first filled its sails.

MILLENARIANISM AND UTOPIAN COMMUNITARIANISM

Millenarian and revolutionary social moods, in their emphasis upon the necessary totality of the transformation of social life and upon the radical

discontinuity between a morally compromised present and a redeemed future, might appear to preclude the project of securing isolated pockets of the future within the present. And yet the 1960s proved to be a fertile period for utopian community building. Discrediting existing social arrangements and raising new hopes, a millenarian movement weakens believers' commitment to established institutions and almost inevitably prepares ground for the idea that the collective salvation relegated to the future and dependent upon massive social change might, after all, be accessible in the immediate present, and on a more limited scale, to those privileged with enough faith, will, and resourcefulness to provide it for themselves.

The same historical moment which is fertile for social movements committed to revolutionary self-sacrifice, violent attacks against the existing order, or a "long march through existing institutions"[3] also favors the hope that in the shell of a moribund world crumbling of its own accord lies a better, more gratifying and coherent one which asks only receptive recognition in order to open its doors.[4] Thus a voluntaristic utopianism (attempting to spatially distance participants from the rejected social order) and a revolutionism which seeks temporal deliverance can serve as alternative postures of social opposition (though not mutually exclusive ones, some so-called activist collectives having tried to combine both). Undoubtedly too the sense of *communitas,* which seems to accompany the disruption of conventionally structured roles and social relations during periods of crisis, encourages the development of communitarian and millenarian or revolutionary movements.

One can speculate upon the reasons underlying the emphasis upon communitarian utopianism over revolutionism, and the burgeoning of the communal movement in the late sixties was interpreted by many, even at the time, as signaling the defeat of more political forms of opposition and a resort to internal emigration. Dissatisfaction with existing institutions in the absence of faith in their reform seeks relief in the comforting conviction that they are, in any case, merely excrescences of a doomed past, and that until the future has been consolidated, life can be passed in an alternative system. "Free schools," "free universities," "people's medical centers," "free stores," and even "tent cities," rose during the sixties beside the educational institutions, hospitals, stores, and settlements perceived as alien and unresponsive. Where such alternative institutions grew out of the hope that life could be lived *within* the dominant society but neither *of* it nor in struggle against it, they served as retreats for tired refugees and—in the end—as testing grounds for later superficial innovation in the dominant institutions they meant to replace. Even the rustic, pastoral component of counter-culture communitarianism might best be

understood not as the harbinger of a historically unique "Greening of America" (as a popular book of the sixties promised), but rather as the resurgence of a traditional American solution to the problem of social discontent: "dropping out" and "going West"—returning, if not literally to the frontier, then at least to its mythologies.[5]

Cal Arts, introducing itself in its early publicity as an alternative educational institution and identifying itself (in part for recruitment purposes) with the spirit and imagery of the youthful opposition movement, was biased in the direction of apolitical and communitarian tendencies.

In a book published in the year the Institute opened, John Cage (anarchist, composer, and a major source of professional and philosophical orientation for many of the school's students and staff) had written (quoting the Wright brothers):

> It is not really necessary to see very far into the future to see how magnificent it will be" . . . it's just a question of opening the doors. Many doors are now open (they open according to where we give our attention). Once through, looking back, no wall or doors are seen. Why was anyone for so long closed in?[6]

This wishful idea that the magnificent future whose inauguration had seemed to entail such struggle and delay might after all be entered without effort, was also expressed when one Cal Arts teacher announced to friends who had remained behind on the East Coast that "California is *after* the Revolution!"

The promise of being able to drop behind the temporal lines of "the Revolution" through a trick of perception or participation in a just community is an enduring utopian theme.[7] The mere hint of such a promise at Cal Arts lent a charisma to the new institution which played an important role in the first phases of recruitment. This charisma was amplified both by the mystique the arts enjoyed during a period intellectually dominated by the idealist assumption that changes in perception and consciousness are the principal motors of historical transformation,[8] as well as by the cultural significance of California (especially during the sixties) as a land of youth,[9] dreams, and easy gratification—as the last heir of New World frontier mythology.

THE IDEAL COMMUNITY AS THE IDEAL SCHOOL

One of the notable characteristics of the communitarian movement of the sixties was the presence of numerous groups adopting educational and therapeutic work as their principal task.[10] This penchant for founding

what came to be called "growth" or "learning communities" cannot be fully explained by the age composition of the counter-culture or by its social base on college campuses even if it is probably true that as farmers might dream of ideal farms, or life time prisoners might envision an ideal society as a modification of the only one they know, the utopian imagination of students or teachers easily seeks ideal human community in an ideal school.

In industrial societies, insofar as schools have come to play a more important role than churches in socializing young adults and in offering plans for both individual and collective redemption, a counter-educational movement rather than an overtly religious one is the logical form which a contemporary millenarian challenge must take. As the subversive idea that all people might enjoy unmediated access to humanity's awesome store of secular knowledge replaces the view that each person is capable of establishing his own unmediated relation to God, the demand for "free schools"—where all would be teachers and all students—becomes the secular version of an earlier radical Protestantism.[11]

The following passage from a counter-culture journal, in its vision of humanity's redemption and unification by a transformed educational system, indicates the mythology in which the utopian strivings of the period were so often expressed:

> The word "university" implies an institution concerned with the universe, an institution concerned with individuals as whole human beings in relation to their whole environments. So let's imagine a university system which includes all people as members and which is designed to enable us to continually learn a better living in the universe. This would be a general organization, coterminous with "society," which would enable us to cooperatively integrate our lives, formulate basic policy decisions, and share the joys and struggles of sentient existence. Through this university, we would have access to the accumulated wisdom and technology of humanity.[12]

As a "mother university" rather than a "mother church" makes humanity "whole" and affords direct contact with the hitherto distant and professionally mediated secular powers which have replaced the older, distant, professionally mediated Gods, the implementation of a "liberating" pedagogy rather than that of corrected religious doctrine becomes the key to collective salvation. Of course, the hope of redemption by means of a pedagogy free of all artificial and imposed social forms is at least as old as the Enlightenment and the publication of Rousseau's *Emile*. More pertinent for our purposes, it has been a central tenet of American

bohemianism.[13] The idea (and the corresponding quest for the ideal school) became particularly captivating in the sixties when young people formed a larger proportion of the population than at any other time in the twentieth century and when more young people than ever before spent long segments of their lives in school. Simultaneously the youth and antiwar movement of the period subjected established schools to widespread and thoroughgoing attack,[14] signaling a crisis in the legitimacy of higher education which new institutions, from experimental, degree-granting colleges to "free universities," sprang up to meet.

At the time Cal Arts took shape, not only could the expanding "business" of education be regarded as a way of subsidizing both art and utopian experiments, but a utopian social mood had opened a new market in the education industry—one which promised to provide a competitive foothold for many small concerns selling both the experience of *communitas* in the present and the formal degrees necessary to secure future economic and status advantages in a stratified society. At first Cal Arts was one of the institutions whose survival seemed to depend only on its ability to secure a niche in this new market; later, however, its fate became determined by the market as the latter contracted in the subsequent period of economic recession and political reaction.

ART AS REVOLUTIONARY PRACTICE: WORLDLY AESTHETICISM

The anarchist orientation and antinomian life style characteristic of the counter-culture[15] has been endemic to the twentieth-century avant-garde. Modernist art might even be regarded as an enclave in which anarchism has been kept "on ice" and given symbolic expression during periods in which it lay politically dormant. If past generations of artists looked upon revolutionary activity with admiration as the "fine art of the proletariat,"[16] an isomorphism in the expression of political and aesthetic revolt also encouraged aspiring revolutionaries of the sixties to look for inspiration to the avant-garde tradition in the arts.

Herbert Marcuse, the most influential of the theorists to explicate the counter-culture to other intellectuals and to itself, argued in a gnostic vein that art housed an exiled divine spark (the image of human liberation and the sublimation of human rebellion) which, breaking its bounds, could inspire the most radical transformation of life ever achieved. In this philosophy, art, by offering a prototypical model of the reconciliation of sensuousness and rationality, freedom and form, points the way to a liberating and humanizing rather than alienating and deforming social organization. If art thus becomes the magically mediating key to a series of

cognitive oppositions of central moral significance, aesthetic experience, by implication, is a form of critical consciousness more profound than any narrowly political leftism, and the artist is an avatar of a new social order. The artist's work need not be manifestly political for this to be the case; in fact, the less addressed to pressing issues of the day and the more single-minded its pursuit of purely aesthetic problems, the more profound its radicalism is presumed to be. In the context of a social order believed to be uniquely capable of absorbing all criticism directed against it, authentic art is seen as one of the last languages capable of communicating truths which transcend the limitations of the prevailing imagination. The following excerpts from Marcuse's essay, "Art as a Form of Reality," contain the essential themes of this aesthetics: art as preparation of a new human subject for a better world; art as presenting repressed truths; art as the last language capable of critical and subversive communication; the historical "realization" of art in a free society:

> The development of art to nonobjective art, minimal art, antiart was a way toward the liberation of the subject, preparing it for a new object-world instead of accepting and sublimating, beautifying the existing one, freeing mind and body for a new sensibility and sensitivity which can no longer tolerate a mutilated experience and a mutilated sensibility. . . .

> The authentic oeuvres, the true avant-garde of our time, far from . . . playing down alienation, enlarge it and harden their incompatibility with the given reality. . . . They fulfill in this way the cognitive function of Art (which is its inherent radical, "political" function), that is, to name the unnameable, to confront man with the dreams he betrays and the crimes he forgets. The greater the terrible conflict between that which is and which can be, the more will the work of art be estranged from the immediacy of real life, thought, and behavior—even political thought and behavior. . . .

> There is a statement by Marx: "These petrified [social] conditions must be forced to dance by singing to them their own melody." Dance will bring the dead world to life and make it a human world. But today "their own melody" seems no longer communicable except in forms of extreme estrangement and dissociation from all immediacy—in the most conscious and deliberate forms of Art. . . .

> I believe that . . . the "realization" of Art can only be the work of a qualitatively different society in which a new type of men and women, no longer the subjects or objects of exploitation, can develop in their life and work, the vision of the suppressed aesthetic

possibilities of men and things—aesthetic not as to the specific property of certain objects (the objet d'art) but as forms and modes of existence corresponding to the reason and sensibility of free individuals (Marx: "The sensuous appropriation of the world"). The realization of Art, the "new art," is conceivable only as the process of constructing the universe of a free society—in other words: Art as a Form of reality.[17]

Thus, in the dialectical dualism of this "Critical Theory," art is honored both as "the Call" which will awaken man's recognition of his alienation in the "false" world of his exile, and as the form the "other" "freed" world will take. In the language of an earlier Western dualism with which this philosophy shares the equation of enlightenment with the consciousness of alienation, one might say that for Marcuse the history of art, conceived in relation to the theme of historical salvation, is the history of "the light exiled from Light, of the life exiled from Life and involved in [this] world— the history of its alienation and recovery, its "way" down and through the nether world and up again."[18]

The counter-culture of the sixties drafted Marcuse as its principal prophet because it was able to recognize in his work a clarified version of its own less systematic interpretation of the world. Ideas similar to Marcuse's (sometimes inspired by his work) can be found among many authors of the period, some of them influential figures in the arts; for example, in the work of director Richard Scheckner and composer John Cage. The latter in particular advances art as a model for freely structured social life and a source of inspiration for social revolution. The following excerpts from essays Cage wrote during the sixties are representative in their assumption that art opens a privileged route to a utopian future:

> Art's obscured the difference between art and life. Now let life obscure the difference between life and art. . . . World needs arranging. It'll be like living a painting . . . our daily lives the brushstrokes.[19]

> Proposal: take facts of art seriously: try them in economics/politics, giving up, that is, notions about balance (of power, of wealth), foreground, background.[20]

> Music's not waiting, but sings final dissolution of politics-economics so that, in exchange for, say, one day's work per year, each person gets passport-credit card (access to what global-village-human-race has to offer).[21]

"Worldly aestheticism"[22] (a term by which—taking liberties with Max Weber's concept of "worldly asceticism"—I intend to signify the aesthetic

equivalent of the religious determination to breach any opposition between other-worldly spirituality and the profane work of historical transformation) has been a source of political inspiration even for nonartists.

Participants in the French revolt of 1968 which became an exemplary revolutionary event for the international youth movement, traced the spirit and style of their rebellion to earlier aesthetic movements (Dada, Surrealism, jazz, and avant-garde theater) as well as to a more narrowly political tradition. Paris graffiti such as "imagination au pouvoir" became symbolic touchstones for a social movement dedicated to mediating any categorical distinction between art and politics, the realm of phantasy and that of everday life. Aesthetic imagination was regarded as the sacred fount of a spirit which could transfigure the world, and revolutionaries playful enough to describe themselves as Groucho Marxists searched for a political practice embodying the aesthetic of their most admired art forms. One Parisian student described the dominant political style as Dadaist, "sauf que dada devait se tourner vers l'absurd, tandis que nous, ça doit tourner vers la révolution.[23] Another compared the collective improvisation of informally structured political gatherings with the expressive spontaneity glorified by several modernist movements in art:

> L'important était de pouvoir s'exprimer. Prévoir, construire, etc. était tout a fait secondaire. Bâtir le futur, oui, mais en paroles et pour le plaisir. Cela m'a fait penser à l'écriture automatique des surréalistes. Ici, c'était de la parole automatique.[24]

Playfulness and aesthetic imagination, exalted as thoroughly radical forces of subversion, were held to be this revolution's protection against ossification and self-betrayal.[25] The ludic spirit and *communitas* so often characteristic of protest movements in their early, preroutinized stages, were embraced by celebrators of the counter-culture as enduring features of a "permanent revolution" and guarantees of its integrity. In the tradition of romanticism, the joyfulness of the Bacchanal, the "Wedding within the War,"[26] were taken as tokens of the authenticity, moral innocence, and trustworthy humanity of the new revolutionaries—as if betrayals of a revolution could only be initiated in an *esprit de sérieux*. And where festivity was conceived as the essential spirit of revolution, the artist became its natural master of ceremonies, theater its most militant tactic, and the *Gesamtkunstwerk* its model of future social life. Spectacular and artful festivity was identified as the spirit of revolution for yet another reason. Insofar as a loosely structured social movement with little control over those who choose to speak for it quickly finds its public image, its message, even its spokesmen, defined and created by the mass media and

the news industry, its image and style tend to become identified, even in the minds of participants, with its most flamboyant (and hence most newsworthy) sectors—the situationistes in France, the provos in Holland, and yippies in the United States. In the early phases of a political opposition movement when politics (in the absence of real power) consists for the most part of guerrilla theater—of upstaging and discrediting official stagings of "reality"—those adept at capturing the attention of the news media become the new political virtuosi. If mass communications media and its image-makers have become of central political and economic importance in the functioning of advanced capitalism, the guerrilla "artists" who could put such media to new uses held the limelight—and the power—in the movement of protest against it. Abbie Hoffman, in a speech later used as evidence in the attempt to indict him for conspiracy, discusses the advantages of "media freaking" over other less theatrical tactics:

> But people that are into a very literal bag, like that heavy word scene, you know, don't understand the use of communication in this country and the use of media. . . .
>
> I mean our thing's for TV. . . . That's why the long hair. I mean shit, you know, long hair is just another prop. You go on TV and you can say anything you want but the people are lookin' at you and they're lookin' at the cat next to you like David Susskind or some guy like that and they're sayin', hey man, there's a choice, I can see it loud and clear. But when they look at a guy from the Mobilization against the War in Vietnam and they look at David Susskind, they say well, I don't know, they seem to be doing the same thing, can't understand what they're doin'. See, Madison Avenue people think like that. That's why a lot SDS's don't like what we're doin'. 'Cause they say we're like exploiting; we're using the tools of Madison Avenue. But that's because Madison Avenue is effective in what it does. *They* know what the fuck they're doin'.[27]

MILLENARIANISM AND FETISHIZED MEDIA

The media, specifically television and video, were endowed by the counter-culture with a mystique which more than matched the glamour they held in the dominant culture. To have plans for work "in media" was one of the most charismatic of all possible self-presentations in counter-culture milieus. For a generation which conceived of the millennium as a revolution in consciousness, communications technology (from strobe lights to videopaks) and people capable of using it were regarded with the same worshipful fascination as psychopharmaceutic drugs and their

adepts: all promised to "blow minds," "dismantle reality," and reconstruct it in a better way. This attribution of a mysterious potency to communications technology can be illustrated by a few passages from *Radical Software,* a publication expounding upon the visionary and political uses of cable TV and video systems:

> A nervous system is close at hand whereby men of love can flow into each other over great distances, a flow going in all directions to all people. With satellites, cassettes, cable systems, computers interfaced with each other, electronic energy can go freely around the globe. . . .

> Videotape is . . . a new tool not connected to the material world alone but pulsing with energies closer to the nonmaterial realm of electromagnetic awareness.[28]

> The self-processing through videotape . . . allows one to think of self not as center on a private axis, but as part of a trial and error nexus of shifting information pathways.[29]

> Anyone who has ever taken his portapak and a portable monitor into the street . . . knows the power this little machine had in making things happen—i.e., people actually begin talking to you! . . . They also start talking to each other and . . . begin to regain something long ago lost to them in a world of giant corporate power structures, and that is the feeling of having control over their own destiny.[30]

Consciousness-raising tools for the revolutionary, aids to the mystic in his manipulation of the boundaries of selfhood, vehicles of cosmic unification: the latest developments in communications technology were as exalted by the youthful millenarians of an advanced industrial society as money and other symbols of European authority had been by the cargo cultists of Melanesia.

Just as Melanesian prophets, while opposing the Europeans, desired to take over the principles of their authority and sought to outwit them on their own ground by assimilating the ideas, artifacts, and power of the dominant culture for their own use,[31] the segments of the youth movement which did not advocate a purist rejection of technology sought contact with the scientific and technological mysteries of the social order they opposed. A prophet of a Melanesian cult reputedly able to produce money at will or to transfer the power of speaking English to all converts, reflects the charisma of the new foreign order while fashioning a synthesis of native and European values. We find a comparable figure in the guru of the sixties who sported a camera or a videopak as expressive jewelry, promised

instant initiation into the mysteries of electronic computer or audio-visual systems, blended the imagery of the scientific-technical order with an earlier religious one to create a new millenarian vision, and promised to prepare his followers for "survival" in the most comprehensive sense. In both cases, a moral critique of the dominant culture is accompanied by ambivalent recognition of the power of its "magic": and in both cases, an intimate association with that culture's fetishized media is sought by people attempting to regain a feeling of proximity to the forces believed to determine their destiny.

REVOLUTION AS AESTHETIC PRACTICE

But if avant-garde artists, their methods, and their media were endowed with visionary significance for the opposition movement of the time, identification also moved in the reverse direction: "revolutionary" activity appealed to some vanguard artists as a fitting *professional* practice, political and social protest providing a new stage for art on a grand scale. Once the commercially successful Abstract Expressionism of the fifties had designated the canvas as an arena for the artist's existential gestures, the convention confining such dramatistic activity to a square of cloth was ready to be challenged—no longer by marginal, occupational segments alone, but by those with access to their profession's ruling organs of publicity and legitimation. First "happenings" and later other art movements opened new "fields" for aesthetic communication. Public telephone booths joined concert halls as officially sanctioned settings for music making, well publicized theater companies took their performances into the streets, and academic artists who might once have applied chisel to stone, carved with bulldozers into the desert. Why, by extension, should not revolution itself be a work of art (*not* primarily that *political* goals might be realized with skill and imagination, but that an enlarged and vital field for aesthetic pleasure might be exploited)? The highly politicized social consciousness of the sixties seemed to many artists to promise a new cultural efflorescence and favored a reidentification with the formative period of "vanguardism" when the military image was used in an inclusive sense, referring to an indissoluble combination of socio-political and aesthetic radicalism.[32]

Moments of widespread political challenge and ferment have been fertile for artistic modernism in the past. The years directly following the Russian revolution, for example, generated major formal innovations in the arts as well as attempts to break down the bureaucratic and academic divisions between them. Similarly, the Bauhaus movement emerged out of a socially tumultuous period bearing a striking cultural resemblance to the sixties.

The link between social and political revolt on the one hand, and "revolutionary" aesthetic movements on the other, can be partially explained by the anchoring of artistic conventions in social structure. Any art form rests upon implicit assumptions about the system of work and patronage (the routinized organization of collective activity) which finally yields a recognized work of art.[33] To the extent that a spirit of social revolution suggests the possibility of transforming the organization of aesthetic work and patronage along with other social institutions, it permits the imagination of hitherto unimaginable aesthetic innovations which new social relations might make possible. New forms of occupational cooperation appear plausible when a revolutionary mood nurtures a strong element of communitarianism; the theater and film collectives of Julian Beck and Lucien Godard, for example, served as inspirational models of new forms of work organization for many artists in the sixties. Conversely, traditional forms of work organization may lose legitimacy in the presence of such a social mood. The antiauthoritarianism of the counter-culture, for example, created new dissatisfaction with any form of collective production requiring submission to a director or conductor. Furthermore, insofar as a revolutionary movement organizes hitherto dispersed members of a population into a group conscious of its unique historical mission and culture, it creates a new audience, new sources of patronage, and new kinds of occasions for aesthetic work—all of which necessarily imply innovations in the conventions governing it.

It may also be true that cultures reflect variations in the experienced rigidity of social structure by placing a high or low value upon the rigid maintenance of all cognitive structures. The sense that the traditional social order is shifting and subject to question appears to foster a generalized questioning and even dissolution of all conventional cognitive categories from those distinguishing academic disciplines or artistic genres, to those distinguishing male from female and the self from the "not-self." Thus periods in which social structure is felt to be unstable and fluid are probably particularly conducive to experiences of ecstasy and mystical fusion at the psychological level and innovative boundary-breaching and mixing of genres at the cultural level.[34] Romanticism, born during a century of extraordinary social transformation, exalted the dissolution of conventional ego boundaries in opium and that of conventional art forms in the *Gesamtkunstwerk*. The counter-culture of the sixties displayed a similar preoccupation with drugs and "mixed media," with the crossing and confounding of boundaries at the most fundamental levels of self-construction as well as in art. A cultural climate hospitable to synesthesia in perception and "mixed media" in the arts understandably stimulated the expectation among artists that an exciting aesthetic revolution was to be won with an imminent social one.[35]

The periodic reunification of political and aesthetic vanguardism can be deceptive, however, if it gives the impression of an inevitable affinity between the two. While the *idea* of the inseparability of aesthetic and social restructuring (in fact, of the former as an effective *cause* of the latter) is an important theme in vanguard mythology,[36] the actual relationship between artistic and political radicalism has been shifting and, from either perspective, opportunistic. The Communist party's attempt—so often cited as evidence of its essential Philistinism—to subordinate Picasso's work to its own goals is comparable to the purely aesthetic enthusiasm for radical politics (whether Fascist, as in the case of the Italian Futurists, or Communist, as in that of the French Surrealists and Russian Futurists) characteristic of the twentieth-century vanguard. As Renato Poggiolo has observed, ". . . in the sphere of political opinion . . . the avant-garde more often accepts, or submits to, a fashion instead of creating or imposing one."[37]

It is the expressive *style* rather than the political *content* of a radical social movement which is likely to attract art workers. Highly dramatic political moments compete, in their poetic and dramaturgical power, with the artists' work; in a sense, they upstage narrowly aesthetic communications. The following account of the fate of the arts during the Paris revolt of 1968 suggests the difficulty artists face in capturing people's imaginations during intensified moments of historical experience:

> During the events of May and June, 1968, culture and art no longer seemed to interest anyone . . . the bloody ballet of the C.R.S. [police] and students, the open-air demonstrations and meetings, the dramatic reports by Europe No. 1 and Radio Luxembourg, the entire nation in a state of tension, intensive participation and, in the highest sense of the word, poetry. All this meant a dismissal of culture and the arts.[38]

And an article by Allan Kaprow offers a similar description of the kind of occupational predicament which may provide one source of enthusiasm for political action:

> Sophistication of consciousness in the arts today (1969) is so great that it is hard not to assert as matters of fact: that the LM mooncraft is patently superior to all contemporary sculptural efforts; that the broadcast verbal exchange between Houston's manned Spacecraft Center and the Apollo 11 astronauts was better than contemporary poetry; . . . that the Southeast Asian theater of war in Viet Nam, or the trial of the "Chicago Eight," while indefensible, is better theater than any play; that . . . etc., etc., non-art is more art than ART-art.[39]

While, as I shall shortly suggest, such "non-art" was *particularly* likely to appear as "more art than ART-art" in 1969, its appeal as such is by no means uniquely modern. The surrealist reported to have exclaimed that there was nothing so beautiful as "shooting a revolver, totally at random, into a crowd"; Baudelaire's remark that even if Latin American politics were barbarous, "at least they caused people to kill each other";[40] Flaubert's excursion to Paris during the Revolution of 1848 to look at it "from the artistic point of view" and his statement that the only form of political activity that he could appreciate was a riot[41]—all attest to the historical endurance of the temptation to pluck disinterested aesthetic pleasure from scenes of "serious" engagement.

But the aesthete's attraction to radical social movements need not be self-consciously decadent or arch; it is probably more often naive. The characteristics of such movements would suggest that much of their appeal is essentially aesthetic in any case. Insofar as they offer not only the spectacle of dramatic militancy but also, as opposed to the qualifications and contradictions of the conventional, common-sense outlook, a unified and internally consistent interpretation of the cosmos and the meaning of human life,[42] they admirably fulfill one of the oldest criteria of aesthetic value—that of organic unity. One can speculate that artists, perhaps drawn to their occupations by their need for an exceptionally coherent and integrated ordering of experience, would be particularly responsive to the poetic appeal of revolutionary movements—to the integrity and internal harmony of their intellectual and moral orientation, rather than to their specific political aims. For artists, perhaps even more than for others, the *form* of revolution (as of other works of art) is the source of its meaning, its value, and its justification.

On such a basis the coincidence of aesthetic and political practice is tenuous. Aesthetic revolutionaries (or, in Thomas Mann's words, "bellezza radicals," attracted to the revolution because it promises to be "pure, beautiful and terrible")[43] quickly become indifferent to any political activity lacking expressive style. And to the extent to which they risk confusing aesthetic resolutions of dramatic problems with practical solutions for political ones, their day in the sun is apt to be brief.

AESTHETIC RADICALISM AND THE BOUNDARIES OF ART

However problematic it turned out to be in practice, during the sixties the identification of art with a "radical style of life" or even with revolutionary work was further stimulated by the imminent logic of the avant-garde tradition. The conventions of modernism, the methods by which twentieth-century art was believed to advance, sensitized even ivory-tower practitioners (and perhaps especially them) to utopian calls.

One of the recurrent themes of aesthetic activity in Western mythologies is that of an opposition between art and life—a theme most thoroughly elaborated by nineteenth-century romanticism. Such a conceptual opposition was constructed only to be immediately apprehended as a problem, promoting a nostalgic search for ways of reuniting the two terms as well as the repeated assertion that the true artist is one who works upon his life and the social world around him, rather than upon canvas, paper, or stone. Whereas a certain strain of romanticism showed a preoccupation with the idea that art parasitically consumed and impoverished Life, [44] the most radical humanism and the most deliberately decadent aestheticism coincided in asserting that the artist's true vocation lay in breaching the distinction by confounding the two.

The impulse to annihilate the distinction between the domain of professional practice and that of everyday life is by no means unique to workers in the arts. *All* professions appear to contain a germ of this kind of zealotry—an impulse to use the theory and conventions governing occupational practice for the regulation and design of all conduct. One can expect to find among psychotherapists a lingering wish that *all* human interaction might be therapeutic and among medical workers, a wistful regret that hygienic conditions (as professionally defined) are rarely maintained outside of clinics. Each professional culture harbors somewhere the conceit that the most desirable of all social revolutions would be the transformation of the totality of life in the light of *its* practice and under the aegis of *its* authority, and laymen's resistance to such expansionist aims is a routine source of exasperation to them. In this sense all professions, and not that of the avant-garde artist alone, exhibit a contested sphere around the boundaries of their practice. Not only do the professions regularly attempt incursions into realms of life governed by nonprofessional considerations, but their conquered territory is similarly violated by those who want to return it to the rule of laymen and lay understanding.

Such border skirmishes took on particular intensity in art once the latter had been elevated to the status of the sacred in a secularized world and idealized as a domain of activity where human wholeness could be retrieved. The utopian impulse which had long expressed itself in religion by the attempt to resecure an earthly paradise, found its aesthetic cognate in the refusal to acknowledge any limitation or boundary to aesthetic activity.

The religious heresy which seeks heaven on earth and refuses to divide tribute between the city of God and the city of Man finds its aesthetic equivalent in the idea that *"anything* you do can be art." Marcel Duchamp's declaration that, "My art would be that of living: each second each breath, is a work which is inscribed nowhere, which is neither visual

nor cerebral. It's a sort of constant euphoria,"[45] represents a Zen attack on conventional distinctions between sacred and profane activity. Each gesture, each breath, is declared equally invested with holiness (art), and conventionally designated artistic works are divested of any special distinction. The aesthetic parallel to the militant Christian form of attack is represented by the conceptual artist who announced the commencement of a work entitled "General Strike Piece":

> Gradually but determinedly avoid being present at official or public "uptown" functions or gatherings related to the "art world" in order to pursue investigation *of total personal and public revolution.* Exhibit in public only pieces which further the sharing of ideas and information related to total personal and public revolution.[46]

And it is represented, however playfully, by Allan Kaprow's suggestion that artists cease to practice their religion at the usual times and places, divest themselves of the air which sets them apart, and make their own activities barely distinguishable from those of "the world" in order to infuse it with art's "spirit:"

> I would propose that . . . [we] *un-art* ourselves, avoid all esthetic roles, give up all references to being artists of any kind whatever. . . .
>
> Of course, in starting from the arts, the *idea* of art cannot easily be gotten rid of (even if one wisely never utters the work). But it is quite possible to slyly shift the whole un-artistic operation away from where the arts customarily congregate. To become, for instance, an account executive, an ecologist, a stunt rider, a politician, a beach bum. In these different capacities, art . . . would operate indirectly as a stored code which, instead of programming a specific course of behavior, would facilitate an attitude of deliberate playfulness toward all professionalizing activities well beyond art. Signal scrambling, perhaps.[47]

Just as a religious sect must be seen against the backdrop of the dominant religious system it opposes, so this form of aesthetic sectarianism, this determination to "live" one's art, must be understood in the light of the dominant understanding that the rites of art fall under the authority of professional specialists and are to be kept separate from other life activities. Insofar as esoteric cultural elites, like religious ones, claim privileged access to a separate and presumably "higher" sphere of value, radical aesthetic movements, like radical religious ones, periodically arise to condemn the antidemocratic bias of such a conception of culture, to

challenge the authority of its priestly specialists, and to attempt to end any segregation of the aesthetic domain from other realities. Radical cultural sectarianism, like religious sectarianism, rejects the priestly solution to the problem of mediating between the sacred and the profane and draws strength from attacking any boundary established between the two.

THE INSTITUTIONALIZATION OF AESTHETIC RADICALISM

Yet while developing a widening interest in such problems during the late sixties, artists also grew increasingly aware of an inescapable irony in all attempts to destroy conventional aesthetic boundaries. The challenge to convention had itself become a new convention of impeccable professional respectability. The church had accorded the sectarian gesture a central place in its service.

As the period between the execution of provocative work and its final acceptance by established cultural institutions radically contracted in the second half of this century,[48] even artists oriented towards immediate professional recognition found it necessary to appear to throw all current definitions of their field into questions and to rupture with its past. One might say, by way of contrast, that if the required role halo for the successful Wall Street lawyer is—according to one description—an aura of political, cultural, and legal conservatism,[49] the required halo for his counterpart in art is an air, if not a substance, of political, cultural, and— above all—artistic radicalism.

The avant-garde aesthetic, by which works are evaluated not in terms of their successful attainment of stable and traditional ideals but rather in terms of their presumed contribution to the historical advance and redefinition of a discipline, had been adopted by the most conservative of cultural institutions. In the opinion of one observer, curators of the once solidly tradition-bound art museums often outstripped artists in pursuit of the new.[50]

With the experience of the early Dadaists to draw upon, it became widely believed in the art occupations that the most honorific (and profitable) tradition to follow in their modern practice consisted, after all, of the "game" by which nonart, or even gestures of defiance against art, became art. Duchamp's dry observation:

> . . . I thought to discourage aesthetics . . . they have taken my ready-
> mades and found aesthetic beauty in them. I threw the bottle-rack
> and the urinal into their faces as a challenge and now they admire
> them for their aesthetic beauty[51]

became a cautionary tale of the academy, pointing out the path to professional success even while its self-irony was savoured. As Huelsenbeck, one of the founders of Dadaism put it, the weapons which an earlier generation had employed *against* art, were now turned into "ploughshares with which to till the fertile soil of sensation-hungry galleries eager for business."[52] The dramatized pretense of overthrowing art simply became one aspect of its profession—no longer for a marginal and beleaguered vanguard alone, but for the most widely recognized and highly rewarded occupational elites. Dada historian Hans Richter summarizes the shift as follows:

> . . . as Brian O'Doherty . . . put it . . . : "Things have reversed themselves and now it may be the bourgeois who shocks the avant-garde." He shames them by reacting, not with shock, but with pleasure, and by opening his purse. He buys, and he enjoys himself immensely. In other words, he does not believe in the rebels' rebellion at all. . . .[53]

Once its role in stimulating consumption had been grasped, the semblance of radically challenging the premises of artistic practice not only ceased to be perceived as threatening—it became recognized as a necessary precondition of occupational success.

The activity which a rebellious avant-garde had initiated against the bourgeois order, ended as a form of "speed-up" imposed upon art workers by that order. The change reflected a transformation in the arts' social base of support and in the principles by which "elite" culture sought to distinguish itself from "vulgarity." These, in turn, reflected changes in the economic imperatives of advanced capitalism and in their ideological elaboration.

Once further industrial expansion came to require the stimulation of market demand through seductively *advertising* commodities and planning their obsolescence by means of changes in *styling,* innovative artists—whether conscious of it or not—assumed a new social function as "research and development men" for this branch of industry. And this function is probably even better served by the most purist and radically avant-garde artists than by avowedly commercial ones—an idea which is unlikely to have been lost upon art's major corporate and foundation patrons. The culture which they help to sponsor is in turn received and consumed by the professional colleagues of its producers and by laymen from an expanding stratum of the youthful, college-educated, high-income upper middle class[54]—exactly the stratum one would expect (due to the nature of its involvement with consumption as well as that of its work

experience) to be saturated with a high valuation of all that is new. Formal innovation in the arts may even provide it with an allegorical way in which to pay homage to the ideal of scientific and technical progress, aesthetic modernism serving merely as the expressive vehicle for a more generalized "modernolatry" (to use the Futurists' expression).

Unlike the elitism of an earlier bourgeois culture, which rested upon the elaboration of stable and traditional values, the elitism of this middle-class culture is preserved by the rapidity with which it absorbs new content. To the extent that such culture continues to serve as an esoteric status marker, it does so by shifting its boundaries to consecrate objects and activities which had formerly lain outside them, while at the same time withdrawing from previously held territory. Once dispersed too widely, the objects and activities which formerly served as emblems of elite membership, become branded as kitsch while the esoteric code moves on to baptize others as art. This culture's connoisseurs are no longer those who display a discerning loyalty toward lasting "quality," but those who appear to have been initiated into the process by which things once branded antipathetic to high culture are recovered by it, those who understand *why* a urinal is now "art." As modernist painting gains wide acceptance, art's *afficionados* learn an esoteric regard for beer cans or piles of sawdust, which—in their turn— fall back into banality once too widely accepted. Such aesthetic experience, in which objects and activities are valued only as long as they are "new" and lose their potency with familiarity, becomes indistinguishable from the experience of fashion and participates in a more generalized cultural orientation toward commodities.

The crucial idea for our concern is that by the mid sixties, prestige-conferring, fashionable, official culture more and more openly fed off those activities conceived as a radical challenge to it. Sword rattling and manifestoes, avant-garde proclamations of dedication to cultural revolution—all appeared as the nourishment necessary to keep art (or rather, its tradition of fashionable "revolution " and ritual revolt) alive. Yet, when elsewhere in the society highly dramatic confrontations erupted in which more than art was at stake, whatever illusion of revolutionary vigor highly professionalized aesthetic challenges might once have been able to sustain was now threatened; a radical social movement which sought to be morally convincing and to build internal solidarity on the basis of public and highly dramatic risk-taking[55] proved particularly overshadowing to ritual revolt in the arts. Thus, artists who were committed to the now respectable professional tradition of ritual aesthetic revolt, even if they were essentially unpolitical people, were likely to find that the particular occupational posture with which they had identified could only be maintained through a symbolic association with the opposition movement.

Such an association was stimulated by other considerations as well. The audience for contemporary art is a youthful one, and in the sixties an entire generation was identified with the counter-culture. A young artist whose work moved against the grain of the mores and values of the counter-culture risked losing a following in his own generation, while an older artist who managed to become a spokesman for the young, gained a new audience and thereby a new lease on occupational life. Only artists utterly indifferent to the possibility of capturing a wide audience among the young could afford to distance themselves from the opposition culture which structured that generation's imagination. The essential dilemma faced by those artists whose public identification with the radical opposition movement had professional motivations was that of the stunt man: to give the impression of radical risk-taking while minimizing the actual risk. Since the "revolution" with which they aligned themselves was one in consciousness only and not in social structure, artists aiming for career success could afford neither to forego identification with radical imagery nor to exhibit essential irresponsibility toward the institutions which determined their professional chances. Where an effective revolution in social structure would have led to a reorganization of aesthetic along with other kinds of work and, ipso facto, to significant innovation, a cultural revolution unaccompanied by significant structural change encouraged artists to assume a radical posture during its duration, but opened no lasting opportunities for fundamentally restructuring the premises of professional practice or the form of its products.

In effect, then, at the time when the Institute was in its planning stages, people motivated by political and cultural opposition to the dominant order and identifying primarily with the period's youth movement, those motivated by uncompromising aesthetic radicalism and identifying primarily with the vanguard tradition, and those who sought strictly professional celebrity and success, were drawn—albeit by different paths—to similar postures, imagery, and rhetoric; the latter consequently changed their meaning depending upon the system of orientation which happened to be in force. Membership in an artistic community identified as radical by means of such signs could thus promise either to deliver refugees safely to the far margins of a rejected culture or alternatively to yield coveted access to its exclusive center.

Such ambiguity in the emblems and rhetoric of radicalism had important consequences for the Institute which used them to articulate goals, define a public image, and recruit new members. It was exactly the overdetermination of their appeal which made their employment tempting. Used in recruiting students and faculty, they could appeal both to those who were disenchanted with established institutions and sought alternatives to them, and to those who were hungry for official

recognition—to those searching for a refuge and retreat, and to those eager to be the first to take advantage of a new market trend. No doubt, many persons harboring manifold and ambivalent impulses found the suggestion that professional celebrity and radical moral integrity might be simultaneously enjoyed, particularly disarming. Revolution without sacrifice and success without compromise: few calls could have such unqualified persuasiveness.

At first, this ambiguity facilitated the Institute's simultaneous appeal to different groups, helping to mask and to hold in abeyance their conflicting values and interests, but it soon proved unstable. The school's different publics would each feel betrayed as common understandings appeared to lose their meaning, and the very shibboleths over which they had come together seemed to have been capriciously and irresponsibly transposed into an alien key.

All radical communities in their concern for uncompromising purity favor the development of schismatic conflict and show a preoccupation with identifying and denouncing the "enemy within." At the Institute such potential for internal conflict was amplified by the treachery of radical rhetoric in the late sixties which resulted in the vigilance of some of the school's members against those they feared unreasonable and intemperate in their detemination to put "the word" into practice and of others against those suspected of "ripping off the counter-culture" and "packaging the revolution."

THE CUNNING OF CULTURE

A historical convergence in the expressions of radical politics and vanguard art, revolution, and fashion, made it expedient for diverse groups to seek identification with a proclaimed avant-garde art institute. Yet, the mores and implicit scenarios of the avant-garde culture which was thereby invoked called for the deliberate disintegration of this social unity and of its institutional establishment. One of the defining features of traditional vanguardism is an assumption of the inevitability of social conflict (hence a preoccupation with unveiling it) and a refusal of social unity based upon moral compromise. The imperative in short is to *épater* not only the bourgeois but, more especially, its "housebroken bohemians."[56]

Another defining aspect of the vanguard orientation is the anarchist conviction that a movement is dead once it has been institutionalized, and that true culture lives only in the tireless readiness to challenge social and aesthetic conventions the moment they have become established. Its central myth is that of permanent revolution, its most heroic gesture, self-

immolation,[57] and the destiny it seeks to transcend, routinization. In the terms of a subculture constructed around the negative pole of a supposed historical dialectic, failure to find acceptance in this world (in the temporal sense) is a sign of moral success, and immediate success raises the suspicion of failure.

To *become* the establishment one attacks is often the unstated goal of the most fevered radicalism, and the latter an effective means of attaining it—not only because avant-garde assault has itself become a conventionally respected genre, but also because, if successful, it discredits the authority of the current establishment, thereby helping to dislodge it and making room at the top. But to "become the establishment" is, from the point of view of the creed embraced in the phase of attack, to find oneself the butt of a familiar and discomforting joke. "Established vanguardism" is a contradiction in terms; the subculture and personal identities constructed around the activity of revolt and the experience of marginality cannot survive acceptance and respectability. At Cal Arts the bind would be expressed tersely: "Now *we* are *they*!" And people accustomed to defining themselves through negation would be disoriented before the problem of constructing and consolidating an institution.

In the early days of Institute recruitment the word spread: "Come now, at the beginning; it should have at least one or two good years." Avant-garde "scenes" and projects have typically been fleeting, due in part to the informal organization and shaky financing of much work in the arts. People come together to work on a magazine, to dance, or to paint, until the shoestring budget is used up, a feud destroys the emotional bonds which held them together when little else did, or the neighborhood gets too expensive. This experience of instability in the work setting (and the necessity of being prepared for it so as not to be taken off guard and left behind when the scene shifts) undoubtedly contributes to the assumption that an authentic and dynamic vanguard scene can never be frozen into a "school" and sustained. The fact that the various manifestations of post-Romantic art have typically been conceived as movements rather than schools, reflects the vanguard notion that "living" culture, as a "moving center of energy," is defined in opposition to the presumably dead culture of academies and conservatories with their masters and methods, their traditions and authorities. If the utopian stream in the counter-culture encouraged the idealization of the school as a source of community, anything suggesting a school signals the end of a movement's fertile period of free fluidity for the avant-garde tradition.

People seeking to found an avant-garde school and to maintain the credibility of such an identification, find themselves inevitably confronted with contradictions between the institutional imperatives of a school and

the symbolic imperatives of the avant-garde tradition they claim to continue and cite as the source of their legitimacy. For example, the Institute had to assure some people that they would receive a profession for their money and others that they would have students in their classes at a time when vanguardism decreed that boundaries between art and nonart, artists and nonartists, had no further validity. It had to assure trustees that they were respected when vanguard culture required that they be mocked, and it had to provide an impression of efficient and responsible management, of sober and disciplined production, where vanguard culture held such qualities in far lower regard than it did consistent antinomianism and uncompromising playfulness.

Bureaucratic and aesthetic mores harmonize well when the aesthetic ones are a product of the academy. But the vanguard aesthetic, according to which "If you aren't a *menace,* you are nothing, because the energy comes from transgression,"[58] does not easily complement institutional roles requiring conventional and routine reliability.
This contradiction is intensified when, to prevent extraartistic limitations upon professional activity, a school is designed and administered by artists. "The bourgeois" may have come to enjoy the minor provocations of the avant-garde but he is unlikely to regard the management of his substantial charitable investments, of his memorial, and hence of his public image as suitable material for expressive experimentation.

In conclusion, the reasons for desiring a symbolic association with the avant-garde tradition during the sixties were many. I have tried to chart some of the paths (of fashion, politics, occupational commitment, and professional ambition) which made it possible for trustees, artists, and millenarians to converge in a single identification. However, once this cultural tradition had been called upon, even if only through expediency, Institute members were forced to come to terms with its constructions of their world and its codes for their action. Cultural systems, once invoked, impose their own exacting discipline—constraining and ineluctable—*comme des choses,* as Durkheim taught us. Only unlike other "things," they resist packaging, enveloping instead their would-be packagers.

NOTES

1. Raymonde Moulin, *Le Marché de la Peinture en France* (Paris: Editions de Minuit, 1967), p. 348.
2. See John and Margaret Rowntree, "Youth as a Class," *Our Generation* 6, no. 1-2 (1968). For documentation and interpretation of the "Youth Movement" of the sixties, see: Massimo Teodori, ed., *The New Left: A Documentary History* (New York: Bobbs-Merrill, 1969); Carl Oglesby, ed., *The New Left Reader* (New York: Grove Press, 1969); Pricilla Long, ed., *The New Left: A Collection of Essays* (Boston: Beacon Press, 1969); Mitchell

Goodman, ed., *The Movement Towards a New America* (New York: Alfred A. Knopf, 1970). See also Angelo Quattrocchi and Tom Nairn, *The Beginning of the End: France, May 1968* (London: Panther Books, 1968); Alexander Cockburn and Robin Blackburn, eds., *Student Power: Problems, Diagnosis, Action* (Baltimore: Penguin, 1969); Herbert Marcuse, *Counter-revolution and Revolt* (Boston: Beacon Press, 1972).

3. The call for a "long march through the existing institutions" was a New Left slogan intended to oppose the sector of the counter-culture which recommended "dropping out" of "the system" rather than actively contesting it.

4. See for example, David F. Aberle, "A Note on Relative Deprivation Theory as Applied to Millenarian and Other Cult Movements" in *Millennial Dreams in Action,* edited by Sylvia L. Thrupp (New York: Schocken Books, 1970), p. 214:

 . . . millenarian movements *do* share something besides tense expectation. I would suggest that many of them have one thing in common. The millenarian ideology often justifies the *removal* of the participants in the movement from the ordinary spheres of life. Indeed, this removal is frequently not only social but spatial. . . . The millenarian ideology justifies the removal of the participants from [the] social order, by reassuring them that the order will not long continue, and frees them to indulge in phantasy about the ideal society, or to attempt to build it in isolation or through violent attempts against the existing order.

5. See Henry Nash Smith, *Virgin Land: The American West as Symbol and Myth* (New York: Vintage, 1957). For a brief suggestion of the relationship between nineteenth-century American communitarianism, social protest movements, and western frontier lands, see Rosabeth Moss Kanter, *Commitment and Community* (Cambridge: Harvard University Press, 1972), p. 61.

6. John Cage, *A Year from Monday* (Middletown, Connecticut: Wesleyan University Press, 1969), p. 165.

7. The jubilant announcement of the Cal Arts recruit is almost exactly echoed by the following bulletin reported from Twin Oaks (a Skinnerian utopian community): "The revolution is over; we won it!" See Kanter, Op. cit., p. 28.

8. The popularity during the sixties of such figures as Marshall McLuhan, Charles Reich, and Timothy Leary is an indication of the period's idealist approach to history. Technological, pharmaceutical, and religious experience was regarded as the key to the collective change of mind which would usher in the millennium.

9. The association of California with youthfulness (which has a certain demographic truth to it, since California's population *is* young compared with that of other states) was amplified during the sixties by the publicity given to western hippies and flower children. Such an association carried glamour in a decade which, like other periods of generational revolt, made a cult of youth. On the traditional adulation of youthfulness in avant-garde art movements, see Renato Poggioli, *Theory of the Avant-Garde* (Cambridge: Harvard University Press, 1968), p. 35.

10. Kanter, Op. cit., pp. 37; 193.

11. The literature of the counter-culture exhibited a strong focus upon pedagogy. Ivan Illich, Paolo Freire, Peter Marvin, and Michael Rossman are

a few of the authors whose pedagogical philosophies seemed to offer an encompassing view of human nature and a vision of a new collective future.

12. Dudley Evenson and Michael Shamberg, eds., *Radical Software,* 5 (New York, London, and Paris: Gordon and Breach, 1972), p. 49.

13. See Malcolm Cowley's summary of the Greenwich Village Creed in Lewis Coser, *Men of Ideas* (New York: The Free Press, 1970), p. 114.

14. For material on the universities' loss of legitimacy during this decade see, for example, Immanuel Wallerstein and Paul Starr, eds., *The University Crisis Reader* (New York: Random House, 1971). For a discussion of the expansion of American higher education during the sixties and its subsequent steady state see Walter Metzger, "The American Academic Profession in Hard Times: Toward an Uncertain Future," *Daedalus* 104, no. 1 (Winter 1975).

15. See, for example, Abbie Hoffman, *Revolution for the Hell of it* (New York: The Dial Press, 1968). Also Jerry Rubin, *Do It! Scenarios of the Revolution* (New York: Simon and Schuster, 1970).

16. See Lewis Coser, *Men of Ideas* (New York: The Free Press, 1970), p. 114.

17. Herbert Marcuse, "Art as a Form of Reality," in *On the Furure of Art,* Sponsored by the Salomon R. Guggenheim Museum (New York: The Viking Press, 1970), pp. 130-33. See also Marcuse, "Art and Revolution," *Counter-Revolution and Revolt* (Boston: Beacon Press, 1972), pp. 79-128.

18. Hans Jonas, *Gnostic Religion: The Message of the Alien God and the Beginnings of Christianity* (Boston: Beacon Press, 1958), p. 50. Jonas's discussion of the early Gnostic concept of "alienation" offers an intriguing glimpse of the ancient and religious version of a myth which has now been secularized in the Marxist tradition.

19. John Cage, *A Year from Monday* (Middletown, Connecticut: Wesleyan University Press, 1969), p. 19.

20. Ibid., p. 54

21. Ibid., p. 22.

22. See Max Weber, "The Religious Foundations of Worldly Asceticism," *The Protestant Ethic and the Spirit of Capitalism* (New York: Charles Scribner's Sons, 1958).

23. Alfred Willener, *L'Image-Action de la société ou la politisation culturelle* (Paris: Editions du Seuil, 1970), p. 40.

24. Ibid., p. 42.

25. Pour nous, la culture et la révolution, c'est la même chose. Toute culture, la vraie culture, celle qui est nouvelle, est toujours contestataire, et si l'on n'a pas la contestation dans les rues, on installe la culture dans la rue. Notre révolution doit être complètement différente de celles qui ont été bureaucratisées et qui ont visé justement à tuer l'art, à tuer la contestation. Quoted in Willener, ibid., p. 45.

26. Title of a book by Michael Rossman. (New York: Doubleday, 1971). See Harvey Cox, *The Feast of Fools: A Theological Essay on Festivity and Fantasy* (Cambridge: Harvard University Press, 1969).

27. Abbie Hoffman, "Media Freaking," *Tulane Drama Review* 13, no. 4 (Summer 1969), pp. 48-49.

28. Dean Evenson, "Open-ended Nervous System" *Radical Software* 5 (New York: Gordon and Breach, 1972), pp. 7-8.

29. Paul Ryan, "From Crucifixion to Cybernetic Acupuncture," ibid., p. 39.

30. Dudley, "Portable Video: The Natural Medium," ibid., p. 55. The idea that communications media are politically revolutionary is also expressed by Gene Youngblood in an even more millenarian vein:

> Global television is directly responsible for the political turmoil that is increasing around the world today. The political establishments sense that and are beginning to react. But it's too late. Television makes it impossible for governments to maintain the illusion of sovereignty and separatism which are essential for their existence. Television is one of the most revolutionary tools in the entire spectrum of technoanarchy.

> Something very important is happening on our planet. Our young souls are buffeted by the shockwaves of radical evolution. The first dissident students at Berkeley were born the year commercial television began. The ghost of electricity howls in the bones of their faces. . . . Previous to today's electronic information network, Earth could be considered an open system as regards communication. The circuits weren't connected. Humanity had no way of coordinating its own ecological pattern behavior. But the global intermedia network has closed the system. We're seeing ourselves for the first time in history, and we're beginning to realize that our behavior is evolution itself in operation. We do not live of our volition; we are lived by a force that we call evolution. The young of the world are demonstrating their Whole Earth Consciousness.

 Quoted in *Arts in Society* 7, no. 3 [Fall-Winter 1970] , pp. 138; 142.

31. Kenelm Burridge's excellent study of millenarian activities in Melanesia offers interesting material for comparison with "The Movement" of the sixties. See his *New Heaven, New Earth* (Oxford: Basil Blackwell, 1969).

32. Only after 1870 did the military image of the avant-garde cease to be used in an inclusive aesthetic, cultural, and political sense. See Renato Poggioli, *The Theory of the Avant-Garde* (Cambridge: Harvard University Press, 1968), p. 10; and Donald Egbert, *Social Radicalism and the Arts* (New York: Alfred A. Knopf, 1970), pp. 119-23.

33. Howard Becker, "Art as Collective Action," *American Sociological Review* 39, no. 6 (December 1974), pp. 767-77.

34. For one suggestion that "loose" social structure is conducive to ecstatic experience, see Mary Douglas, *Natural Symbols: Explorations in Cosmology* (New York: Pantheon Books, 1970). For a discussion of normative change and antinomianism from a psychological perspective, see Nathan Adler, "The Antinomian Personality: The Hippie Character Type," *Psychiatry* 31, no. 4 (1968), pp. 325-38.

35. The association between the dissolution of conventional aesthetic boundaries and the anticipated dissolution of social ones was explicitly drawn by Dick Higgins (intermedia artist and vanguard publisher) in a piece on the dawn of a "new mentality", in *Something Else Newsletter,* February 1966: "Much of the best work being produced today seems to fall between media. This is no accident. . . . We are approaching the dawn of a classless society, to which separation into rigid categories is absolutely irrelevant." Quoted in Hugh Fox, "Dick Higgins and the Something Else Press," *Arts in Society* 2, no. 2 (Summer-Fall 1974), p. 311.

36. The idea that severing with conventional aesthetic form has profound

political implications is illustrated in the following excerpt by Stefan Themerson from "Kurt Schwitters on a time-chart":

> To us, today, it may perhaps seem that the act of putting two innocent words together, the act of saying: Blue is the colour of thy yellow hair, is an innocent aesthetic affair, that the act of making a picture by putting together two or three innocent objects, such as: A Railway Ticket & A Flower, & A Bit of Wood, is an innocent aesthetic affair. Well, it is not so at all: Tickets belong to Railway Companies (or to the State), Flowers— to Gardeners, Bits of Wood—to Timber Merchants. If you mix these things you are making havoc of the Classification System on which the Régime is established; you are carrying people's minds away from the Customary Modes of Thought and people's Customary Modes of Thought are the very foundation of Order (whether it is an Old Order or a [in his case: Nazi] Order), and therefore, if you meddle with the Customary Modes of Thought, then,.. —you are (whether you want it or not) in the very bowels of Political Changes. Whether he wanted it or not, whether he knew it or not, Kurt Schwitters was in the very bowels of Political Changes. Adolf Hitler knew it. He knew that putting two innocent things together is *not* an innocent aesthetic affair. And that was why Kurt Schwitters was thrown out of Germany. Nothing, nothing is resisted with such savagery as a New Form in Art, wrote Kandinsky, quoting an historian of the Russian Theatre, Nelidoff.

Stefan Themerson, "Kurt Schwitters on a time-chart," *Typographica* 16 (1967). Also included in Maurice Stein and Larry Miller, *Blueprint for Counter-Education* (New York: Doubleday, 1970).

37. Renato Poggioli, *The Theory of the Avant-Garde* (Cambridge: Harvard University Press, 1968), p. 95.
38. Michel Ragon, "The Artist and Society," in *Art and Confrontation*, in Jean Cassou et al. (Greenwich, Connecticut: New York Graphic Society), p. 34.
39. Allan Kaprow, "The Education of the Un-Artist, Part 1," *ARTnews* 70 (February 1971), p. 28.
40. Cited in Cesar Graña, *Modernity and Its Discontents* (New York: Harper and Row, 1967), p. 119.
41. Ibid., pp. 120; 204.
42. Egon Bittner, "Radicalism," *International Encyclopedia of the Social Sciences*, Vol. 13 (New York: Collier-MacMillan, 1968), p. 294.
43. Quoted in Henry M. Pachter, "The Intellectuals and the State of Weimar," *Social Research* 39, no. 2 (Summer 1972), p. 235.
44. Maurice Beebe, *Ivory Towers and Sacred Founts: The Artist as Hero in Fiction from Goethe to Joyce* (New York: New York University Press, 1964).
45. Pierre Cabanne, *Dialogues with Marcel Duchamp* (New York: Viking Press, 1971), p. 72.
46. Lee Lozano, "General Strike Piece," in *Six Years: The Dematerialization of the Art Object*, edited by Lucy Lippard (New York: Praeger, 1973), p. 78.
47. Kaprow, Op. cit., pp. 30-31.
48. This statement applies primarily to what used to be the arts of painting and sculpture, because the rate at which the arts change varies. The larger the required supporting public, the larger the necessary funding capital, the more the practice of the art rests upon slowly acquired craft skills, and the more control art workers can exert over the market for their skills, the

stronger the brakes upon rapid change will be. For suggestive remarks on some of the causes for differing rates of change in the arts, see Roy Mc-Mullen, *Art, Affluence and Alienation: The Fine Arts Today* (London: Pall Mall Press, 1968). See also, Harold Rosenberg, *The Tradition of the New* (New York: Grove Press, 1961), and his *De-definition of Art* (New York: Horizon Press, 1972).

49. Erwin O. Smigel, *The Wall Street Lawyer* (Bloomington: Indiana University Press, 1969).

50. Harold Rosenberg, *The De-definition of Art* (New York: Horizon Press, 1972), p. 235.

51. Cited in Hans Richter, *Dada: Art and Anti-art* (New York: Harry Abrams Inc., n.d.), p. 208.

52. Ibid., p. 211.

53. Ibid., p. 209.

54. For profiles of culture's consumers see William Baumol and William G. Bowen, *Performing Arts: The Economic Dilemma,* A Twentieth-Century Fund Study (Cambridge, Mass.: The MIT Press, 1966), pp. 71-97, and Alvin Toffler, *The Culture Consumers* (New York: St. Martin's Press, 1964).

55. On the encouragement of risk-taking in radical movements, see Egon Bittner, "Radicalism and the Organization of Radical Movements," *American Sociological Review* 28 (1963), pp. 928-940, and Barrie Thorne, *Resisting the Draft: An Ethnography of the Draft Resistance Movement,* Ph.D. dissertation, Brandeis University, May 1971, pp. 117-59.

56. On one occasion, a high-ranking member of the Institute addressed others about the compromises necessary in the school's program in order to secure its survival (or rather, implicitly, the good will of its trustees). The poet sitting next to me slipped me his own paraphrase of the message:

 "We aim to please
 You aim too, please."

 A vanguard's honor lies in skillfully revealing and parrying such "aims"—no matter what the cost.

57. Even suicide has been admired as a sublime vanguard gesture. See A. Alvarez, "Dada: Suicide as an Art," *The Savage God: A Study of Suicide* (Harmondsworth, Middlesex: Penguin, 1971). See also Richter, Op. cit., pp. 85-87, and Poggioli, Op. cit., pp. 65-68.

58. Cal Arts member (personal communication).

Chapter 3

FOUNDING FATHERS AND SEED MONEY

In the beginning there was the money. The presence of some money and the promise of more preceded this settlement as the presence (or rumored presence) of fish, coal, or fertile lands has preceded others. Like the coal, fish, or fertile lands of other communities, "the money" (a word used at Cal Arts to refer to funders as well as funding) played a salient role in the ecology of this community, subtly molding its social organization and helping to determine its fate. The amplitude and potential sources of funding were only vaguely conceived by the Institute's early settlers, but just as the discovery of one vein of ore may draw prospectors to a frontier town before the full economic possibilities and limitations of the area are known, the discovery of some core nuggets of financial support led to a euphoric settling of this "boom" institution. My account will begin with a description of the money's appearance on the scene.

A FARMER'S MARKET OF THE SOUL

The California Institute of the Arts had roots in two earlier Los Angeles institutions: the Chouinard Art Institute, founded in 1921, and the Los Angeles Conservatory of Music, founded in 1883. Both schools enjoyed a primarily local reputation preparing their students for commercial rather

than academic careers. Their central city location (making concert halls, galleries, dealers and artists' studios conveniently accessible) as well as the absence of residence halls for students made them less insular as social environments than Cal Arts was to become and marked their greater distance from the liberal arts college model of higher education.

One of the commercial arts for which Chouinard provided trained workers was film animation. In 1929 the Disney Studios began sending animators to Chouinard drawing classes and eventually one of the instructors at the school administered the studio's recruitment and apprenticeship program. When Chouinard began to have great financial difficulties in the late 1950s, Disney started to pick up the school's deficit, eventually taking over its management and developing elaborate plans for its transformation. This was the period in which the Disney organization had turned to designing large-scale planned environments—Disneyland, Disney World, the Mineral King Resort—and early projections of the art school's possible future took on the coloring of these other Disney projects. They were devised by a consulting firm established with Disney financial backing which would be known fifteen years later as having helped to develop almost every major amusement park in the United States.[1] Early descriptive brochures of what was dubbed a "community of the arts" referred to a nucleus of music, art, dance, theater, and television schools surrounded by a commercial complex of galleries, theaters, openair museums, restaurants, and motels. The arts and the artists were to be the main attractions in a new combination of the recreation and culture industries, later described by one of its designers as "a kind of farmer's market of the soul which would spin off cash flows to the schools."

At their most ambitious, the plans painted a picture of a cultural mecca capable of drawing international visitors. At the very least, they represented the aspiration to create a Disney version of the large cultural centers (such as the Lincoln Center or the Los Angeles Music Center) receiving public attention at the time—more inclusive perhaps in the activities it dignified as arts, but participating in the same impulse to bring hitherto separated fields of cultural activity together for centralized management and marketing. The project can perhaps best be seen as an imaginative exploration of the possibility of expanding the recreation industry in new and prestigeful directions. Disney had already transformed the traditional amusement park into a respectable middle-class institution and a Disney "City of the Arts" would have represented a further step in the direction of respectability and "quality merchandising"—one, moreover, encouraged by business analysts of the period who predicted that high culture was about to become a boom sector of the economy.[2] This prediction of a major boom in consumer expenditure for the arts was heavily qualified

several years later, but at the time when the "City of the Arts" was considered, Disney and his consultants might easily have thought themselves early arrivals on a promising economic frontier.

While the project was eventually judged impractical and therefore abandoned, it deserves attention for one reason: it was the only version of the future school which held Disney's interest for several years. His death in 1966 left those charged with carrying out subsequent plans to speculate upon whether they would have won Disney's approval. The "City of the Arts" was seldom mentioned by people who became involved with the institution constructed in its place, and official histories exhibited particular care to gloss over the commercial aspects of the rejected scheme. But while at first glance these early blueprints bore no resemblance to the later Cal Arts, they reveal an underlying orientation which could later be discerned in the attitudes of some of the school's trustees. Not only was art to be democratized by being brought into a new "worldly" relationship with business, but the future school's workers (as well as their work) were expected to offer an inspiring spectacle to the public. It was perhaps this expectation more than any other which lay at the root of future conflicts between the artists and their financial backers. For the institution which, as originally imagined, was to be unusually permeable to visitors' observation, deliberately turning such traditionally backstage areas as artists' studios and rehearsal halls into public ones, required instead protection from public scrutiny. Not only did its workers fail to offer dependably inspiring performances but they threatened to be dependably embarrassing to the sponsors who had to present them. In fact, controversy over whether the aesthetic activity carried out at the Institute should eventually result in any publicly visible product or performance whatsoever became a recognized source of social division among its members.

A "CAL TECH" OF THE ARTS

During the years in which Disney took over the financial and managerial affairs of Chouinard, the Los Angeles Conservatory of Music was seeking a solution to its equally severe financial problems. In 1957 Lulu May Von Hagen (whose male kin served on the Board of the California Institute of Technology) joined the Board of the Conservatory and began to consult with administrators at the California Institute of Technology, the University of California, and the Ford Foundation about the Conservatory's future. She was advised that the time had come to combine the arts for centralized management and funding as the sciences had been combined at Cal Tech, and encouraged to seek "a good angel" (patron) for

such a project. (Such advice reflects the fact that as government and foundation patronage becomes increasingly important, organizational concentration in the areas to which they channel money is encouraged. One large arts organization with a fully developed administration capable of projecting an image of permanence was believed to be in a better position to capture foundation support than a small music conservatory using rented space or a struggling art school with a small faculty.) Von Hagen found her "angel" after a meeting with Disney was arranged, and in 1961 Chouinard and the Los Angeles Conservatory of Music legally merged under the name of "The California Institute of the Arts."

THE ELITE'S POLITICS AND THE
ORGANIZATION'S ECONOMY

The new institution's Board of Trustees consisted at first of Lulu May Von Hagen, Thornton Ladd (a friend who had joined her on the Board of the Conservatory), Walt Disney, his brother Roy O. Disney (Chairman of the Board of Walt Disney productions), Royal Clark (Vice President of Retlaw Enterprises, a Disney company), and Harrison Price (President of Economics Research Associates, the consulting firm involved in earlier plans for a "City of the Arts"). These people, eventually designated "Members of the Corporation," became a self-perpetuating body electing other members to the Institute's Board of Trustees. Of the twenty members of the Board appointed between 1962 and 1967, over half were either members of the Disney family, close family friends, or persons economically indebted to the Disneys. (During this period, for example, the Board came to include, in addition to those listed above, Walt Disney's daughter, his son-in-law, Roy O. Disney's son, the legal secretary for Disney Productions, and the former head of the artists' training program for the Disney Studios).

The logic determining the formation of this board is suggested by one member's recollection that:

> Walt didn't really want a board in the beginning. He wanted advisors so he'd be left some freedom in defining his own ideas. Walt was a highly creative person—so he just touched a few of us he wanted as advisors.

This trustee's statement that Disney wanted only advisors assumes added significance in view of the reported autocratic organization of the Disney business empire and of Disney's reluctance to delegate authority. According to one writer, Disney made every studio product his own

through "incessant interventions" in the most minor details of production and did not permit even a commercial to be released without personal review:

> There was always something obsessive about Walt Disney's personality ... his possessiveness about his business, his unwillingness to share its management with any outsiders. ... He became something of a sneak in his own studio, prowling the corridors at night and on weekends, trying to get a glimpse of story ideas and sketches before his writers and editors were ready to show them ... He took a similar interest in the physical plant itself, leaving notes for the maintenance people when he discovered, for example, a burned out light bulb or an overflowing trash can. In later years he even patroled the vast reaches of Disneyland on the same errand, leaving instructions on sheets of blue note paper that he alone in the organization used.[3]

Cal Arts' early Board of Trustees was formed in such a way that it posed no threat to this need for personal control. Its members were all local residents, some were or had formerly been economically dependent upon the Disneys, and—more significantly—none had the independent financial power to resist Disney ideas in favor of their own. The pattern was thus laid early for the California Institute of the Arts to become, in essence, a family organization and a single-donor institution.

Several years later one trustee explained:

> Until a school is broadly supported it will always turn around the leadership function of the people putting up the money. It's an awful responsibility to build something like this, and you can't delegate it to a bunch of people who aren't supporting it. It's your thing if you're paying for it.

When the Institute later grew unpredictably and staggeringly costly, it became increasingly obvious that the burden of financial support had to be shared; and yet, the composition of the Board which was to raise revenue had been determined more by the motive to retain control in the hands of "the family" than to ensure a broad base of financial support. In short, the economy of the new institution was greatly affected by the strictly political consideration of its elites—at first only the Disneys, but subsequently the school's administrators whose own recommendations for Board appointments reflected greater concern with finding sympathetic advocates than with strengthening the school's fund-raising capability.

A DEATH AND A MONUMENT

Disney's death left the Institute with about $15 million and the money's custodians—the trustees who were to have served as advisors. Had Disney lived longer, the school would probably have been dominated by the same personal authority with which he ruled the rest of his business empire. Upon his death, ultimate power over the fate of the school fell to other members of the Disney family and consequently the Board sought to buttress the Institute's security as well as their own certainty of purpose by grounding the legitimacy of their decisions in the interpreted desires of the deceased founder. Carrying out the will of the dead and "fulfilling Walt's dream" became the mandate in terms of which specific courses of action were henceforth justified. The spiritualism of one trustee who continued to communicate with Walt after his death, reporting these consultations to others with the assurance that "he is with us now and he approves," was only the most literal expression (and shrewd utilization) of this aspect of Board culture.

Two weeks after Disney's death, the Board declared its intention to rename the school *The Walt Disney Institute of the Arts*[4] but four months later reversed its decision. This vacillation, reflecting uncertainty about the degree to which the Disney affiliation should be publicly stressed, was the first sign of what was to become an increasingly prominent dilemma. On the one hand it was feared that overt identification of the school as a Disney project, while gratifying to local friends and supporters, would alienate potential donors who were unwilling to contribute to a Disney memorial. On the other hand, to the extent that the Disneys continued to provide the Institute's economic life line, public gestures of recognition were called for—even if such gestures threatened to create a spiral of increasing dependency.

Since it was not until after Disney's death that the school's architectural plans were fully approved and its final site chosen, later settlers would question whether trustee action on these matters carried out or departed from Disney's intentions. (Institute culture provided various answers in the form of deathbed lore: stories of Disney's expressing last minute reservations which were ignored.) Originally an urban site had been considered, but this was first rejected (before Disney's death) in favor of a ranch owned by Disney Productions. Subsequently, in 1967, a site was chosen at the edge of a freeway in the new "planned community" of Valencia, thirty-two miles north of Los Angeles. Trustees later justified the choice by noting that "in years to come, as the Los Angeles metropolis becomes a megalopolis, the school won't seem so far away from the city." But faculty and students who came to refer to the concrete buildings as "the

fortress on the hill," perceived the school as a lonely outpost connected to the world only by the strip of freeway which, in allowing some faculty to escape after working hours, increased the isolation of those left behind. Geographical isolation has contributed to the solidarity of many communities, including that of Black Mountain College which the Institute later adopted as one of its models. But Cal Arts' isolation was not complete enough to serve this purpose. At a time when other utopians deliberately chose rural settings for their experiments, Cal Arts' members experienced the school as an awkwardly placed urban institution. They made jokes about its comparability to Paris or New York and expected the school to make restitution for the lost city—its coffee houses, street life, and galleries. This expectation was one the Institute would never be able to fill.

The other major decision, in addition to the choice of a site which was made before administrators were recruited, concerned the appointment of an architect and the approval of his plans. The architectural firm of trustee Thornton Ladd took the commission in March 1966, designing a plant which became so fatefully costly—requiring almost $25 million to construct and almost $1 million a year to maintain—that the artists later referred to it as "Moby Dick." Its heavy rectilinearity and conventional institutional style made it as frivolous as a standard electronics factory or city hospital—an appearance it shared with the older Disney studios. And, in fact, the new community continued to repeat, quite innocent of its origins, old studio lore about its architectural environment—in this detail, at least, participating in a wider culture of Disney employees. It was rumored that the building was deliberately designed for alternative use as a hospital should the school fail, and when failure seemed imminent, there were whispers that negotiations for its conversion had already begun. It is possible that the conversion lore of the Disney studios was based upon fact—at least one book on the Disney business empire presents it as such.[5] But I think it equally possible that the book's author accepted folklore as history and that both at the Studios and at the Institute this earnestly held belief reflected not only occupational insecurity which caused solid structures to be perceived as fleeting but also alienation from a physical setting perceived as sensually impoverished. For what better symbolic construction could be opposed to the traditional image of the artist's working environment than the bare and silent corridors of a hospital? Since the Institute office complex, like the studio "factory," was the architectural embodiment of a new organization of production, artists' negative preoccupation with the "hospital" in which their employers had placed them could in both cases draw nourishment from their discomfort with changing occupational roles.

SPENDING AND MANAGING THE MONEY

The projected cost of the new school rose steadily and dramatically during the years after the Board's first planning sessions. In 1963 construction costs were estimated as $5 to 6 million; in 1965, as $10 million. In 1967 the Board approved a construction budget of $19 million, and by the time the building had been completed, without many of the facilities which had originally been planned, it had already cost almost $25 million. Since, at his death, Disney left the school $15 million, a small portion of which was lost shortly thereafter in an uninspired investment decision, all money was spent before the school opened. Like the marbled exterior of an uninsured bank, the Institute's initial lavish expenditures were highly deceptive, encouraging people to invest parts of their lives in an institution whose permanent appearance belied the lack of a corresponding financial solidity.

One can only speculate upon the causes of such financial mismanagement on the part of trustees who bore ultimate responsibility for assuring a reasonable relationship between income and expenditure. Many of them undoubtedly took for granted that all costs would continue to be met by the Disneys and thus failed to anticipate that after Walt's death other members of his family might not wish to adopt the school as their own favored project. They also overestimated the ease with which money could be obtained from other sources. Planned at a time when the United States economy prospered and educational institutions were expanding, the Institute opened in a period of falling enrollments, cutbacks in federal funding, and economic recession. Expecting to ride a new wave of educational development, the Board found it had already crested before they began.

And yet, the fact that there were miscalculations about the ease with which money could be raised does not completely account for the failure to set aside a substantial proportion of the available money as an endowment. How was it possible for seasoned businessmen, who often spoke of planning for the distant future, to act as if they had been charged with overseeing the construction of a physical plant rather than a school? A partial explanation, no doubt, can be found in their belief that money spent on the facility, by yielding immediately visible results, would give the school a tangible "presence" helpful in attracting more money as well as students and faculty. But in addition to this rational motive for their behavior, I don't think the possibility should be overlooked that these trustees, like the artists who came after them, were seized by euphoria when offered the chance to "play" brashly in an arena removed from their workaday worlds—as if, heady with the size of the fortune they believed to

be at their disposal, "sold" on their own rhetoric of creating a "Cal Tech of the Arts," they threw off all caution, conscious only as one of them phrased it, of "not wanting to lose a certain momentum."

In any case, whatever the reasons for this financial behavior, it placed limits on future options and determined many of the life dramas which later took place in the new community. Once the seed money had been spent on a facility, it was inevitable that (1) in the absence of a windfall, the Institute would remain unmitigatedly dependent upon the Disneys to underwrite its deficit from one year to the next; (2) during its first years, the school's uncertain future would create an atmosphere of chronic crisis and collective insecurity; and (3) that all school policies and activities would soon have to be regarded in the light of their effects upon the institution's economy. In the absence of a substantial endowment, any activities or "manners" which could be construed as making fund raising difficult were likely to become the subject of major controversy, until eventually the imperatives of institutional survival defined "reality" for the artists who came to the school. Later, as the artists moved painfully from one shared reality to the other, each would age, weigh his shifting occupational alternatives, measure his integrity and that of his fellows, and try to make sense of that portion of his life which was bound to the institution. Perhaps, the combined styles in which they did this formed the grand collective work—played primarily before the eyes of colleagues and breaching the boundaries between art and life—which many of them came to the Institute hoping to achieve.

NOTES

1. "The Fun Formula," *Newsweek* (23 July, 1973), p. 63.
2. William Baumol and William Bowen, *Performing Arts: The Economic Dilemma* (Cambridge: M.I.T. Press, 1966), pp. 33-39.
3. Richard Schickel, *The Disney Version* (New York: Simon Schuster, 1968), p. 120. See also ibid. p. 161.
4. Though the institution had been a joint project of Disney and Von Hagen, Disney's provision of economic support gave the school's public affiliation a heavily patrilineal bias. Some trustees used the phrase "founding fathers" (which excluded Von Hagen by definition) as if this were a hereditary status transferable through the male line of continuing Disney economic control.
5. Schickel, Op. cit., p. 198.

Chapter 4

ALLURING THE ARTISTS: THE CONSTRUCTION OF AN ART SCENE

"I have never been in a place where
there were so many hopes and then such
a hard crash! Even the *old* men had
such expectations."

Musician

"This rise and degeneration of hope
always happens in the art world."

Theater Designer

"But it was fun—to dream without any
constraints."

Dean of School of Design

The cultural climate of the sixties was hospitable to many forms of
utopianism. The slogan, "if you are not part of the solution, you are part of
the problem"—a widely adopted moral touchstone in the counterculture—

reflects a choice between the two worlds of the past, and the future, which encourages withdrawal from all involvements with the past, making it possible to regard wishes, hopes, and expectations as imminent realities. Once the future is no longer experienced as continuous with the past, the constraints upon phantasy drop away and men and women live in their dreams. The following pages explore 1) the conditions which allowed people at the Institute to dream together, 2) the relationship of their dream imagery to the realities of their working lives, and 3) Cal Arts' institutional functions and their lasting consequences.

WORK IN THE ARTS AND GREAT EXPECTATIONS

While the intellectual climate of the sixties favored utopian forms of consciousness, the nature of career experience in the arts may make collective "great expectations" and their degeneration endemic among art workers. If some forms of utopian consciousness are characterized by a sense of sharp temporal discontinuity—a euphoric anticipation of a radical breach between past and future[1]—such temporal experience is also fostered by careers in which success is not measured by degrees but is thought to be either sudden and spectacular or negligible and to depend upon events over which the worker has little control. If a relatively orderly and predictable bureaucratic career in which advancement takes place by seniority permits a temporal experience of continuity between past and future, some sense of effective agency, and a positive estimation of temporal duration as a creative force, then those occupations in which careers are highly unpredictable and which are stratified into a small elite of handsomely rewarded stars and a majority of workers whose incomes are small and undependable seem to reflect their workers' lack of effective agency in generating a sense of temporal discontinuity and a preoccupation with "lucky breaks" and the fearful destructiveness of the homogeneous passage of time.[2] Such an orientation bears great similarity to the intense presentness of gambling and of messianic experience, and art workers who share it may be particularly receptive to these forms of individual and collective utopian consciousness insofar as they are characterized by a consonant temporal structure.

A preoccupation with temporal breaks in a career was accompanied among many Institute artists by a vulnerability to inflated promises and to illusions of omnipotence.

People making such statements as the following tend not to be overly cautious when lured to a new institution promising them opportunities to participate in "the most exciting art scene in the world":

In this kind of work, seems like you're either rich instantly or you got to hustle and hassle all your life (composer and electronic musician)

I'm trying to decide whether to go into jazz or into an orchestra. I just keep thinking that my friend S. really cashed in one year. He made $42,000. But there's always the danger that you'll starve the year after (instrumentalist)

When you freelance as I do, one week you're starving and the next you're rich (film maker)

For the chance at a "real break," one young recruit told me, he would have been willing to join the Institute's faculty without pay. Euphoric expectations come easily to those who labor at work in which a person is either described as "one of the best in the world" or as "nobody" and in which chronic economic insecurity can be partially compensated by the excitement of participation in something believed to be of major spiritual and historical importance.[3] To attract such workers, the Institute projected the image of being the center of the entire art world and a "powerhouse of creative energy." When it eventually lost their faith, their disappointed attribution of failure and insignificance would be as absolute and lacking in gradation as their earlier hope. "Actually," one of them said in explaining the "failure" of the institution that was supposed to have gathered "the best in the country": "it turned out there was *nobody* there!"

CHARMING THE MONEY

In 1967, the California Institute of the Arts (for the brief period of less than a month named Walt Disney Institute of the Arts)[4] consisted of a thirteen-member Board of Trustees, Disney monetary resources, and students and faculty of what had formerly been Chouinard and the Los Angeles Conservatory. If faculty later compared their recruitment with the California Gold Rush, one might say—drawing out the implications of this metaphor—that in 1967, from the perspective of the eastern artists who came to settle the newly opened territory, Cal Arts consisted of an imprecisely determined but potentially great amount of wealth and of the native population which posed an embarrassment to its complete recovery by the newcomers. In October, 1967, the Board (chaired by H.R. Haldemann, who had not yet resigned to join the Nixon administration) appointed as the Institute's new president the dean of New York University's School of Arts who, in turn, recruited a former director of the Repertory Theater at Lincoln Center as Provost and Dean of Theater.

Together, both men recruited five deans for the other schools of the Institute: the chairman of the Art Department of the University of California at San Diego became Dean of Art; the chairman of the Yale Composition Faculty became Dean of Music; the former chairman of the Brandeis Sociology Department became Dean of General Studies (a program intended to satisfy the Institute's accreditation requirements); a Hollywood film director became Dean of Film; and a former president of the Western Behavioral Sciences Training Institute became Dean of Design. With the exception of the film director all had academic careers and titles, and although they liked to play down their academic identification, they tended to define themselves—even in their gestures of rejection—in academic terms. For example, although the Institute had no formal system of tenure and academic ranking, some of the deans sought recognition for having sacrificed tenured positions elsewhere, and regarded only those who had made the same sacrifice as peers in commitment.

Oriented toward the segments of their professions which controlled the prestigious professional schools and toward an established professional vanguard of their own generation (which had come to occupational maturity during the fifties), they faced the problem of recruiting respected artists to an institution emblematically identified through the Disney name with "square" mass culture and political conservatism.[5] To establish a school which would meet their own standards and carry prestige in the national professional orbits in which they moved, they needed to lure artists from the East by presenting Los Angeles as a creative capitol capable of rivalling New York[6]—in the jargon of the art world, as an emerging "message center." They also had to convince artists identifying themselves as culturally radical that a Disney institution was a defensible base for activity. In a sense, to turn to another folk model[7] used at the Institute, the new administrators were matchmakers for a delicate alliance between art clans symbolically defined in opposition to one another. In the words of one administrator, "When it seemed that Disney was willing to support an avant-garde art school, it was easy for an artist to think, 'The enemy came to me: he capitulated!' " In creating "their" Institute, the president and deans had not only to secure the support and commitment of the trustees, but also the confidence of prospective students and faculty. The story of their "planning year," as it came to be called, is principally one of seduction and of "the dream" that was developed in the course of its practice.

Both trustees and administrators made analogies with sexual liaisons in conceiving their mutual relationship. One administrator, only half jokingly, described himself as "basically a procurer," another as a pimp,

and a third spoke with satisfaction about "having really charmed" the trustees, "swept them off their feet," and later worried openly that his old charm had deserted him. One of the Institute's trustees described the first year with the "new management" as the honeymoon phase of a love affair:

> On paper the leadership checked out like it was made for the job. When we took on the leadership it looked lovely. C. [the president] *brought in B.* [the provost]. He *did* have to introduce us to the people he brought in, but we went along with his recommendations and gave him a free hand.

> If you ask me now [1971] what went wrong . . . it's like walking in on marrieds ten years later and asking why they don't love each other any more. Now that we've lived with our mates and understand the things we don't like, it's real easy to say. But back in the beginning, everything looked beautiful. It's like a courtship where we should have slept together before we got married, and there was no way to do it. What you really have to ask is, "why did the people financing the institution fall out of love with their leadership?"

It is not clear which group—trustees or deans—had the feminine role in this romance, though it is clear who brought money and who brought charm to the match. Financial investment in an art school at a time when aesthetic fashions are rapidly shifting and are not easily comprehensible to a layman, might aptly be termed "risk capital philanthropy."[8] A trustee of such an enterprise may vacillate between enormous hope and doubt about the value of what he has bought, but he will never have the certainty and the concomitant lack of both apprehension and excitement of those who have purchased well-established, conservative stock yielding predictable returns. Modern art, especially in the fifties and sixties, was dominated (from the perspective of its producers) by the ethos of risk-taking and became (from the perspective of its patrons) an object of both aesthetic and economic speculation. The heroes of patronage were those whose shrewd and knowing "belief" in marginal or even vilified art (like investment in growth stock) later "paid off" in public recognition and market validation. But if some patrons of this kind have at least been able to diversify their risks—speculating upon different paintings and upon several artists—and have been connoisseurs of the branches of art they sponsored, Cal Arts' trustees invested in a single "oeuvre"—an institution publicly identified with the Disney name—and were not habitués of the art forms they supported. Feeling, as laymen, that they were unable to rationally calculate the wisdom of their investment; investing, in fact, in occupations

whose practitioners cannot with certainty calculate the results of their own career "investments," they needed to have their doubts and fears put to rest by constantly rekindled enthusiasm. In short, they required romancing. As one of the school's administrators recalled, "They [the Board] knew they were taking a calculated risk—and some of us were *charming!*" If, at moments, some of the deans spoke of their charm with emotional distance and presented themselves, however wryly, as con men and whores, the threatening identity against which the trustees had to defend themselves was that of the "john" who naively falls in love with a "trick"; of the country square who is taken by the eastern hustlers. The trustee quoted in the passage above, reconstructing the history of the honeymoon period, recalled his awakening apprehension when, in his presence, one administrator jokingly remarked to another:

> "Wait till they find out what they bought!" Whereupon they both chuckled deeply. And I . . . was very much aware of what I'd heard.

THE "ART" OF ADMINISTRATION

However determined they had been not to interfere, at the first signs of crisis the Disney family came to regard Cal Arts as a Disney production. Their local reputation, especially within the Disney Studios, was bound up with the school, and in the face of conflict with its administration they began to claim creator's rights. One trustee indignantly recalled an early crisis about the question of administrative autonomy:

> I sat with B. [the provost] and heard him say that if he couldn't have it his way, from his standard of principle, it was too bad—and if it destroyed the School, tough shit . . . He said it in front of me and C. [the president], and I spent two hours arguing with him. I said, *"You are talking about the creation of other people!* You don't have the right to talk lightly about this, in theoretical terms, in abstractions; to say that if it can't be molded in a certain fixed way, and if it therefore dies: too bad."

But the deans too regarded "their" schools as vehicles of self-expression, as "signed pieces,"[9] and understood their professional reputation and integrity to rest upon unambiguous freedom from trustee influence. If they had been Hollywood artists with a history of work in the film industry they might have regarded their administrative creations from the beginning as subject to political bargaining; American movie industry producers have exercised a great degree of creative control, and imposed changes in a

script writer's or director's design are routine.[10] But coming, as they did, from academia, with its ethos of academic freedom, and from segments of the art world strongly committed to the value of professional autonomy, their occupational integrity demanded a posture of unbending independence from lay control.

The conceptualization of the various schools of the Institute as individual works of art and as embodiments of the unique visions of their deans was evident in the tendency of Institute members to refer to them as, for example, "Paul's school." For the deans themselves, regarding the schools as personal works helped to stave off the threatening but insistent suspicion that in becoming administrators they had ceased being visionaries.

The deans' anxiety to preserve their identity as artists in their own as well as in their colleagues' eyes, and the requirement, in a subculture infused with anarchistic values, that people wielding authority disavow any interest in it, called forth frequent expressions of role-distancing. During the Institute's initial orientation meeting, the Provost made joking offers to abdicate; one of the deans opened his school with a de-deaning ceremony; another emphasized that if he found that he had been hired not to compose music he would cease to administrate; a third joked with his faculty:

> I'd like to think they hired me as a painter rather than as a paperpusher. That's probably an illusion, though. They were looking for a good working painter who had already sold out because he had been a department chairman.

A fourth dean ruefully observed that while as a film-maker he had thought of himself with some pleasure as an honest whore, now, having accepted the position of administrator, he had become "declassé as a pimp" and would find it difficult to regain acceptance in the world he had left.

The aim, then, of administrators whose most cherished aspirations and self-image remained professional, was to define their schools as works of art and to gain recognition for them as such in their professional milieus. If one of the associate deans of the Music School spoke proudly of that school's administrative team as a "formidable quartet," this may have indicated a preference for craft-related figures of speech. The following description, however, by the Dean of the Art School of the only teacher who had served him as an adequate role model, is more suggestive:

> In college you get poor models as an artist. There's always the feeling that your teachers have been unsuccessful. There was only one

teacher who affected my life. He was very ambitious. Saw the school as a structure through which he could project himself into the world. He used the school itself to aggrandize his art. Got the school to buy lots of equipment, formed the students into a closely-knit working body, taught them how to show. And the shows were seen as *his* shows.

To the extent to which a school comes to be seen as a display or performance reflecing the innovation and boldness of its designers, its offices become highly personalized launching pads for professional renown, and the institution itself is pressed to conform to the timetable requirements of its creators' careers.

"THE CENTER OF THE REVOLUTION"

If the deans regarded the Institute schools as personal "works" reflecting the quality of their creators' imaginations, the aesthetic by which they judged this administrative art was an avant-garde rather than a classical one. While, in assembling their faculties, some of them took pride in the range and representativeness of their "collections," claiming that they had recreated a cross section of their professional worlds, their principal aspiration was to construct schools which would win recognition for advanced contemporaneity. The Dean of Music designed his school to include, in addition to the classical conservatory tradition of Western music, a strong emphasis upon contemporary composition and electronic music as well as non-Western music from India, Nigeria, and Indonesia. The Dean of Art rested his claim to having constructed a school which would stand at the front of its field in its relation to so-called poststudio or conceptual art. The Dean of Design wanted to create a school which would redefine the design field as a kind of all-purpose futurology concerned with remodeling everything from furniture to social structure. The Dean of Film was committed to a program which would train students in the use of the most recently developed visual communications technology, and the Dean of General Studies (which was later called Critical Studies) aspired to create a school which might serve as a model for antiprofessional and antiacademic liberal arts education.[11]

But if each of the Institute's schools projected the image of being a standard-bearer for its profession's vanguard, the core of Cal Arts' appeal lay in the suggestion that the Institute as a whole would confront and explore *all* the emergent public issues of the period from antiprofessionalism and anarchistic communitarianism to democratized pedagogy and sexual liberation. For professional artists who identified

with their occupation's prophetic tradition and therefore could believe that the stature of their work would depend upon their ability to synthesize a single total vision out of the experience of their period,[12] such a suggestion was tantamount to a guarantee of creative power. For adolescents, prepared to equate a call to art with a call to the "wild heart of life," such a suggestion designated the school as a navel of the world.

The image of the Institute as a focal point of history was skillfully communicated in the special issue of a national arts journal, designed at the school with the intention of providing it with publicity.[13] Entitled "California Institute of the Arts: Prologue to a Community," it devoted a great deal of space to reprinting a private correspondence between the Provost and an Institute novelist which alternately offered intimate glimpses of their family lives and their reactions to the dramatic news events—from demonstrations to assassinations—of the time. Interspaced with quotations from Institute documents, letters from prospective students, and statements by faculty, the journal featured full-page photos of personages and events with definitive symbolic significance for the youth movement of the sixties: Stokely Carmichael, soldiers in Vietnam, Governor Wallace, rock star Mick Jagger, Woodstock, Kent State, Altamont. At the most manifest level of communication, the association of the school with symbols of the youth movement's culture and political experience identified the Institute as an expression of that movement.

More implicitly, such associated imagery suggested that the Institute, like Woodstock, might be seen as a counter-cultural event. People could hope that at Cal Arts the historical drama in which they were involved principally as spectators would finally be opened to their full participation, that—in the telling jargon of the time—they would finally be "where it was at." One of the deans described the attraction the Institute held for men of his age:

> There was something compensatory in building the Institute. People felt dispossessed by the student movement of the period and [Cal Arts] gave you your own territory to play in . . . There was a sense of stasis among people of our age. The sense of "where is it all going: life, we, the arts?" Everything seemed to be standing still despite all the surrounding change.

Artists who wanted to comprehend their cultural milieu in its most radical and "advanced" expressions as well as people identifying with the youth movement eagerly seized upon the notion of a territory of their own where the cultural themes of the period could be directly experienced and explored.

The Provost in particular assumed the role of visionary and director of the historical drama to be articulated on the Institute "stage," defining Cal Arts as a "total theatre" whose actors, from young revolutionaries to electronic musicians and mimes, would generate a uniquely creative "scene." If each dean regarded his school as a personal work, the Provost was the artist whose vision promised to guarantee the integrity of the whole. Some faculty, like actors in a play directed by someone whose ideas they admired but only dimly understood, took the institution on faith as the product of a greater understanding than their own. When, later, the Institute underwent a series of crises, they would tentatively voice the blasphemous idea that "he" hadn't had a true vision after all.

If, in the period of enthusiastic planning and aspiration, people imagined they were building a uniquely fertile institutional art colony, a new Bauhaus or Black Mountain College, they saw their Provost as its charismatic leader, its Gropius or Rice. The kinds of expectations generated under his early leadership can be glimpsed from the messianic tone and imagery, however tongue-in-cheek, with which he began the first faculty orientation meeting:

> Provost means warder. In that case, perhaps I possess the keys to the kingdom. Whatever I tell you of the over-all scheme of the Institute will be close to divine wisdom. But you can take that with a grain of whatever you're using these days. You are all pertinent to my own devious purposes. I'll be serving you. You'll certainly be serving me. The Institute is close to total theater and I am here because I require you for that purpose . . . The vision of totality being a spirit which dominates the sensibility of the arts, the task is to restore a unitary vision to the arts and to reality itself . . . We may find the only paradise is the paradise we've lost, but Cal Arts is one of these institutions of modernist and postmodernist thought that is determined in some peculiar way to put the whole cracked world together again.

The rhetoric is free-associative, mythical, and entrancing in its rhythm. (One of the trustees, suspicious of this penchant for a charismatic posture, later referred to the Provost as "Rasputin.") Though the messianic role is mocked even as it is adopted, it *did* help to set the tone of early expectations.

To the extent to which artists in crafts with an individualistic work organization tend to regard the absence of explicit organizational structures as desirable and are, therefore, suspicious of any institutional program amounting to more than an inspired sense of direction, an

institution seeking to secure their commitment is compelled to adopt charismatic forms of legitimation. At Cal Arts, despite (or, perhaps, because of) the commitment of some of its art workers to keeping the institution "unstructured," whenever there were troubles to be surmounted many people spoke explicitly of the institution's need for a "strong father." Furthermore, even those artistic crafts in which production is more collective (e.g., orchestral performance, dance, and theater as compared to painting or composing music) tend to give a prominent place to a single authoritative figure. Musicians praise qualities of assertive command in conductors,[14] and dance and theater companies are commonly identified with a head who may play a very parental role in relation to the troupe's members. In finding the Institute's meaning and mission in the messianic vision of its Provost, some art workers merely continued their characteristic pattern of commitment to work organizations: as one theater designer explained, "you join a theatre company because you admire the director. I came to Cal Arts because I admire B. [the Provost]." If some theater groups build their organizational cohesion upon a director's charismatic vision, not only did faculty expect to find such vision at Cal Arts, but the Provost, as a director, was accustomed to attracting and holding a "company" on that basis. The early messianic definition of the situation and the elaboration of a utopian dream during the year in which the deans planned the Institute can thus be understood as a occupation-derived solution to the problem of building a new institution.

The early definition of the Institute as a focal point of history—as the secular equivalent of a religious pilgrimage center uniquely favorable to serious and consequential action—is evident in the following excerpt from an early deans' meeting which focused on aspects of the relationship between the new administration and the institution's trustees:

> Right here we are at the center of the revolution. Because we are involved in the formation of an institution which is committed to the idea of a radical change in consciousness and mode of operation. And we are now confronting the sources of power that are both making it possible and resisting it. And we are confronting them very directly. It seems to me, that is the major issue in this country at this time.

The phantasy that Cal Arts was "at the center of the revolution" and the frequent definition of the problems which had to be confronted there as "major historical issues" endowed even trivial matters with weighty moral significance and gave life at the Institute, as the following examples indicate, a somewhat quixotic dimension.

The first meeting of the newly-gathered faculty was interrupted by someone's rather hysterical shouts, "The workmen are taking down the swings! People who want to sit-in at the playground better come right now." (Swings symbolized at that time a childcare center and thus sexual equality, which in turn symbolized thoroughgoing radicalism and revolutionary integrity.) When the Provost objected to this militant disruption, insisting that childcare was not one of the Institute's priorities, he was immediately attacked as a sexist by a man aspiring to establish himself, through relentless radical confrontation, as an opposition leader. One of the deans, trying to establish a truce in the dispute, attempted this appeasing interpretation:

> The anger here is not 'cause we are bad, but 'cause we are good. People *do* come with high expectations. We expect *this* group to deliver, expecially on the major issues American society is confronting today.

Such high expectations were widely shared in the early phases of the institution. As one administrator later put it, "We tried to take on every conceivable institutional and aesthetic problem of the period. And yet that was the grandest part of the thing. Totality of vision: that's the sum of modernism." As another example of the way in which the school, as an informant phrased it, promised to "allow people to confront substantive, human issues which get lost elsewhere" during the first year of operation, a sign reserving parking space for the Provost's car came to be deeply resented by some students as a betrayal of the institution's promise of community. Its systematic removal became the object of a small-scale guerilla war, with the Provost supplying himself with a quantity of signs sufficient to replace each one as soon as it was torn down. Two years later he remembered the battle with obvious pleasure as having offered an opportunity for adopting a well-considered moral position:

> One of the kids came into my office and asked me about the nature of Cal Arts. Then he asked me, "*Why* are you putting up the sign?" And I answered, "'Cause I have the power." Now, at another school, I'd never dream of putting up a parking sign for myself. At Cal Arts, it seemed like a good thing to do . . . It was like St. Athanasius holding up orthodoxy against the world, or the "Long live the King" of *Danton's Death*. That was the most libertarian impulse in the play!

If Cal Arts projected an aura of excitement which more mundane schools seemed to lack, it accomplished this as much by providing

ennobling interpretations for common activities as by stimulating innovative ones. During the Institute's earliest period, sitting-in at a playground or putting up a parking sign, gave people a chance to take a stand before history, to throw their weight into the scales which would decide "the major issues of the country," and to help "put the cracked world together again." This could hardly fail to seduce a group of workers whose crafts tempted them (like Madame Bovary or Don Quixote) to *live* the dramas they admired. If the problem with Bovary and Quixote, according to their authors, is that each had consumed too many romances, surely artists as professional producers of romance, could be expected to nourish a similar nostalgia for a mythologized reality—for an uncommon "scene" in which common objects and interactions pointed beyond themselves to become stakes at a wider morality play.

PROCURING STARS

Actually, what I really do best is
procuring.
 Administrator's parting joke
 after an interview

It was all like a great big movie without
content. Just flashes of personalities.
 Faculty member

When questioned about their recruitment to the Institute, the faculty usually began by claiming that they had either "believed in the dream" or that they had "never believed in it" but had come for other reasons. In either case, though, the barely established institution was conceived as an object demanding belief. Faith that it would prove to be a powerful creative center and an "uncommon scene" was bolstered by the reassuring presence of well-known professional "names."

Studding a production with famous stars has been a traditional movie industry strategy for attempting to secure the success of films involving high financial risk. To some extent such a strategy represents an attempt to stave off doubt among the producers through recourse to a kind of magical identification of the power of the stars with the power of the production. At Cal Arts, too, a star-studded faculty helped to project an image of excellence to the Institute's lay publics, especially its trustees, and to secure the confidence of its members.

Deans gained prestige with one another by demonstrating their power to attract nationally and internationally known "names," these names in turn

serving as lures to attract others and lending additional seductive appeal to the school which had been visibly able to seduce them. Once this process began, the glamour of association with a dazzling array of "names" became one of the Institute's principal attractions and a major source of its legitimacy for members. An administrator, in describing the heady euphoria of the initial recruitment period, recalled hearing "names" mentioned to him with the admonition, "but you'd never be able to get him"—only to find with increasing excitement that those defined as being out of reach *were* accessible.

The following passage is excerpted from an interview with a musician who was quite proud to have been "among the first to be asked" to join the Music School:

> Originally M. [the Dean of Music] wanted every slot to be as prestigeful as possible. He got D., me, [some other names] . . . and A., who is the younger member of the group who little by little is making a good name for himself, even though he doesn't have our international name. The thing that characterized all of us is that we'd all made a very strong mark.

This emphasis upon "names" in recruitment reflected the school's identification with the professional (rather than the academic) art world in which, since the nineteenth century, art has been merchandised and advertised by focussing upon the names of its producers;[15] professional aesthetic production is anything but impersonal and a successful artistic career consists very much of "making a name for oneself," in contrast to, for example, "earning a good degree" and "securing a good job." Even formal organizations, therefore, which become renowned for having hosted important art "scenes," enter occupational history in terms of "who was there," the specific names they are known to have gathered coming to constitute, *ex post facto,* their greatness. Administrators, employing a vocabulary tending toward dynamistic imagery, dreamed of a "center of energy" created by the "chemistry" of bringing together all the "right people" (occasionally described as "hard chargers," "real dynamos," and "powerhouses"), and imagined their judgement would be historically vindicated when "someday someone looks at the important artists and suddenly realizes, 'My God, all these people came from Cal Arts!' " The Institute's early focus upon recruiting "stars" was reinforced by the school's antibureaucratic bias against defining curriculum abstractly—independently of the particular people who were to implement it. The notion that "people can only teach what they are into" was accepted as an article of faith. Once a school's program is equated with its faculty who teach only their own work, the quality of its curriculum comes to be

measured by the teachers' renown. In short, the focus upon "stars" was encouraged by the absence of an institutionalized curricular structure, this reflecting in turn both the anarchistic bias of Institute culture and the inevitable difficulty of institutionalizing education for rapidly changing crafts.

While well-known "names" attracted other faculty and students and impressed lay trustees with the drawing power of the recruiting administrators, they were costly and their recruitment reproduced a highly stratified occupational system within an institution ostensibly committed to "community." When budget limitations became evident, well-paid stars who often spent little time at the Institute were balanced, as in the professional world outside, by less glamorous workers with considerably lower salaries.[16]

BRINGING FRIENDS

If one of the aims of the Institute's early recruiters was to attract "names" carrying professional honor and glamor, another was to assemble "all the people they cared about" in one place. A great deal of recruitment moved along lines of close friendship and long association and, in describing their reasons for coming, people often showed pride in longstanding ties of affectionate patronage. As one faculty member states:

> I was high and dry in L.A. when I met my old friend C . . . He is the kind of person who tends to fall in love with people quickly and strongly, and he does a lot for the people he cares about. He used to make things happen for me. Anyway, I came here through him.

Opportunities in the arts are often structured by informal association—friends showing their paintings together, creating theater companies, or founding quartets. Since professional reputation may depend less upon *where* than *with whom* artists play or show their work, friendship ties are useful not only in securing new positions but also in minimizing the possible career risks of taking them. If one can convince professionally respectable friends to show their work with one's own or to commit themselves to the institution one is considering joining, their association helps to protect one's own reputation. The following remarks offer an example of the kind of personal bond which brought some faculty to the Institute:

> I came here because of H. [a theater director]. I've worked with him for years, and I know he'd rather work with me than with anyone else in the world. When you get right down to it, theater is really a bunch

of friends working together. You find if you get along with somebody, you work better. So people keep on working with one another over a period of years.

The movement of a chain of seduction along lines of old friendship and association disarmed new recruits and facilitated trust and belief in the unknown institution. One dean who realized after arrival that his personnel budget was not as generous as he had anticipated, described his recruiting efforts at an early planning session with his administrative peers:

> I'm adjusting to having been seduced—to having heard myself promised a villa in *Gstaad* and chateaubriand, and suddenly finding myself in the Dixie hotel with a hamburger. Dames know about that—but I'm just learning about what one does under those circumstances . . . My one achievement in bargain hunting has to do with some students of mine who are for the moment terribly impressed by me and will follow whither I go. They're beautiful creatures . . . very gifted, very seduceable, and very young. . . For Y. I was competing around $32,000, but I managed to do to him what was done to me. I seduced him. But my seductive powers are waning. Nevertheless, with L. [a woman] I have a more natural approach to the problem of seduction than I did with D.

The tone is, of course, intended to be facetious, and yet the reference to recruiting administrators as pimps and procurers and to the process of recruitment as one of seduction was insistently frequent. The chain of seduction described by the dean is mirrored in the later attempt by one of his faculty members to grapple with what appeared to him as a chain of betrayal:

> On arrival I found that things were not all as I had been promised. It had all been so loosely drawn and gemütlich, and I guess I didn't check things out carefully enough. After all, I'd known [the Dean] for thirty years. I hardly expected a written contract. I guess he was fooled by [the President], who was fooled by the Disney Foundation . . .

This manner of recruitment had poignant consequences: while early trust and enthusiasm for the new institution were supported by people's faith in their friends, once expectations were frustrated, responsibility for this "betrayal" was often also attributed to friends. When budget cuts required reducing the size of the faculty and trustees imposed unforeseen demands for accommodation, those who had once been in a position to "make things happen for their friends" had to fire some of them and to compromise themselves before others.

If recruitment had often been a matter of friendship, survival in the institution, especially given the initial absence of formal bureaucratic procedures, required both having friends and, when necessary, betraying them. Institute culture was preoccupied with the feudal themes of loyalty and treachery, and its members, while idealizing friendship, were also capable of recommending "Mother Courage" as a model for action. One dean, fond of repeating that survival depended upon "having one's own set of cronies," told "his" faculty, "You don't have any real problems until you get a new dean who didn't hire you. *We* start out with trust and affection."

Just as each school was seen as embodying the personal vision of its dean, the positions of its faculty members were guaranteed and legitimated—especially in the absence of tenure—by his loyal protection alone. The obverse of such protection is, of course, the betrayal of personal bonds of trust and affection, and in occupations structured by informal association, a person's reputation as professional and as friend may be linked. When Cal Arts' President, for example, succumbed to Disney pressures and fired the Provost, many faculty believed that his own professional career would be destroyed once it became known that "he had turned on his old friend."

One long-term consequence of focussing recruitment upon procuring stars and bringing friends was that each failure of an expected "name" to arrive, each firing, and each voluntary departure created crises of varying proportions. Those who had come to the school "because of people who were there," whether friends or "names," began to withdraw their commitment as soon as the latter left. Chains of recruitment were thus later mirrored in more or less identical chains of emigration and defection.

Artists at the Institute often insisted that good "scenes" in art education were of short duration with a school becoming known as an important creative center for a year or so and then falling apart. The shifting quality of such occupational scenes and the rapidity with which they dissolve can be at least partially accounted for by the pattern of organizational recruitment and commitment which has just been described. Artists are more likely than other academics to regard a teaching position merely as a job, and to the extent to which their institutional commitments are heavily mediated by personal ties, the system of relationships constituting any particular scene is highly unstable.

GOLD RUSH, STRIP MINING, AND LOOSE SPENDING

First thing I did when I arrived was to
go out and buy an orange suit!
 Dean

Money was being spent as if there were
no tomorrow.
Administrator recalling the
Institute's first year

Hollywood has long been associated in American cultural mythology
with both "easy" money and relaxed moral strictures, and these
associations together with the school's locale and the industry which had
produced its funding capital lent its own resonance to the Institute's
collective phantasy life. The association of Hollywood with money was
even further strengthened by the fact that the movie and television
industries have provided comparatively highly paid employment for
writers, musicians, and other kinds of art workers.

When the first administrators were recruited to Cal Arts they shared the
excited sense that unspecified but vast sums of money lay waiting to
transform their most daring occupational imagination into reality, and
this phantasy of unlimited financial resources provided the foundation on
which other phantasies could be constructed. During a budget-planning
session, for example, one of the deans referred facetiously to the
assumptions he had held upon arrival:

> I consulted with X, and he suggested that I think in terms of a budget
> of $600,000, but I thought to myself, "I'm going out to the lotus
> eater's land where money grows on Hollywood Boulevard," . . . and
> so I added $150,000, and estimated the budget at $750,000 a year.

Another dean recalled that in his first talks with the Institute's President he
had developed the impression that the school would be backed by
"Rockefeller kind of money. Enough to build another University of
Chicago exclusively devoted to the Arts." The assumption that the
Disney's had guaranteed between fifty and seventy-five million dollars to
the Institute and had attached no conditions to the gift played enough of a
role in luring some of the school's first settlers to lead some eastern artists
to draw an analogy between their own recruitment and the earlier
California Gold Rush.

The vision of beckoning wealth gained credibility by its transmission
through trusted, long-standing personal relationships. As one
administrator recollected:

> Even at the time I thought: "it just doesn't make sense for fifty million
> to be handed over with no strings attached," but H. assured me that
> the money was all there, and I believed him because he was an old
> friend.

Belief in the new institution's immeasurable wealth was also reinforced by the extravagance with which early recruits were wooed since they took this as a tangible sign and foretaste of the future awaiting them. Two of them later recalled their first impressions:

> It seemed as if people were flying all over the place. If anybody wanted to fly to San Francisco—fine! They just did it. It was like mana from Disneyland. I was amazed! They were incredibly generous. Paid my airfare, the hotel. It seemed as if the myth of all this money was actually being borne out. At City College we never got this kind of thing. I thought "This place is for real. They've got all this bread they don't know what to do with."

> The place seemed so powerful you felt insulated from anything that could go wrong. You'd snap your fingers . . . here boy is some coffee. Such unabashed luxury. If you wanted to fly to New York you'd just call up and you flew to New York. I'd been wooed by other institutions and all you'd get would be lunch at the faculty club. Here, there was the feeling of being one of a select few admitted into a *royal company*. I flew out three times prior to my appointment—had languid garden lunches in the President's super-house with its collection of superb paintings. I got the impression of a powerful man, the president of a major institution, the radical son of the most prominent Episcopal bishop in the country, who had seduced the Disney's into giving an unlimited amount of money for everybody to realize their dreams.

Once administrators had begun the process of collective dreaming—which at the time they thought of as planning—the dreamers developed their own mechanisms for protecting the dream state, one of the major ones being the delegation of reality-testing to the institution's head. The President, as an ostensibly "radical son of the most prominent Episcopal bishop in the country," served as intermediary and matchmaker for a marriage between two clans, at least one of which defined itself in opposition to the other. As one of the deans put it, "The President faced both ways." All information about the trustees' attitudes and the school's finances was filtered through him, and the deans made few independent attempts to determine the financial limitations of their situation for themselves. When they did have moments of apprehension, their concern focussed upon trying to determine whether the President was personally trustworthy, and they sought reassurance in the assumption that, in any case, the Provost had the President "under control." In short, they depended heavily upon one man for crucial information about the terrain

in which they were to work and upon another for guaranteeing the first one's reliability. Concern with the adequacy of their information tended to be transmuted into a simpler concern with establishing the personal trustworthiness of their intermediaries.

The delegation of reality-testing to a figure marginal to the colleague group of deans was not solely the outcome of any imposed organizational structure; the deans themselves found this a convenient division of mental labor. When, in an early meeting, the question was raised whether the money the deans were planning to spend was really there, they shied away from it nervously, joking about having a sabbath goy [the President] to take care of fiscal matters. The implication of the joke—which derived its power from the fact that four of the six deans were Jewish, and that a son of an Episcopal bishop served as their mediating link with a "goyish" board— was that comprehensive budgetary analysis was a task ritually unfit for men of their office. They rejected ways of thinking about money which constrained the imagination, viewing it as a kind of tabooed dirty work from which they should be spared.

Approaching the work of administration with the values and ideals of their primary occupational identities, the deans cherished the image of themselves as imaginative, reckless "idea-men," and shrank in distaste from more pedestrian aspects of their work. In relation to money they wanted to see themselves as bold strategists or even courageous gamblers, not as cautious accountants. Constraints imposed upon a dean's expenditures were considered morally compromising if they required any part of his original vision to be relinquished, and any voluntary renunciation of costly projects was regarded as a mark of contemptible timidity. With the benefit of hindsight several administrators later admitted that during this initial period they had engaged in reckless overspending and explained this away by asserting that "artists are naive about money"—that they had not known that the Disney's would limit their support, making it difficult to raise money elsewhere. Combined with financial mistakes made by the Board, unforeseen building costs, and the failure to raise substantial funds to supplement the Disney money, the spending behavior of the new administration did contribute to an eventual financial crisis.

But it is noteworthy that extravagant spending was only one aspect of a more generalized euphoria characterizing the Institute's early period. Some people actually spoke of their first months at the Institute as an experience of "tremendous loosening" from the constraints of the "straight" and "uptight" milieus they had left behind, and openness and looseness (identified with liberation) was the valued modality for a wide range of behavior, not only in the Institute but in the wider counter-culture

as well. This initial optimistic period was characterized by an emphasis upon the freedom with which resources of any kind should be dispensed and the ease with which gratification could be taken. To this period belong naked swimming parties, memos from one administrator to another ending with the words, "I embrace you," sexual orgies in the music practice rooms, a hippie "free store," a student-operated "free restaurant" in which payment was discretionary, and a fairly unguarded attitude toward the distribution of expensive equipment (one faculty member, for example, expressed an anarchistic desire to "give away the tools to anybody who needs them"). When the school finally recognized the precariousness of its financial situation and budgets had to be slashed, people stated sadly that things were "tightening up," that it would be more difficult to get access to equipment and that there would be "no more dope and no more sex." In this subsequent period, the free restaurant ceased operating and the title of a student publication, "No More Free Lunches," symbolized the new tone.

The financial decisions of the administration—for example, the decision to open with an extremely costly theater facility and with the faculty necessary for a complete orchestra—may also have been influenced by the temporal structure of careers in the arts. If the Institute's schools were to constitute the "production" of middle-aged artists, these "shows" had to open on a scale appropriate to successful men of their own age. Aiming for the recognition of professionals of their generation, administrators could not afford to build their facility or their faculty slowly. Some openly expressed the fear that once a school had been defined as "second string" it would take at least ten years to recover from such a reputation, and ten years was (for them) too long: by that time they would be seen as having followed the usual dreary path of retirement from professional life to pasture in "provincial" academia. Furthermore, to the extent that one of their strategies for establishing the new institution's reputation was to attract a "galaxy of stars," "dazzled," as one of them phrased it, "by one another's names," the school had to burst upon the art world all at once, before the fleeting radiance which had been collected could dull and disperse.

In opening on a large and costly scale the Institute, like the conceptual art of the period, reflected the rhythm of production imposed by professions whose work consists of "making art news." Wanting to achieve avant-garde celebrity by capturing the attention of the news media, it could no more afford to begin modestly and develop slowly than a young artist, anticipating rapid and unpredictable shifts in aesthetic fashion, could afford to take up a craft requiring years of practice. The impulse to "make news" was further strengthened by the administrators' assumption that the confidence of a lay board which neither shared nor understood their

aesthetic could be best secured by winning quick public attention and praise.

A foreshortened time perspective can lead to an effort to exploit all occupational resources as quickly and intensively as possible, and traces of such a strip-mining mentality existed at Cal Arts in regard to human as well as monetary resources. An institution intent upon remaining avant-garde could not allow people to grow old before severing its ties with them. Administrators decided not to introduce any system of faculty tenure, and many faculty welcomed this as a measure of the institution's commitment to "getting rid of dead wood" and to keeping abreast of the changing art "scene." The ideal art school is one which harbors no career academics and whose highly transient faculty spend just enough time at the institution to allow others quick contact with their most recent work. Once their work is no longer in fashion such a school has little use for them.

When listing the Institute's distinctive attractions, many teachers cited the youthfulness of its faculty. A few forty-year-olds constituted its "old men," and both administrators and young faculty appeared to welcome the opportunity to be unburdened of a senior generation of academics. One administrator even stated flatly that older artists were either too successful to be interested in teaching jobs or too embittered by their lack of success to be any good for students. Since the faculty "inherited" from Chouinard and the Los Angeles Conservatory were without the protection of written contracts, the new administration fired most of them even though some had held their positions for decades and had taken their tenure for granted. As the Dean of Art told a reporter, "They are not the people I would choose to start a new school. I am looking for an openness to the newest kind of thing in contemporary art. Practitioners first and teachers second."[7] The decision not to retain the earlier faculty was seen by some as an act of moral courage and professional integrity. One dean even fantasized that he was begrudgingly admired as a "tough bastard" by those he had refused to rehire. Art, under present market conditions, is a harsh master, and the culture developed among its servants places little value upon security, whether their own or that of others. Even the "dirty work" of firing teachers whose work was out of style reflected some degree of honor upon the "tough bastards" capable of carrying it out and was perfectly compatible with this subculture's conception of a commitment to radicalism.

The new administration's attempt to protect their school's contemporaneity by rejecting the concept of tenure, while enthusiastically welcomed by most of the youthful faculty, allowed the trustees to equate the institution with its permanent building rather than with its potentially transient occupants. During later crises, even the faculty who had once

welcomed the absence of tenure as a guarantee that their collegues would be pruned of "dead wood" bemoaned their own job insecurity and ruefully observed that "only the building had tenure." A Hollywood movie which has overrun its budget or one which has lost the faith of its backers can simply be dropped and its crew fired. While most faculty members had only one-year or two-year contracts, one of the trustees emphasized that he was accustomed to being able to "fire a writer in a week" and that he had been surprised to learn "how much advance planning is necessary in this school business because contracts are longer and you can't operate on a day-to-day basis." The absence of tenure, which the faculty originally saw as a form of radicalism, ultimately helped to make the Institute— understood by its Provost as "total theater"—a producer's rather than a directors' or actors' work of art.

A JOKE IN THE SOCIAL STRUCTURE

We used to joke about our ability to
pull off a really radical thing in the
context of conservative backers. We kept
saying, "Wait till they wake up!" and
treated it as a great source of
amusement.

<div align="right">Dean</div>

The one social condition necessary for a
joke to be enjoyed is that the social
group in which it is received should
develop the formal characteristics of a
'told' joke: that is, a dominant pattern of
relations is challenged by another. If
there is no joke in the social structure,
no other joking can appear.

<div align="right">Mary Douglas[18]</div>

One of the recurrent thoughts in Cal Arts' early dream life was the idea that the *trustees* were asleep and that in the brief interval before they woke up an experiment of major importance would have been launched. The definition of the situation as one in which "THEY" were asleep, by dissociating the administration from the trustees, helped to smooth over an embarrassing alliance and to allay anxiety among the institution's recruits. The dependence of self-identified radicals upon money symbolically associated with political reaction and mass culture

constituted an ambiguous joke in the social structure which had to be publicly recognized and disarmed by an invitation to enjoy the comedy. One of the associate deans used to repeat that the Disney funding was "the best joke in a series of jokes"; another administrator recalled that presenting the situation as a joke became a standard recruitment "line": "People used to say, 'We've gotten together an avant-garde school funded by Disney. Isn't that a laugh!'" At the first faculty orientation, even the Provost pointed to the "cosmic comedy in the genesis of the Institute," and to the "irony latent in the endowment of a radical educational experiment by conservative people."

The "joke" constituted by the unexpected association of symbolically opposed cultural groups was ambiguous insofar as it was unclear at whose expense the reordering of social relations had taken place. If the new alliance between dissonant cultural categories (radical artists and conservative backers) was not to signify that the artists had been bought out, it had to be seen as a joke played on the Disneys. As far as I know, the trustees did not experience the association of conservative money and supposedly radical art as an anomaly calling for humorous recognition. The Institute's jokesters came from among its faculty and student body, and though at least one dean joked openly *in front of* some trustees about their having been swindled, no one joked *with them* on this score: even among faculty and students only those committed to a radical or vanguard identity perceived the newly-forged alliance in a way demanding recognition and release through humor. The joking definition of the situation at Cal Arts was brief, barely lasting through even the earliest period of recruitment: once a series of crises made it clear that the Disney family retained decisive power at the new institution, the "joke" which had drawn power from the apparent possibility of their subversion lost its humor and ceased to be told.

TRANSIENTS AND HUSTLERS

I have always been pretty fortunate to
get into new schools. After about the
third year of a school things get to be
pretty ordinary. The life rate of art
schools, their heydays, are very brief.
<div align="right">Art teacher</div>

I am not against cheating the Disneys
which, I think happily, we're all doing—
and I think, very creatively.
<div align="right">Administrator at an early
planning session</div>

Akin to the early understanding of the Institute as a "joke" or a dream
which would come to an end when the trustees "woke up," was the
assumption that people had been gathered for the purpose of cheating the
Disneys creatively. The image of the artist as a ruthless and wiley trickster
capable of conning support for his dreams from the world was universally
cherished at the Institute. Practitioners of all crafts from film-making to
violin playing took it for granted that professional survival required highly
skilled hustling. The Dean of Film, for example, describing the type of
student he wished to recruit, emphasized that while sympathetic with
"poetic types" who despised the "rat race," "I'd prefer them to go some
place else. I'm looking for less lovable types: rats who want to be fast in a
new kind of race." Administrators both promulgated and participated in a
positive identification with con men, and though they were at times
idealistically romantic about the school they had come to develop, they
were also capable of regarding their project with the cynicism of seasoned
hustlers. As one associate dean put it: "From the very beginning there was
an element of 'Let's' take 'em for what they've got'." The orientation of the
con man who intends to "take the money and run" came to be justified by
asserting an inevitable conflict of interest between "conservative squares"
and "hip radicals". In fact, conning and hustling constituted an
occupational adaptation, transcending any particular institution, which
people brought with them to the Institute and which was ready to be
activated as soon as the initial utopian idealism was disappointed.

A glimpse of the economic terrain which encourages the development of
this adaptation can be gleaned from one administrator's description of his
experience with a foundation funding work in the arts:

> The whole game is played out as though seed money were being
> granted, but no eyes meet, because everybody knows this money is
> not going to seed a bloody thing except this particular effective con
> man or con woman who got to the foundation, hustled them out of
> thirty grand and got his or her little *shtick* going in Sanduskie for a
> year.

Under such conditions of production, where economic support is
unreliable and appears in the form of unrepeatable windfalls, any hope for
lasting accomplishment lies in exploiting newly discovered resources
quickly and without scruple. Particularly to the extent that artists' careers
are likely to take them from one disparate "gig" to another, they must learn
how to make the most of a "scene" before it disappears or they lose their
insecure foothold. Thus, not only did the millenarian temper of this entire
cultural period and the anarchistic ethos which proclaimed anything
established as "dead" favor a preoccupation with the Institute's demise

even at its moment of birth, but the occupational experience which many artists brought to the new school predisposed them to view it as a highly temporary source of valuable supplies.

The following recollection by a member of the theater faculty offers a typical example of the kind of prediction which new arrivals tended to make in a collective attempt to gain their bearings:

> One night S. and I were talking and she said to me, "The other day P. asked me how long I thought the Institute was going to last, and I told him: ten years. How long do *you* think it's going to last?" I told her "Three years: one year starting it, one year doing it, and one year during which it falls apart." That's the way it's been in the past for me—for example, with the Stanford Repertory Company.

Even in their most trusting and enthusiastic moods many people regarded the Institute more as a brief but historically important event than as an enduring institution. "The way some people talk about Woodstock," one woman put it, "I talk about Cal Arts. I'm so glad I'm here *now* instead of just hearing about it later after it's over." Institute culture was preoccupied from the very start with questions about how long it would last, what signs would forewarn that it was over, and who at any given moment was rumored to be leaving (for once a "scene" is recognized as over, people receive prestige in the order of their decampment as they once received it in the order of their arrival).

The fatalistic belief in Cal Arts' inevitable disintegration, like the expectation of unlimited plenty, discouraged long-range planning. In a sense it diminished the future dimension of experience altogether, and this may have contributed to its appeal for those who wanted the Institute to serve as an uncompromisingly radical pedagogical and aesthetic experiment. If the institution's future was in any case foreclosed, radical imagination would be as protected from compromise as if resources were unlimited. Experience characterized by this absolute presentness takes on the characteristics of an "adventure"[19] outside the normal ongoing stream of life, and this is precisely how many artists saw their relation to the Institute.

AN EXPERIMENT AND AN ADVENTURE

M. came even though he predicted the
place wouldn't last because he saw there
would be money for an adventure.
<div align="right">Musician</div>

I'm not married to this place. It's just a
long love affair.

<div align="center">Dean</div>

The conception of the school as an open frontier where everything could be
expected and anything could be tried was nearly universal among its first
recruits. People came seeking a *tabula rasa* for experimentation in
pedagogy, in art, and in their lives. When I set up my own living quarters,
for example, I followed an impulse to paint my entire room white and to
pare the furniture down to the essentials of a monastic cell. One of the
deans took the opportunity of the move west to leave his household
furnishings behind, living with his family in a nearly empty house whose
walls became easels for the colorful graffiti of his school community. Other
new recruits stripped themselves of their family relationships through
divorce, doffed their clothes to experiment with public nudity around the
school's swimming pool, tried to shed their established habits of
perception through drugs, and attempted to move beyond their inhibitions
through new forms of sexual experience. The bare walls and the bare
bodies symbolized the impulse to radically purify the community and its
members of all conventional routine and signaled the desire to create a
"liminal situation"[20] where people could divest themselves of old identities
and old working habits in order to reach the cleared rock bottom upon
which new selves, a new community, and a new art could be constructed.

Radical experimentation and innovation in all activities was one of the
central norms of early Institute culture. Deans emphasized the
experimental nature of their programs and assured newly arrived faculty
that everything remained open and unstructured. The Provost even called
for "vigilance" against any surreptitious return to old forms of educational
or artistic practice, and so much was the rejection of traditional
pedagogical and aesthetic routine normatively identified with the spirit of
the place that some faculty and students complained of vertigo and feared
being found unworthy if their inner core of conventionalism should be
exposed.

But if Cal Arts aimed to establish a reputation as a site for radical
innovation in both aesthetic and social forms, it rapidly became clear that
few people were willing to maintain a disinterestedly experimental attitude
toward either their source of livelihood or their lives. those who had
"objectively" committed themselves most strongly to the institution by
buying mortgaged houses or giving up tenured positions elsewhere or who
recognized that they had no other employment alternatives which
promised to yield a comparable salary, did not long retain their initial
"subjective" commitment to uncompromising experimentalism. Once

their lives had become inextricably bound to the Institute's future, they bargained and retreated when it seemed necessary to ensure their own and the Institute's survival. On the other hand, those choosing or able to spread their risks—because they maintained different careers simultaneously, held tenured positions elsewhere, or knew that they could easily obtain comparable employment—could more easily afford to remain faithful to the Institute's early values. A sustained commitment to radical experimentalism was thus strongest among people who were free to regard their involvement with the Institute as an adventure outside the mainstream of their lives: as an affair rather than a marriage.

One of the major sources of bitterness in a community which had employed a radical moral vision in attracting new settlers was that those most tied to the institution were eventually most compromised in the light of its ideals. The early Institute was a utopian community in which the longer one stayed, the further one fell from honor. Like other art scenes whose temporal limitation is taken for granted and to which people flock out of desire to "have been there" during the privileged moments of peak vitality, one had to leave it quickly in order to redeem its early promise. Like romantic affairs, its first days were regarded as its best, while its development was viewed as the progressive disintegration of a dream.

NOTES

1. For description of messianic temporal experience see Karl Mannheim, *Ideology and Utopia* (London: Routledge, Kegan and Paul, 1960), pp. 177; 190-197. For a recommendation of this experience of time as the only liberating or authentic one see Walter Benjamin, "Theses on the Philosophy of History," *Illuminations* (New York: Schocken Books, 1969), pp. 260-64.
2. If "breaks" in the arts promise immortality of sorts—or at least the temporal expansion of the ego through fame—time passed without their occurrence in careers in which youthfulness is an asset only *decreases* their likelihood, thereby advancing occupational "death." The most powerful wish in the Cal Arts dream was to be rescued by a "break" from time, so that those who dreamed together would grow, not older, but younger together; the dream was over when the dreamers realized they had aged further in the course of it.
3. For a description of job insecurity and dreams of grandeur in another work setting, see Hortense Powdermaker, *Hollywood the Dream Factory: An Anthropologist Looks at the Movie-makers* (Boston: Little, Brown and Co., 1950), p. 37.
4. This ambivalence about the school's name—the decision to change it to the Walt Disney Institute of the Arts in honor of its recently deceased benefactor, followed by a hasty annulment is symptomatic of the structural dilemma of all single-donor institutions: to the extent that they are dependent upon, and indebted to, one major monetary source, they are driven to public shows of appreciation and recognition. But the danger of such public identification is that the more an institution becomes defined as

one man's—or family's—project, the more difficult it becomes to solicit funds elsewhere. In the absence of alternative sources of funding a spiral of increasing dependence upon a single source may be created: the necessity of publicly "appreciating" the source by identifying the institution with it makes it even more difficult to raise other funds, thereby increasing the institution's dependency and further diminishing the degree of autonomy it can afford to exhibit in relation to its primary funding source. Such a spiral of dependency is familiar to political economists studying problems of development encountered by nations rather than by formal organizations.

5. For Cal Art's older generation, Disney was remembered for uncompromising and punitive opposition to unionization in the studios and for black listing during the House of Un-American Activities Committee investigations. Among younger people in the counter-culture, the expulsion of long-haired male visitors from Disneyland had assumed significance as a symbol of the chasm separating the "hip" generation from the "square" culture in which they had been reared.

6. For a note on the predominance of New York cultural institutions over those of other American cities see Edward M. Levine, "Chicago's Art World: The Influence of Status Interests on its Social and Distribution Systems," *Urban Life and Culture,* Vol. 1 (October 1972), p. 294.
 The problem which a Southern California school aspiring to attract a nationally prestigious faculty faced can be surmised by the remark of a Cal Arts performing artist one year after his arrival in Los Angeles: "I'm local. That means I only work out of New York."

7. On the concept of folk models see Claude Lévi-Strauss, "Social Structure," in *Anthropology Today: Selections,* edited by Sol Tax (Chicago: University of Chicago Press, 1962), p. 324.

8. I have taken this phrase from Richard Colvard, "Risk Capital Philanthropy: The Ideological Defense of Innovation," in *Explorations in Social Change,* edited by George K. Zollschan and Walter Hirsch (Boston: Houghton Mifflin Co., 1964).

9. "Pieces," in the occupational jargon of the time, were works of art which took the form of performances rather than of objects, and this vogue for art as performance overdetermined the perception of the deans' schools.

10. See Powdermaker, Op. cit., and Richard Schickel, *The Disney Version* (New York: Avon, 1969), for descriptions of producer-control in the movie industry.

11. The Dean of Critical Studies was fired quite early in the school's history, and this only made his "art" of administration all the more successful by the canons of vanguard aesthetics. When his critics accused him of having "courted disaster in Dadaist style," some of his defenders could reply, "But he was just doing his 'piece,' " knowing that the work's uncompromising internal consistency and unambiguous temporal boundaries were understood to be measures of an artist's discipline rather than of his lack of it. If administration was to be regarded as an art, there could be little disapproval (during the sixties) for a self-destructing "piece."

12. For description of the belief held by artists of earlier generations that it was essential for their work that they gain direct experience of the most "advanced" tende ..es of their time, especially with socially radical ideas, see Donald Egbert, *Social Radicalism and the Arts* (New York: Knopf, 1970), pp. 154; 465.

13. *Arts in Society,* Vol. 7, (Fall-Winter 1970).
14. Robert R. Faulkner, "Orchestra Interaction: Some Features of Communication and Authority in an Artistic Organization," *The Sociological Quarterly,* Vol. 14 (Spring 1973), pp. 147-57.
15. For an historical account of the use of names for purposes of merchandising painting, see Harrison and Cynthia White, *Canvasses and Careers: Institutional Change in the French Painting World* (New York: Wiley, 1965).
16. An emphasis upon the pedagogical virtues of a youthful faculty were convenient to administrators who needed to save money on some salaries in order to pay for the "stars." As one administrator bluntly put it: "I have a good feeling about young people teaching. They are more zealous. And they're a hell-of-a-lot cheaper."
17. "Teachers at Chouinard Art Fight Firings," *Los Angeles Times,* (12 November 1969), p. 2.
18. Mary Douglas, "The Social Control of Cognition: Some Factors in Joke Perception," *Man,* Vol. 3, no. 3 (September 1968), p. 366.
19. See Georg Simmel's phenomenological analysis of "The Adventure," in *Essays on Sociology, Philosophy and Aesthetics,* edited by Kurt H. Wolff (New York: Harper and Row, 1959), pp. 243-58.
 Especially intriguing given the manner in which Institute people described their experience is Simmel's comparison of the structure of an adventure with that of a dream or of a work of art: ". . . a remembered adventure tends to take on the quality of a dream. Everyone knows how quickly we forget dreams because they, too, are placed outside the meaningful context of lifeas-a-whole" (p. 242). And: "It is because the work of art and the adventure stand over against life . . . that both are analogous to the totality of life itself, even as this totality presents itself in the brief summary and crowdedness of a dream experience" (p. 245).
20. I take the concept of "liminality" from Victor W. Turner, *The Ritual Process: Structure and Antistructure* (London: Routledge and Kegan Paul, 1969), p. 94:

 ". . . all rites of passage or "transition" are marked by three phases: separation, margin (or limen, signifying "threshold" in Latin), and aggregation. The first phase (of separation) comprises symbolic behavior signifying the detachment of the individual or group either from an earlier fixed point in the social structure, from a set of cultural conditions . . . or from both. During the intervening "liminal" period . . . the ritual subject . . . passes through a cultural realm that has few or none of the attributes of the past or coming state."

Chapter 5

ARTISTS' COCKAIGNE

During the past decade sociological scholars have expended considerable intellectual effort pointing out and unveiling the ideologies which occupational groups develop to further their economic, status, and power interests.[1] If less reflective attention has been focussed upon the place of utopian thought in occupational subcultures, this may be in part because the same intellectual climate which facilitated critical distance from professional ideologies made it difficult to recognize occupational utopianism as such. Quite frequently, the critique of an occupational ideology has itself been rooted in a utopian project.

Yet an examination of occupational utopias—collective mental constructions of ideal but as yet unrealized work orders—can yield glimpses of otherwise unarticulated discontents and impulses in the social milieus out of which they arise. Like an individual's dream image of reality "corrected" in the interests of pleasure, the collective utopian dream of an occupational group highlights the problems for which it seeks at least symbolic resolution. Thus, to decipher the seductive appeal of such a vision is to understand more about the daily aspirations and frustrations of the work world to which it corresponds.

While occupational utopias are informally nurtured in many work cultures—even if it should require a wider millenarian spirit to stimulate their organized expression—occupations perceived as redemptive such as work in art, education, religion, or therapy may be particularly receptive hosts to the utopian imagination. Since workers in such fields have a generalized mandate not only to provide specific services but to show the

way to a better life, their enthusiasm for creating an ideal work order draws strength from the assumption that in *their* fields such an accomplishment would simultaneously provide a model of a more ideal human order.

Utopian yearnings to perfect the social organization of artistic production have surfaced during earlier waves of utopian socialism. Van Gogh, for example, urged his friends to form a cooperative society of painters producing paintings collectively and sharing all revenue received from their sale. Gauguin, Mallarmé, and some of the Synthetists of the late 1880s nursed similar fancies of founding a Fourierist phalanstery of artists. One sociologist, Raymonde Moulin, remarks of the utopian schemes which appeared among nineteenth-century French painters that they often expressed an impulse to recuperate the most attractive features of past systems of patronage while conveniently overlooking the historical totalities which made these systems possible. According to Moulin theirs was an attempt to resecure, for example, the social integration but not the anonymity of the medieval artisan; the glory but not the dependency of the seventeenth-century court painter; the Romantic mission but not the economic insecurity of the nineteenth-century vanguardist.[2]

The millenarianism characterizing parts of Europe and the United States during the late sixties stimulated another wave of utopian fantasizing in the arts as well as in other occupations,[3] and the imagination of an artist's Cockaigne collectively embroidered by the Institute's early recruits was one of its manifestations. "The Dream" (as it was called at the Institute) functioned as a recruitment myth persuading musicians, actors, painters, dancers, poets, and film-makers to leave New York and other cultural centers for a new institution in the desert. Created by art workers occupying different positions in a collective division of labor and holding opposing interests in its reorganization, this dream of an ideal work milieu for the arts harbored contradictory features. But it is in the nature of the dream form to gloss over such contradictions, permitting the entertainment of notions which would be rejected by a form of thought less governed by desire.[4] The axioms which harmonized the dream contradictions (for example, the assumption that the new Institute had limitless monetary resources, that its students would be peerless in motivation and talent, or that with formal structure kept at a minimum, people would cooperate freely and harmoniously) constituted wish fulfillments in their own right, and formed the definitive dimensions of the Cockaigne universe.

ART WORLDS IN ASHES — ART WORLDS TO BUILD

The sense of being on the brink of a new occupational world (and a vehement expression of discontent with the old one) was stimulated during

the sixties by the possibility of identifying with the rhetoric produced by the culture's most dramatic opposition movement. The following passages extracted from a publication devoted to the opening of the new Institute show a wider millenarian imagery being focussed through the prism of narrowly professional discontents. Drawn from a letter addressed by an Institute poet to one of his colleagues, these passages express the author's anger at having been rejected for an invitation to read at the Guggenheim Museum and follow his observation that it is almost impossible for poets who have not published "a hardcover book by one of a certain group of upper Manhattan publishers" to obtain such an invitation:

> . . . Black Power, the oratory and fury of the past few years, teaches us an important lesson: that it is not they, the Blacks, is "what is happening" . . . but, that we are, and can learn from them. They are not unreal; they are very real; but we too are, as poets, not just as artists, but as poets, *living in occupied territory and ruled,* that our flowers leak out, to each other and slight spill over of students/critics/friends but the whole business has for traditions been established and we are repeating the *round* that other minorities are ceasing to respect. We respect the pigs long as we allow ourselves to be dictated to by them . . .

> I am saying here it is time you and I not only recognized but acted on the fact that the enemy is not poets, nor magazines edited by poets, but the pasteboard powers that *determine the fate of poets,* and that we should recognize ourselves as a spiritual circuit and move as a body to abolish these powers . . . and stop once and for all accepting dribble favors, the little prizes of silence and award (same thing) we get for staying in our place.

> I don't know what you want, but among other things . . . *I want my power to be realized.* I want power, and I suspect . . . any artist who says he doesn't want power.[5]

The frustration of occupational powerlessness, the anger that laymen, not poets, control the avenues to publication and support, seeks expression through identification with the period's central drama of oppression and revolt. After calling upon poets (cast as a "minority") to free themselves from the laymen (pigs") wielding power over their profession, the text goes on to report:

> I had a vision in Peru of one central place, a ritual center for poets that would be a theater, hostel, bookstore, printing factory, which

would be organized by poets and serve them, where they could meet, stay, and hear each other . . .[6]

The well-publicized millenarianism of the youth culture, with its message that the dominant social order was "dead" and waiting to be amortized, nourished the traditional insistence among vanguard artists that current relations of aesthetic production and the genres which depended upon them were "dead" as well. For this group, the opening of a new institution seemed to offer an unparalleled opportunity to break with the past. Severing occupational and residential ties elsewhere in order to move west to the new community held the appeal of a clearing or demolition ritual which might prepare the ground for fresh creativity.[7]

During the initial planning sessions of the Institute, virtually every artistic discipline was declared to have reached an historical impasse and to be awaiting a rebirth. For example, a composer introduced himself and his field in the following vein:

> In the early fifties . . . it became apparent to people of my age that music was done with Webern. By around 1960 I decided I'd never write another piece of music as such again—that is, a piece that would be performed on the stage . . . I gave up the concert stage as an institution because I couldn't simply add pieces to not only a dying structure, but a dead one. Only the people in it don't know it's dead. There is no other institution in which people are still wearing tails! Tails are a joke!

Administrators of the Institute's art and theater schools echoed this tone, stressing, respectively, that not only painting but the gallery system was "finished," and that a younger generation of actors rejected both traditionally organized theater companies and "linear" forms of drama. Even the defense of a costly traditional art form was strategically mounted with an admission of its "death"; the desirability of creating a full orchestra (though this required an expensively wide range of teaching staff) was argued as follows:

> The orchestra is now in our field the greatest challenge to the mature creative mind for the very reason that it died! . . . The greatest question facing every creative musical mind is how to make eighty people do something worth doing in our terms . . . how to resurrect this thing. That's the only challenge . . . It's the phoenix aspect of the situation that's interesting.

The insistence upon the "death" of all traditional art forms and the concomitant excitement surrounding the establishment of a community believed capable of giving birth to new ones, was overdetermined. Insofar as a nontraditionalist aesthetic demands above all that work exhibit originality, the proclamation that orchestral performance, painting, etc., are "dead", by symbolically severing present from preceeding work, appeals to artists who otherwise fall short of the absolute "new beginning" their creation myths require. Furthermore, to the extent that the arts serve as rites, idealizing past and contemporary social structures, attacks upon the legitimacy of the predominant forms of social relations inevitably subvert the rites which reflect them: tails were a *joke* to the composer cited above because they no longer functioned as part of a credible *rite*.[8] When in the sixties national political figures were mocked and a draft resistance movement celebrated the individuation of the person through opposition to mass mobilization, a symphony orchestra with its sober uniforms and its subordination of all players to the direction of a single, spotlighted conductor became newly distasteful for many young musicians. If the composer pronouncing the "death" of the orchestra explained that:

> It died because there were no individuals. The guy at the eighth desk was playing the same notes as the concert master . . . The problem is how to get them all to be individual, virtuoso people. . .,

the problem to which he attributed this death was as much ceremonial as musical.

But the conviction that existing aesthetic genres are "finished" is particularly compelling when the social institutions which support them appear to be on the verge of bankruptcy. For musicians watching famous orchestras threatening to fold for lack of funding, for film-makers witnessing the decline of the Hollywood movie industry, and for painters working after the collapse of the international painting market of the early sixties, there was solace in the assumption that institutions which could not guarantee their security were in any case slated for a rapid demise. The rapid growth of art programs in academia during the latter's last decade of burgeoning expansion[9] contributed only further to many artists' sense of being on the brink of a new occupational world stimulating the redefinition of their work and the reorganization of its execution. If academia appeared to be offering a new world for the arts, the Institute was to be its utopian colony. The heady anticipation of one film-maker is representative:

> We'll have the gear and be able to do things which the Hollywood studios themselves can't afford to do . . . We've always seen the

university as the ivory tower. But now . . . the big studios have
become ivory towers. And what's happening is, for economic
reasons, on campus. The studios don't dare, can't afford, to try new
things. We can.

A COMPLETE FACILITY UNDER PROFESSIONAL CONTROL

Rumored to be dazzlingly well-equipped, the Institute promised to offer
workers in occupations whose technology remained largely preindustrial
contact with glamourously modern tools and with the derivatively
glamourous occupational segments using them. Perhaps the artistic elites
attracted to the Institute might be compared to the social elite of an
underdeveloped country in their self-consciousness about belonging to a
sector of the professional world still dominated by traditional handicraft
technology and in their aspirations to modernization. If so, Lenin's
apocryphal dictum that socialism consisted of "Soviet Power plus
electrification" might be adapted to describe this artist's Cockaigne as a
vision of "community plus electronics."

Early planners spoke of the school's future library as a "research facility
for the artist rivalling the one MIT offers the scientist"—a facility so
heavily computerized that "information would fall into one's lap at the
poke of a button." Even the word "library," with its connotation of print
rather than electronic or film media, was slighted in favor of such names as
"experience bank" or "information center." The school's theater,
publicized as "one of the most experimental in the world" because its
hydraulic pistons allowed sections of the audience and of the stage to be
raised to varying heights, seemed almost to be regarded as an autonomous
creative agent, or at least as a machine with the awesome power to amplify
the creative productivity of its users. The music school offered some of the
best electronic studios in the country, and before the limits of Institute
financial resources became clear new recruits dreamed of a printing press
for publishing avantgarde books, a multi-media coffee house featuring
continuous audio-visual shows, mobile cinemas, video environments, and
even a unique drive-in theater for showing Institute work to the
surrounding communities.

The anarchistic bias of both the counter-culture of the sixties and the
avant-garde tradition in the arts[10] induced Institute planners to minimize
the development of formal administrative structures, wistfully turning
instead to communications technology for solutions to organizational
problems. One of them argued, for example, that it was more important to
buy video equipment than a lathe because the former would "knit the
Institute together." And as the following testimonial from an early

administrative meeting reveals, such tools—like the theater previously mentioned—had an aura not only of unrivalled contemporaneity, but of "metaphysical" potency:

> There are two kinds of technologies: those that are merely facilities and those that are metaphysically necessary—that is, those kinds of tools which when used open up whole new areas of human experience—personal, social, and meditational. Video is one of those metaphysical tools without which we can't live in this age of the arts. It completely alters one's sensibility, one's mode of being in touch with the environment, with others and with oneself.

Perhaps, though, the fondest wish aroused by the new institution was that it would be comprehensive enough to offer a microcosm of the professional worlds of its members—that it would publish, distribute, display, and, above all, publicize the artists' work, thereby freeing them from the ancillary, lay-controlled institutions upon which their careers depended. It was the perennial utopian theme of self-sufficiency, perennialy expressed in aesthetic utopias as "L'art aux artistes."[11] At its most extreme, the desire for freedom from lay control found expression in proclaiming that the artist's work need not yield any finished product or performance for a lay public. Artists at the Institute liked to speak of themselves as doing "research" in their disciplines, whether this meant acting or playing the violin, and one of the attractions of the Institute's name was that it permitted identification with "pure" scientific work. One member of the theater school, for example, contrasting the "art of theater" with "professional glitz," insisted that the former demanded time and freedom to experiment without any pressure to stage a public production:

> Even an experimental theater such as the San Francisco Actor's Workshop was never able to deal with itself as profoundly as it wanted: it was too productive; the midnight lab sessions became marginal.

Similarly, musicians anticipated that the Institute appointment would liberate them from stale, conservative repertoires by enabling them to play primarily for (as well as with) colleagues, and painters looked forward to a source of financial support allowing them to be more indifferent towards their painting sales.

Eventually this desire to work only before the eyes of colleagues came into conflict with the Institute's communitarian ideals, the bounds of colleagueship becoming so narrowly defined that workers in one craft

perceived those of another as alien laity. Nevertheless, one of the most potent ingredients of the early recruitment myth was its promise that an institute for reserach in the arts would assure the artist's final ascension to pure professional status by freeing him from the despised role of layman's entertainer.

"COMMUNITY OF THE ARTS" AND STRUGGLE IN THE WORK SYSTEM

If asked why they had been drawn to the Institute, many of its faculty would quickly mention the promise of "community," a word endowed with a multiplicity of meanings. Early formulations of the institution's mandate stressed the uniqueness of a setting in which all the arts would be housed "under one roof" and the conduciveness of such centralization to new kinds of artistic collaboration. Public relations brochures and news releases painted a picture of musicians composing scores for their film colleagues, of painters and sculptors designing sets for the theater, of filmmakers documenting work in dance, and of artists in each of the nominally separate schools of the Institute enjoying access to the personnel and equipment of the others. Some faculty saw the new work organization as an opportunity to develop a new "multi-media art,"[12] one of them envisioning "the fulfillment of some great symbolist synesthetic dream with disciplines collapsing into each other, going under, and forms dissolving."

But most faculty, shrinking from being identified as "artists" (a term considered vulgarly inclusive) and carefully referring to themselves as dancers, painters, or film animators, were less interested in working on the boundaries between disciplines than in placing the equipment and personnel of other crafts in the service of their own. Thus, when interpreting the invitation to participate in establishing a "community of arts," film-makers hoped to use theater school students for their productions (but did not expect to share their own scarce equipment), musicians imagined dancers accompanying their solos (but did not expect to perform while the dancers exercised), composers anticipated calling upon the talents of virtuoso performers (but did not expect to teach instrumentalists the fundamentals of musical theory). In fact, every occupational group looked forward to a hitherto untested freedom not only from lay interference but from subordination to other kinds of art workers as well. While composers were prepared to stress that it was the duty of accomplished and neophyte performing musicians to play contemporary work, many of the latter were adamant about their unwillingness to spend time (or, in the case of singers, risk their voice) on

music which added neither to their enjoyment nor to their professionally marketable repertoire. The anarchist vision of a community of people each "doing his own thing" permitted every artist to anticipate a situation in which his own work would see its final unhampered expansion as others in his work system at last adopted their proper facilitating role.

The aspiration for a new work order was particularly marked among people whose crafts are subordinated to other arts in a collective "production." Theater designers are sensitive to being regarded as mere technicians or, insofar as their work may include fitting clothes on actors, servants to others whose creativity wins greater public recognition. As one of them explained:

> In most theaters, whoever directs gets to make art and everybody else just has to help them do that . . . But the only kind of theater I will work in any more is one in which everybody gets to do his own thing as much as possible and in which there is PR to let the critics *know* it is everybody's production.

Another offered the following description of the hopes which had brought him to the Institute:

> *I hoped job distinctions would be wiped out.* Because it's time for the director to take a back seat—to do away with that whole notion that the director is a father of the total idea of the production. If there has to be a hierarchy, the director should play a secondary role and the *designer should become the architect of the event* . . . As a designer, I wanted to direct the actors in those things which only I could do. Because that archaic system, in which a director calls in a designer, then talks to his actors apart from the designer, and maintains alienation between these categories of people, is crumbling.

For these people, talk of community and of projected theater ensembles in which they would work harmoniously with actors surrepticiously suggested not only the possibility of release from very specific sources of resentment in the conventional division of labor but also from the possible hegemony of their own craft over that of others. The anarchistic bias of Institute utopianism, in discouraging the development of explicit formal regulations which might have revealed the potential contradictions in the desires it fanned, served an important ideological function by prolonging the ambiguity in which the enthusiasm so crucial for recruitment could thrive.

THE WORK OF TEACHING AND THE IDEAL STUDENT

We're making the assumption that every
student who comes into the art school is
an artist.

 Dean of Art

Talented students need two things: they
need good equipment and they need you
to get out of their way.

 Electronic Composer

Reference to the new organization as an *institute* (with its connotations
of scientific and scholarly prestige) and as a *community* implicitly
distinguished Cal Arts from other *schools* where artists teach students. In
fact, the term "school" was used pejoratively, with disillusioned artists
pronouncing bitterly that what had promised to be an uncommon scene
and community proved to be only a school after all. The fundamental
tenets of early Institute educational philosophy were (1) that students
should be regarded as fully-fledged artists and colleagues, (2) that
education should be completely noncoercive and responsive to the unique
needs and developmental rhythm of each student, and (3) that faculty
members should only teach "their own thing"—subjects in which they were
immediately and personally engaged. There was to be no grading system,
no standardized time-table for graduation, no course requirements, and
the commitment to avoid any imposed sequence of instruction was
registered in such slogans as: "no information in advance of need" and "as
many curricula as students."

After a brief attempt to implement this educational philosophy, a good
number of the faculty longed to reintroduce formal, standardized
curricular organization. They were unwilling to accept young students as
artists when the latter failed to meet their inflated expectations, and
became anxious when the distinction between professional and amateur
work was blurred. The absence of formal course requirements made it hard
to limit competition for access to scarce equipment or to guarantee each
instructor the minimal student attendance required to maintain "face,"
and the lack of a standardized sequence of instruction made it difficult for
teachers to rationalize their expenditure of time and energy and to protect
themselves from harrassment by repetitive demands to demonstrate the
use of, for instance, a printing press. Eventually such concerns created
faculty support for a revision of educational philosophy, but during the
initial period of organizational recruitment, an institutional ethos stressing

the collegial status of students and a bias against the bureaucratic organization of instruction proved highly attractive to prospective faculty.

Perhaps the greatest allure of the insistence upon student autonomy and self-direction was its suggestion of freedom from much of the drudgery of teaching. The belief that the most significant learning takes place through the propinquity of neophytes and working artists reassured artists that a job at the Institute would not threaten to ciphon energy away from their own work. The high expectations for the representatives of a supposedly unique and creative generation (the adulation of youth during the sixties endowing students with a special mystique) together with the suggestion that every student should be regarded as an artist added to the fantasy of a school in which students would altogether lose their bothersome qualities. Self-motivated and skilled young people (in the performing arts in particular) would serve as resources for faculty work, but beyond that, the ideal student for most artist-teachers was the nonexistent one. It was this vision of freedom from students as such—of an institute consisting solely of colleagues—which the promise of a loosely structured "community of artists" invoked.

Furthermore, the substitution of the term "community" for "school" eased one of the major embarrassments of professional art education: its inability to assure duly certified graduates of employment in their field. Graduates of professional schools are, in a sense, products of their instructors' work, their market value implicitly providing one measure of the value of the work of educating them. Teachers in the arts must find ways to defend themselves against the demoralizing charge that—as it was phrased by one nonteaching member of the Institute's staff—"it is hardly any service to society to churn out more unemployed people!" As a uniquely inspiring community rather than a common school, the Institute hoped to be in a better position to parry the expectation that it would be capable of establishing its graduates in the occupations for which they had been prepared. In fact, the question of students' future employment was somewhat taboo, as the following indignant response by one faculty member shows:

> You can't talk about things like that! We have utterly *no* obligation to think about jobs for students. It's dishonest to think in those terms. After all, why have artists gone to places like Paris or New York? Because they needed some sort of community. What if you went to Paris to paint or write a novel? If you make it—good! If you don't make it—you leave. Talking art is not talking academically. People are always talking about everything but art!

In time, the analogy fostered some resentment as students pointed out that a Paris or New York artistic community did not consist of some who paid for their membership and others who were paid for it. But as long as this objection could be overlooked, the insinuation that the Institute was less a school than an art colony appealed to both faculty and students who—even as the historical locus of aesthetic production shifted—continued to identify with the Bohemian rather than academic tradition.

RADICAL COMMUNITARIANISM AND ART AS A WAY OF LIFE

Now it's just a gig. But when we first
came, it was a place to live in—a place
to *be*—not a job. We felt we were here
to do our thing—to do what we do.
<div align="right">(Musician)</div>

Developed by a group of workers particularly receptive to the romance of the period's counter-culture, the vision of ideal aesthetic community included some impulses which not only went beyond narrowly professional aims but contradicted them. The Institute's "freaks" (as those identifying strongly with the counter-culture referred to themselves) cherished the most utopian fantasy of all: that a redemptive community would liberate the potential artist in all people and the aesthetic dimension of all activity. Distinctions between artists and laity, colleagues and family, home and work, work and play would be erased as the experiential categories accompanying the industrial organization of production were transcended in a new unity, and both people and their activity freed at last from instrumental evaluation.[13]

The suggestion that the new organization would combine collegial, friendship, and family relations in a single community was particularly compelling to workers in crafts which are still widely practiced in home workshops. Impulses which might otherwise be attributed solely to nostalgia for a preindustrial way of life must—in the context of the art occupations—be seen, at least in part, as stemming from the desire to carry the social forms of an urban art scene into a new setting. The absence of nepotic rules enabled faculty with bargaining power to obtain official employment at the Institute not only for friends but for family as well. Those without bureaucratic means to make their life at the Institute a family affair had to rely upon informal understandings that membership would not be restrictively defined. They insisted that it was a "crime to break up the family" by arbitrary organizational rules distinguishing tuition-paying students and officially employed staff from noncard

carrying friends and relations who wished to "make the scene" and use the facility. To deny "nonpaying students" (as they became officially labeled) the private music lessons for which they had enrolled or to maintain that a graduated student had no further legitimate claim on scarce Institute resources (such as electronic music studios or photographic equipment) was regarded by many faculty and students as an ugly breach of spirit.

Art scenes have long attracted itinerants, and the Institute was no exception; as word of the facility spread, members of its staff who were concerned with balancing its books and protecting its public image became increasingly concerned with what chroniclers of other utopian communities have called "the visitor problem." After the initial euphoric period when a dog was formally admitted with the rest of his communal "family" and librarians accepted beads or other personal pocket items rather than library cards in exchange for books, recognition of any form of community membership which eluded bureaucratic channels of accounting was officially discouraged. The fact that some faculty, rejecting the role of watchdog, felt morally committed to "share the tools with those who could use them" in a rehearsal for a new propertyless communal age, and that this idealization of openness and sharing left an institute housing lavishly costly equipment vulnerable to theft, ensured that the "visitor problem" became linked to the "rip-off problem." Neither was a problem for many faculty, though, who while enjoying their new-found comfort as organizational employees recognized certain kin obligations to poor relations who continued to make their living and their art outside the shelter of academia.

The anticipation that work at the new Institute would be almost indistinguishable from play (an anticipation which helped make the place a mecca for those seeking the "free life") can be gleaned from the Bacchanalian tone of an administrative memo sent to each of the deans before the school opened:

> . . . could you start sending into my office immediately specifications on what each member of your staff already accounted for will be doing, that is, will he be offering a series of non-matrixed inspirations, festivals, orgies, whatever.

That the anticipation was to some extent born out, the following recollection of the Institute's first year testifies:

> From an administrative point of view, it was a catastrophy. But there was a spirit there which will never be recaptured. When one of the art classes had an orgy the story of it went to New York City. It just

seemed logical to have orgies in a class like that. There was a total involvement—a remarkable togetherness, a love there which I've never seen in an institution before. It had to become physical.

That early period was later remembered with nostalgia as one in which activity yielding neither a polished product nor performance could be justified as "process" (or simply as fun), and in which an aesthetic stressing that "art"could be found in life rather than in production located people's value to the institution as much in their "beauty" as in their successful performance of specific tasks. In fact, the value placed upon artful personal style influenced both staff hiring and student admissions. One administrative assistant later recalled:

When I got people hired in the admissions office I wasn't looking for typing skills! One guy I made them hire just cause he was crazy and beautiful. You see, I bought the dream . . . that you had to get people in who were nuts. Now those kind of people are no longer around.

And when we were recruiting students, they would have to have an energy source! It didn't seem necessary to see work to match. It wasn't a matter of them proving themselves. We admitted them on the basis of who they were. We'd say "we don't know what that student's going to *do,* but we do know he has to be here." We were meeting some strange, strange people.

Each school of the Institute had its members who were "beautiful" or "brilliant" but "impossible"—who did "everything except what they were hired to do," who were loved and admired and eventually regretfully fired.

Many colleges have their pranksters and urban Bohemias have traditionally included their life-artists—people less interested in producing art than in living artfully.[14] The modern conception of the artist's sacred office is replete with imagery of harlequins, court jesters, and fools, giving jokesters and artful troublemakers strong moral claims upon any arts organization. The resurgence of Dadaism during the sixties further legitimized a spirit of radical playfulness as the artist's most fitting professional demeanor and "worldly aestheticism" (the extension of art into life) as his true calling. Thus the Institute's most flamboyant members—its hipsters and its tricksters, its "beautiful people" who just "hung out"—often without any formal affiliation, appeared as the true heirs to its strongest occupational imagery and to one of its most honored professional traditions.

At first, realizing that their geographical location outside an urban center threatened to isolate payrolled artists and paying students from

their traditional fellow travelers, the school's planners hoped to provide a formal place for "crazies" and "picadors." Yet, the institution proved unable to afford much "irresponsible" playfulness. When trustees became offended by bare feet, nude swimming, and a faculty member's provocative strip at a Board meeting, and a shrinking budget forced administrators to cut their staff, the latter came to regard "crazies" who were "a joy" but "a pain in the ass" as luxuries the school could no longer support. And yet, paradoxically, this position heatedly defended by one administrator ("This school is my life and I won't have a goofball threatening my life!") could only erode the Institute's vanguard legitimacy. For in what had become the most honored professional tradition of the period, playfulness was taken as a sign of seriousness and "goofballs" were a "luxury" no school professing to be avant-garde could afford to be without.

The youth culture of the sixties, with its Dadaist put-ons and its rejection of the values of productivity and professionalism, was incompatible with the requirements of any bureaucratic or professional organization.[15] But the profession whose work was ambiguously close to play could not expel "freaks" without compromising its own mandate. The Institute's authorities soon found themselves in the unenviable position of having to distinguish professional playfulness from irresponsible fooling around, and of having to ensure that libertarian rhetoric and imagery, once having fulfilled its recruiting function, was not taken overly seriously.

VISION BECOMES "HYPE": ECONOMIC IMPERATIVES AND A PR STRATEGY

It was easy to establish the presence of
this institution. The press is very
receptive to bright dreams.
 Institute Press Officer

We needed a vision, but in the end it
was only an advertisement.
 Disillusioned Musician

Once its disparity from institutional reality could not be denied, the vision of an artists' Cockaigne became a mere public relations pitch. Even before the school opened, the initial optimism of its planners met with severe blows. The trustees' announcement that parts of the building program would have to be indefinitely postponed and the equipment budget cut for lack of funding, shattered the fantasy of unlimited financial resources which had underpinned so many other utopian projections. The imagination of "open sharing" in a "community of the arts" which

transcended disciplinary boundaries had—like other utopian conceptions of the sixties—assumed a "post-scarcity" situation. In a struggle for scarce resources, traditionally defined disciplinary membership, coinciding with bureaucratic fiefdoms, became reaffirmed as the effective basis of occupational kin ties.

An even greater blow to the artists' fantasy of omnipotence was delivered when the Board of Trustees refused to hire Herbert Marcuse—at the time an international symbol of political radicalism—for the Institute's School of Critical Studies.

The blocking of Marcuse's appointment eroded the artists' faith that they had their politically conservative funders "under control" and revealed the limitations of their project to combine aesthetic and social radicalism in an avant-garde institution. Yet, exactly at the moment when it began to appear doubtful whether early visionary projections would ever be realized, the Institute's administration attempted to strengthen their position and to "establish the school's presence" by amplifying its innovative image in the news media. As the school's public relations officer recounted:

> There are two ways to raise money. Either through quiet fundraising—dedicated trustees, meetings, letters, proposals—or through more public promotional publicity. If you're going to raise money the second way, you're going to have to make strong claims. Yet it's generally recognized that there is a risk in loud public relations—the risk of building expectations so high that *nothing* can substantiate the promise. I saw that was a danger here, and I said as much. So when I was still told to get as much PR as possible I saw what the situation was: I realized *that* was what we were going to depend upon.

Reminiscing about her own first days at the Institute, another member of the staff who had participated in the collective dreaming remarked, "The Elysian period of this job was the period when we all *believed* what we were saying." As the production of inspirational rhetoric became an economic imperative disengaged from "belief" and unaltered by revised estimations of the likelihood of its realization, those who continued to produce it as well as those who spoke of themselves as having "bought" it became more and more cynical. Not only had the transformation of utopian vision into hype made advertising artists of the visionaries who had aspired to impeccable professionalism, but in an organization in which there were to have been no ordinary jobs nor routine uninspired forms of commitment, work which could no longer be conceived as a mission became only a gig. And thus, the Institute which was to have hosted an

uncommon scene in the arts hosted a common one instead: beginning with tremendous hope and a dream of community, it revealed, after losing its charismatic legitimacy, an underlying ethos of individualistic hustling and offered a microcosm of the harsh competitive work worlds which it had once mirrored only in "corrected" dream form.

NOTES

1. On the concept of occupational ideology see Elliott A. Krause, *The Sociology of Occupations* (Boston: Little, Brown, 1971), pp. 89-91. For the analysis of specific occupational ideologies, see, for example, Elliot Freidson, *The Profession of Medicine* (New York: Dodd, Mead and Co., 1970); Ivan Illich, *Deschooling Society* (London: Calder & Boyars, Ltd., 1975); John McDermott, "Technology: The Opiate of the Intellectuals," *New York Review of Books,* 13 (July 31, 1969).

2. Raymonde Moulin, *Le Marché de la Peinture en France* (Paris: Editions de Minuit, 1967), p. 369.

3. For a discussion of the effect of a period of student activism and social criticism upon young students of medicine and law, see Barrie Thorne, "Professional Education in Medicine" and "Professional Education in Law," *Education for the Professions of Medicine, Law, Theology, and Social Welfare,* by Everett C. Hughes et al. (New York: McGraw-Hill, 1973), pp. 95-99; 125-27.

4. See Sigmund Freud, *On Dreams* (New York: W.W. Norton, 1952), p. 65: "Ideas which are contraries are by preference expressed in dreams by one and the same element. 'No' seems not to exist so far as dreams are concerned." I am assuming that the analogy (made by the participants themselves) between a collective "daydream" and an individual's primary process thinking *is* helpful.

5. Clayton Eshelman, "Who is the Real Enemy of Poetry?" *Los Angeles Free Press* (11 September 1970), p. 56.

6. Ibid., p. 56.

7. Renato Poggioli speaks of the avant-garde's "ideal of the tabula rasa" and its attraction to "the demolition job" in *The Theory of the Avant-Garde* (Cambridge: Harvard University Press, 1968), p. 96. Harold Bloom compares writers' ritual breaks with the past to an "undoing compulsion" in *The Anxiety of Influence: A Theory of Poetry* (New York: Oxford University Press, 1973), pp. 14; 77-92.

8. Mary Douglas claims that jokes have the opposite effect of rites: "They do not affirm the dominant values, but denigrate and devalue. Essentially, a joke is an anti-rite." "The Social Control of Cognition: Some Factors in Joke Perception," *Man,* Vol. 3, no. 3 (September 1968), p. 369.

9. Jack Morrison, *The Rise of the Arts on the American Campus* (New York: McGraw-Hill, 1973).

10. "Actually . . . the only omnipresent or recurring political ideology within the avant-garde is the least political or the most anti-political of all: libertarianism and anarchism . . . The individualistic moment is never absent from avant-gardism . . ." Poggioli, Op. cit., p. 97. For one of the best ethnographic descriptions of the "antiinstitutional" posture of the youth

culture, see Daniel Foss, *Freak Culture: Life Style and Politics* (New York: E. P. Dutton, 1972).

11. Vincent van Gogh, in a letter urging the foundation of an artists' cooperative, reported in Moulin, Op. cit., p. 481.

12. The phrase "multi-media" was used at the Institute to refer to the expansion or transformation of one art to the point where it began to resemble another or possibly a new art: e.g., mixing electronic sounds with film or developing "happenings" on the border between painting and theater.

13. Daniel Foss, a folk hero among the Institute's "freaks" and an ethnographer of Freak Culture, expresses this phantasy succinctly in *Freak Culture*, Op. cit., p. 198:

> In the post-industrial society . . . the individual will not owe anything to anybody or anything for any reason whatsoever . . . people may work extremely hard because they are into their thing; or they may hang around doing nothing; neither will be prized over the other. People will cease to have careers, but will have '—'bags" that they are into. People will not be "hired" for "jobs" but will work together with their friends. The concepts of "education" and "labor" as compartmentalized aspects of life will vanish.

14. Anselm Strauss notes that art schools attract young people seeking a haven or a moratorium in life, and that the boundaries of "art worlds" are highly permeable, including not only professional artists but people adhering to common aesthetic values. See "The Art School and its Students: A Study and an Interpretation," in *The Sociology of Art and Literature: A Reader,* cited by M. Albrecht, J. Barnett, and M. Griff (New York: Praeger, 1970), pp. 159-78.

15. Foss, Op. cit., p. 147. Foss describes the freak's feeling of being:

> hemmed in by any structure which is not entirely created by oneself; which means by any structure in which anyone else is involved; which means by any structure, period. The feeling develops that all formal hierarchies are alien impositions which mutilate the self and disrupt the desired free flow of consciousness; they are somebody else's "trip".

Chapter 6

LAYMEN AMONG ARTISTS

And don't call me a businessman! I'm a
frustrated artist.

Trustee—in response to heckling at an
Institute convocation

Like other professional organizations, one developed to sustain
aesthetic activities requires the ancillary services of many
nonprofessionals. Studies focussing on the role of lay opinion in shaping
artistic practice have concentrated almost exclusively upon artists'
accommodation to patron and audience demands. But this by no means
exhausts the categories of laymen whose sustained cooperation may be
essential for the production of art—especially as complex formal
organizations play an increasingly important role in such production. The
laymen who in moments of ritual deference affirmed their dedication to
furthering and "supporting" the artistic work of the Institute ranged from
the school's trustees to nonacademic administrators, academics teaching
the humanities courses necessary for the school's accreditation, secretaries,
librarians, and security guards. While those groups differed greatly in their
mode of participation in Institute life, their relationships to Institute artists
displayed certain common themes.

All were formally committed to "serve" professions possessing a potent
mystique and characterized by highly ambiguous boundaries of

membership. While acknowledging in principle that the practice and teaching of the arts was the Institute's supreme goal and facilitating it the aim of their own work, many of the laity remained in a chronic state of barely muted insubordination when it came to recognizing certain of their coworkers' activities as "art." In occupations whose practice requires no formal licensing or certification and affords a livelihood to very few, the distinction between amateur and professional status is fragile and vague. Even Institute faculty disagreed over credentials and threw doubt upon one another's professional claims. When trustees and nonacademic staff criticized student and faculty work, some of them felt they did so as fellow artists, not as laymen, though they learned to be cautious in expressing this sense of colleagueship. A few had been highly successful in commercial arts disdained by the faculty; others practiced one of the arts as a hobby, or had worked as artists during an earlier period of their lives until age or family responsibilities forced them to find financially secure employment.

But the blurriness of the distinction between the Institute's laity and its professional artists can be attributed as much to the cultural idealization of art as a constitutively human activity as to the artistic experience of those not formally employed as artists. In a subculture idealizing aesthetic activity as man's highest calling and artists as (more than superior craftsmen) superior human beings, the distinction between professionals and laity *cannot* be rigidly exclusive lest it sever anyone from his potential more perfect humanity; rather, being an artist must be seen as a matter of *degree*—which was precisely the view adopted by Institute laymen who preferred to refer to themselves as "never having been brilliant artists" rather than to abandon all claim to the title.

Many laymen shared yet another experience: having in a sense come to the Institute to pray, they found they had stayed only to be mocked. If art in Western culture has inherited some of the "spiritual," redemptive significance of religion, the Institute's initiates and "priests" (particularly those considering themselves avant-garde) distinguished themselves from the laity by playing in the temple and ridiculing the earnestness of those who wished to worship. Art's auxiliaries, many of them attracted to the Institute out of a desire to participate in their own way in fine and serious activity, found that it was exactly their belief in "culture" which marked them as outsiders. If anything, Institute artists expected true peers to be decently *un*cultivated," as the following remarks by one of them suggest:

> Who goes to concerts? Only the consumers! School teachers, insurance salesmen, accountants—they go to concerts, art shows, etc. Artists make their art. If they have a friend who's a poet, they read the poems when they're given a book. If their friend is a

composer, they go when he has a concert. They do not have season tickets to the theater. They are not cultured people! They are not art lovers! The broadly cultured person, that's the school teacher! *They* are "interested in" things. Most of *us* are too goddamned busy making what we make.

Another observed that the very words "art" or "artist" would "bring out the cold grue" in him. The tendency to regard a reverential attitude towards "art" as essentially philistine posed a compound problem for the laymen who needed to exalt the profession they were expected to "serve." They wanted to view artists as spiritually gifted, morally deserving, but otherwise rather helpless types who might reflect well upon the more worldly persons whose good work supported them. Yet, as much as the laity wished for models of cheerful discipline and struggling creative effort to inspire and shed grace upon their own labor, they as often found (in some arts more than others) "workers" whose performances "inspired" only indignation and whose occupational values and demeanor seemed to mock their own.

In effect, the Institute contained two distinct work cultures. Members of each of them attempted to "educate" those of the other in the proper fulfillment of their role, the Institute's artists engaging in such border skirmishes with particular intensity. But although they defined the bounds of colleagueship narrowly and attempted to impress "outsiders" with the importance of deferring to professional authority, they were unable to prevent their "illegitimate" critics and unavoidable audience (the trustees, secretaries, and security guards whose services they required) from subverting some arts and facilitating others on the basis of their own judgment.

"REAL WORK" IN STUDIO AND OFFICE

The layman's indignant exclamation when confronted with a contemporary work of art that a child could do as well has become a clichéd joke of modernist lore. Institute laity displayed this reaction on occasion, and were invariably informed that the professional quality of the work they thus criticized was only visible to other professionals. But if the artists' work sometimes looked like child's play to the laity, office work was regarded as similarly unreal by the artists, who viewed those connected with it as "weird" and "strange." When budget cuts became necessary, artists suggested that the administration be virtually eliminated and that they and their students take on the few administrative tasks which were indispensable; the underlying assumption of such a suggestion was that

most paperwork was unnecessary and that "anybody" could do it. The very materials (paper) and procedures ("going through channels") of bureaucratized clerical work symbolized for some artists a corrupt way of life which they could only guard themselves against by systematically undercutting its pretensions to seriousness. They joked about "playing committee" during meetings which administrators regarded as important (or failed to attend altogether), refused to communicate through memoranda (one of them insisting, "If I have something to tell someone, I *talk* to them!"), scrambled the titles on office doors, and mocked bureaucratic procedures (i.e., sending food through the Institute mails in order to complain about the cafeteria "through channels").

Lay administrators were defensively sensitive to any suggestion that their work, compared with the artists', was trivial, necessarily unsatisfying, or insofar as it was seen to be less "free"—degrading.[1] As one of them explained:

> One of the discouraging things about working here is the attitude many people have toward the "paperpusher." Perhaps because I've been a deskworker, I have a healthy respect for the work accomplished in unglamorous spots in an organization. Many academic and artistic people feel that there is no possible way to enjoy a job that isn't truly creative. They don't *try* to make you feel inferior; it's not *conscious,* but if pounding the typewriter doesn't turn them on, then they think it's degrading. People walk into my office, and I can tell they are actually surprised that I am as delighted by what I see outside my window as they are. They tend to assume that deskwork gives you tunnel vision—that I'm *tied* to this, and that no one in his right mind could have chosen it.

The conception of artists as a "natural aristocracy"—at least as old as the nineteenth century—and the assumption that they alone freely unfold themselves within their work and truly enjoy it, remained alive in some sectors of Institute culture; the artists were "ennobled" by the presumed contrast between their "free play" and others' toil and the status of their work, mystified as a "natural" superiority of the worker. The deskworker cited above, for example, ended an interview with the following admission, "It's in all of our natures to feel slightly inferior to the truly creative person. You have to admire and respect creativity—be jealous it isn't yours. I've always believed that the true aristocracy is the aristocracy of creativity."

The symbolic equation of artists with aristocrats and their comparable lack of integration with the industrial work world, suggested moral laxity and parasitism as well as purity and "superiority." And at least in part, the

conflict between the Institute's artists and its lay administration represented a clash between an industrial and preindustrial labor force, with the issue of "work discipline" a paramount one between them. The artists, most of whom came to the Institute with a history of only fleeting, irregular contact with bureaucratic work organizations, could be exasperatingly "irresponsible" from an administrator's point of view. They did not keep time by the clock, were chronically late for appointments or forgot them altogether, kept an irregular, unpredictable work schedule (i.e., working all night and being visibly absent during the day), forgot to sign their contracts and were, it seemed, unduly suspicious of the most routine bureaucratic procedures. In an indulgent moment one administrator avowed, "These people are so interesting that it is even a pleasure to nag them!" But for the most part, members of each group were mildly embarrassed by the sheer physical bearing and symbolic environment created by the other.

The costume and demeanor dictated by one work culture communicated "looseness" and those of the other, crisp, "tight" self-control; the artists violated canons of white-collar respectability by ritually polluting the workplace with orgiastic sexuality and its symbols, while the laity offended the artists' ludic ethos. For the Institute's white-collar workers, cleanliness was associated with disciplined productiveness, and an absence of concern for maintaining it was interpreted as a sign of slackness. To many artists, on the other hand, a pristine work setting suggested sterility. Thus, the "order" which ritually set the stage for productiveness in one work culture was interpreted as an inhibiting "disorder" by members of the other, who wished accordingly to secure the reign of their own order against its incursion.

Looking for models of supreme professional "dedication" and disturbed by apparent absences of discipline, the lay staff favoured those arts which demanded organized cooperation and formal scheduling and whose performance was highly visible. They praised the dedication of Institute dancers, whose work, in addition to being physically demanding, was collective and imposed hours similar to those of the clerical staff. Classical musicianship found favor for similar reasons: the expertise it demanded was immediately apprehensible to laymen and publicly "displayed". The inseparability of the worker's person and "performance" from his product—that is, the ritual nature of the concert—in addition to the cultural conservatism of the social strata supporting such music, dictated a style of dress and demeanor unlikely to offend office workers. Finally, the organizational imperatives of a performing art—the necessity, for example, that all players arrive at rehearsal on time—made this group of artists unreceptive to the philosophical anarchism cultivated in more

individualistic crafts and fostered a concern for order, promptness, and rules which better harmonized with bureaucratic values. In short, the arts most likely to be credited as "real work" were those which not only bore the greatest organizational similarity to the administrator's own, but ritually affirmed the values of industrial work discipline.

The laity showed the greatest discomfort with arts which did not require easily recognizable physical expertise and whose performance—unpredictably scheduled and carried out in individual isolation—was less visible and seemingly less "disciplined." Administrators remarked with resentment that painters and conceptual artists spent fewer hours on the premises than did faculty in theater or dance, and insinuated that at *that* rate of pay *they* would certainly like to teach art. While the work of the Institute's composers was less provocative than that of its conceptual artists, it was even less visible and equally unroutinized. Claiming that "you can't schedule something like this," some composers met with their students only when there was completed work to discuss, and were as likely to be found in the music studios between 2 A.M. and 6 A.M. as from 9 A.M. to 5 P.M. Working in isolation and demanding little more of others than that they be left in peace to "play" with readily available equipment, they were among the staunchest defenders of both aesthetic and organizational anarchism, explicitly arguing that while organizational chaos might waste energy, it was also fertile and preferable to the establishment of stultifying, formal regulations. A few, like some of the conceptual artists, insisted that their "work" found its entire meaning and justification in its own "process" rather than in any "product" or outcome, and in thereby eliminating from that "process" even the anticipation of a future audience, they willed their isolation complete.

Nothing could have been further from the orientation of the laity who were concerned not only about Institute artists' visible "productivity"—with the "usefulness" and even "saleability" of their work—but with the "employability" of the Institute's principal "product," the students who would emulate their teachers' attitudes. (The fact that employment opportunities for composers are negligible and that the occupational attitude just described might represent an understandable accommodation to this fact did not prevent laymen from being disturbed by a shameless confounding of work and play, nor did it prevent their anxious suspicion that such attitudes were the "cause" of artistic indigence.)

From one point of view, all aesthetics can be seen as conceptions of an ideal mode of work and of its outcome, and all tend to merge with wider systems of belief reflecting an entire way of life. Classicism, with its apotheosis of harmony, order, discipline, and control, or romanticism, with its adulation of the spontaneous, the irational, the disordered and the

"unfinished," encouraged and legitimized not only certain qualities of art, but particular ways of working and of living. A vanguard aesthetic stressing the value of the unpredictable and the unplanned, the primacy of artistic "process" over "product," and the interpenetration of art and life, had organizational consequences: artists committed to it attempted to resist any routinization of procedure in the new Institute. On the other hand, the occupational culture of bureaucratic administrators contained an opposing aesthetic with its own norms for judging styles of work and workmanship.

ADMINISTRATIVE JOBS AND AESTHETIC DECISIONS

To the artists' exasperation, though it was patently *not* the nonacademic administration's task to make aesthetic decisions, in the course of doing "their job" they made many of them. Responsible for fund raising as well as for the physical maintenance and protection of facilities, the administrators regarded many of the Institute's professionals as jeopardizing the very life of the organization they attempted to protect. As members of nearby business and community associations, they were more concerned than the artists with enhancing the school's local reputation by encouraging "appreciated" entertainment and preventing violations of local sensibility;[2] faced with the task of "selling" the Institute to potential donors as well as managing the "appearance" it presented to existing ones, they became sensitive to the artists' "presentability," even rating them for their serviceability on fund-raising campaigns.

> We could never take X downtown; you could have him to somebody's house with a small group, but you could never take him to any establishment place downtown. Y and Z were really the most presentable . . . and W, you wouldn't have taken to a dog show! You could *never* have presented W to the public!

If they regarded the artists with apprehension as unreliable actors in the show it was their job to stage, their care for its backdrop led them even more directly into areas of aesthetic judgment. They not only threatened to remove "offensive" displays from Institute walls, but attempted to assume a positive responsibility for interior decoration by picking "suitable" art for the school's public spaces. Similarly, while they made no effort to disguise their disapproval of some theatrical productions, they actively attempted to sponsor work which they did favor.

Just as administrators favoured "presentable" artists, they liked the "presentable" (and saleable) arts, ones easily shown and "talked about." One of them explained:

We've raised more money for music than for any other school because it's the school one can talk about without touching upon controversial subjects. As long as it's not all Bartók and Hindemith, it will continue to flourish. People are anxious to be publicly and visibly associated with the School of Music. Now as for film, you can't show half the films to Mrs. Gotrocks. Dance is fine. We've been able to get money for dance 'cause it involves hard work, craft and discipline. But I don't know what to tell people about the Art School—you sure can't talk about "beauty" anymore.

Though administrators appeared to share the aesthetic taste of the people among whom the Institute sought financial support, their orientation was at bottom a pragmatic one. They would have supported any art which facilitated fund raising. As nonprofessionals, *their* show was still for the public; if they adjusted it insofar as they could to audience taste, the social composition of their audience was beyond these impresarios' power to change.

If administrators' anticipatory sensitivity to patron taste made them appear to the artists as representative philistines, other lay personnel's routine responsibility for protecting and maintaining Institute facilities was an even more significant source of bitterness as suggested by the incensed helplessness of the following account:

The security staff thinks they own this place! They rip down the kids' work. Last year, one of them took a piece off the wall because he said it was a fire hazard—said we couldn't hang anything unless it was approved. They treat people rudely. One of them goes around asking people to pick up their crap in the studios. And that weird little creep who sees everything as a fire hazard! I told him, "Didn't it ever occur to you that this is an art school?" He just said, "It's a fire hazard!" A lot of changes had to be made because of this little creep with the fires.

Insofar as many artists came to the Institute primarily in order to take advantage of its technical facilities, the lay staff's concern with "security" and their tendency to try to protect the facility *from* the artists placed them in a very sensitive position. Especially in disciplines such as film or electronic music, the power of a secretary who kept the keys to the electronic music studios or the projection booths could be considerable. Faculty complained of secretaries who "opened doors" for some students and created difficulties for others whose professional purpose or demeanor they regarded with suspicion. Since a freakish, ragged appearance was

widely cultivated in some disciplines, they argued that secretaries were, in fact, deciding not only which students but which artistic disciplines "deserved" the most coveted work space and equipment.

On the other hand, from the staff's point of view, the undeniable occurrence of theft and damage to equipment provided evidence enough that there were many artists who could not be trusted. In indulgent moments, staff members spoke of the artists as "irresponsible" but fascinating children who had to be gently trained. A secretary, for example, described her job as:

> not that different from being a housekeeper or a mother—just more children and more rooms to clean and everybody's little needs and demands. The faculty aren't that different from the students. It's interesting how impatient they are. Demanding instant gratification. We've even had our tantrum hours. But most of them are broken in now. The tantrum-makers gave up when they couldn't get results.

As this quotation indicates, the very techniques some of the artists tried using to control the laity led to their being perceived as infantile. The "tantrums" whose ineffectiveness this secretary stresses were reported with pride among faculty and students as occasions on which a particular teacher "threw a beautiful artiste scene." Thus, the same behaviour interpreted by the laity as signalling a childish loss of control, was cherished by some artists as a fine old occupational tradition which only a master would dare attempt.

But while stories of such scenes were repeated with relish (as were reports of administrative reaction to love-making in the music practice rooms), the artists were *not* as sanguine about their success in teaching the nonartists to "know their place" as the laity were about their corresponding educational efforts. The lay staff could not even be regarded as redeemingly "interesting" people by whom it was a "pleasure to be nagged," but only as exasperatingly close representatives of an imperfectly comprehending "square" world.

PATRONS AND BROKERS

The Institute's trustees, apart from a few individuals functioning directly as patrons, consisted mainly of brokers seeking other people's money (abbreviated in the argot of their subculture to o.p.m.) for the artists and protecting it *from* them. Without substantial funds of their own, they mediated between the artists and actual or potential sources of funding among the local rich. As emissaries and connecting links between mutually

suspicious social groups, they alternately regarded themselves as having to "protect" each of them, and were subject to embarrassment by their association with each when in the presence of the other. Thus, when on campus some of them expressed a wistful admiration for the outlandish "elegance" of students who they would not dare to introduce at a fund-raising party, tried patiently to explain that the dress and demeanor affected at the Institute would not be acceptable "out there," and took distance from their own conventional dress by calling it a "costume for raising money in." On the other hand, they reported feeling embarrassed by student "slobbiness" when they brought friends and potential donors to visit the school.

As far as the Institute's artists were concerned, fund raising was the trustees' sole legitimate function—the ideal trustee, from their point of view, being one who was involved enough with the Institute to be motivated to get money for it, but not enough to pose any danger of interfering in its life. Though they frequently spoke of the necessity of "educating the trustees," the aim of such education was to prevent any trustee claims to aesthetic authority. In fact, trustees with professional experience in either the music, film, or art industries were looked upon with greater suspicion by artists working in these fields than by faculty who could rest more assured of their lay status and "disinterested" concern.

In contrast to the faculty view of their role, however, trustees resisted any attempts to define it in purely financial terms. Some spoke of a "division of labor" on the board between those principally engaged in financial management and those helping to formulate educational policy; but even the latter professed belief in the "rights" of patrons to have a "say in what they're paying for," and all defended the notion that their aesthetic judgment, the ideas they brought to their job, were as important as the money they were expected to provide.

Stressing the importance of a patron's "vision," one trustee cited the Florentine Medici as a model of the "power generated by a patron's understanding" and, in so doing, revealed a nostalgia like that of many of the artists for earlier aesthetic institutions. The personal relationship between patron and artist, the former's sense of direct, educated participation in the artist's work, and his opportunity to exercise and display his own taste through the provision of material support, passes into the hands of administrators in a bureaucratized arts organization, while the patron's role, compared with the fifteenth-century model, becomes specialized and impoverished. In a sense, the trustees of such an institution provide support not only for its artists' work, but for its senior artists' patronage, for it was one of the latter whom I observed paternally stroking an artist's beard and referring to a member of "his" faculty as "one of our jewels."

TRUSTEE TASKS AND TRUSTEE AESTHETICS

To feel comfortable raising money for the institution, trustees needed to "believe in it" themselves. Their job was to inspire others with "belief" by displaying their own enthusiasm and this task of "selling" the Institute shaped their perception of it. Though they needed to be able to convey the impression of knowing dedication in order to represent the organization for fund-raising purposes, their sources of information were actually quite limited, newspapers and magazines featuring strongly among them. Upon the Institute's opening, administrators invited the attention of the news media in the hope that favourable coverage would help them secure the confidence of the trustees, who in turn regarded such coverage as an important aid in their own task of raising money. But reporters' need to formulate news as stories imposed its own structure upon the view of the school which they communicated. Unconventional styles of dress and deportment received a lot of attention as sources of easy imagery; "incidents", particularly any which could be related to a myth-worthy battle between "conservative trustees" and "radical artists" were repeated in story after story for their dramatic value. In short, press narrative was quick to identify and focus upon crises, and trustees came to view Institute personnel and activities in terms of the risk they posed to the Institute's media "image." Like irresponsible children, the artists seemed always on the verge of "misbehaving" in ways which could cause trouble for the brokers who had to secure their support.

The paternalistic theme of the artist as child was reiterated by trustees as much as by the lay staff. Like parents, they were expected to provide support in exchange, at best, for diffuse respect and a relationship which would make them "proud." Like children, the artists often appeared to them as ungrateful, unconcerned with the problems involved in getting the money they were so imaginative in spending, and unreasonably demanding. More than one trustee compared them to "kids in a toy store who naturally feel they have got to get everything." When members of the Board wished to praise one of their peers—or the Board as a whole—they invariably used the word "dedicated"; the virtuous trustee was one giving the impression of tireless and selfless dedication to the welfare of the organization. And like other lay personnel, they sought evidence of similar qualities in the artists, only to be appalled by what they termed the artists' "egotism."

The kind of problem which artists accustomed to a bohemian work setting and oriented towards its freedoms and social controls can create in an academic work setting can be gathered from the following account by a member of the Institute's theater group:

A lot of theater people are crazy. Like X—he can do anything! He's priceless. He's also an alcoholic. But he's brilliant. Now, in the theater he wouldn't be any problem—but when you're running a school, it's different. In a small theater group you know everybody— you work things out, and you can say "do your job or you're fired." But in a school you have *contracts!* You can't replace people easily, and you can't say, "if you show up drunk once more this week you're fired!" All of a sudden these people have contractual privileges rather than just personal dealings. In the theater it doesn't make any difference what you do when you're not working. You can do your job even if you've been bailed out of jail the night before—the audience doesn't know. But in a school, there's no way to keep students from knowing—personal things get in the way of what's going on.

Insofar as they considered Institute faculty to be "hired hands," trustees were concerned that the organization get an adequate return for its money in labor time. And like the lay administrators, to whom they implicitly delegated responsibility for overseeing the artists' work discipline, they sought reassuring examples of dedication in the most visibly performed arts, among people who, as one trustee phrased it, "play eight hours a day on the piano or dance until their hearts come out." In accord with the philanthropic tradition which emphasizes the importance of "helping those who help themselves," artists were expected not only to show some degree of gratitude and respect in exchange for their support, but also to provide evidence of moral worthiness. Because their work produced little certain exchange value, the discipline with which they carried it out became a crucial measure of its merit. Should the artists prove ungrateful and—if not really "working"—unworthy, patrons would be cast as servants to their wards, working to support the latter's play.[3] In short, if the artists were not "serious," the gift-givers would appear to have been "taken."

Trustee philanthropy exhibited a rhetoric of patriotism and service to society—a concern with the social integration and *usefulness* of art— which was disagreeably alien to Institute faculty. Among some the concern with social purpose took a Saint-Simonian form, with the artist cast as a new prophet and industrial leader. Other trustees, particularly those holding management positions in commercial art industries, adopted an adamantly practical view, regarding the Institute as a potential spawning ground for "new talent" and insisting upon the importance of sponsoring a nonesoteric, "serviceable" art.

The artists' occupational mythology encouraged them to regard trustees as cultural conservatives standing as an opposing brake to their own

artistic radicalism and innovation. And yet, while the organizational integration of the art occupations envisioned by some of the trustees could be traced to an impulse towards "vertical integration"[4] in the culture industries which they managed, there is no reason to believe that such integration would be less fertile and stimulating to cultural innovation than the kind of "cross fertilization" of disciplines the artists liked to call for. Trustees favored bringing "under one roof" both the so-called "fine" and "commercial" arts—arts whose production and distribution systems have been hitherto segregated and whose participants have little contact with one another: fashion design, magazine illustration and avant-garde painting, rock music and classical music, underground cinema and Disney style animation. But the artists, though repeatedly announcing the collapse of disciplinary boundaries and calling for "cross-fertilization," implicitly addressed such appeals to a tribe of "fine artists" whose endogamy was taken for granted. Interested only in integrating disciplines which were equal in status, they heatedly opposed the integrative impulses of culture's industrialists (their patrons) with an insistence upon the strict segregation of occupational castes. Since aesthetic innovation is likely to be spurred by changes in the artistic division of labor, such concern to protect their occupational status from the threat of unseemly association placed limits upon the artistic developments which could be countenanced at the Institute—just as it does elsewhere.

PERFORMING FOR THE TRUSTEES

While trustees scrupulously avoided any attempt to impose their own taste upon Institute art (showing to this extent, that they were "well-disciplined" and willing to defer in principle to professional authority), their work created an implicit aesthetic which appeared far more objective and imperative than any merely personal predeliction. Judging the Institute's performance in terms of its financial solvency, its capacity for attracting funding and customers, and its visible "productivity," they criticized Dadaist gestures as an inappropriate substitute for recognizable artistic "work" and favored disciplines which facilitated fund raising by yielding visible, presentable (and ideally portable) results. They found the most useful aides to their work in the classical musicians who could perform indubitably established pieces at board meetings or in trustees' homes, and to whose off-campus concerts they could invite prospective donors without risk of embarrassment. The strikingly "performed" aspect of classical musicianship and, above all, the continued cultural viability of traditional repertoires, made it easy for the Institute's Music School to gain trustee confidence. Consequently, its power within the Institute grew as other disciplines and their administrative protectors fell from favor.

The visible political advantage held by a discipline in which pieces fifty years old are still labeled avant-garde inspired one painter to the rueful remark: "If only we had a way to copy Rembrandt and show that to the trustees!" The abstract nature of musical communication and professional legitimacy of nonprovocational work made it possible for the musicians (in the words of one of them) to "render unto Caesar what is Caesar's," tactfully accommodating the trustees while maintaining their professionalism. Criticising other sectors of the Institute for championing work which seemed designed to give offense, they implicitly appealed to the parent-child metaphor of trustee-artist relations, saying, "When your Mama comes around, what you want to hurt her for?"

Yet despite the suggestion in such a comparison that it was only necessary to exercise tact during occasional "parental" visits, by the end of the Institute's second year members of all schools believed programs were modified in directions calculated to secure trustee goodwill. Classical musicianship, for example, was strengthened at the expense of other parts of the music program (avant-garde composition, ethnomusicology) originally praised as uniquely innovative but less geared to popular public performance and more likely to resist organizational routinization. Similarly, in the Art School the weight of financial support shifted from a conceptual art program (which had played with the ambiguity of the boundary between art-making and living) to a traditional painting program yielding recognizable "products." And the Theater School, having initially recruited faculty with the promise that they would be free to devote themselves to "research" with colleagues, placed them under increasing pressure to offer evidence of accomplishment by mounting polished public performances. Even more to the point, faculty in all programs who had adopted a Dadaist attitude of playful defiance toward bureaucratic forms and authority as they came to be regarded as a luxury the Institute could no longer afford were fired.

LEARNING OPPORTUNITIES AND PERFORMANCE RISKS

As pressure to "perform" rose, some faculty noted a contradiction betweeen performance and educational considerations. Conceptual artists complained that their students were not asked to show work in the school's most public spaces:

> Only the painters were alerted about having a show. Paintings *look good.* This is what comes out of trying to make this place a show case for the public rather than a learning institution. There's the idea that the work in the gallery is what visitors are most likely to see, so let's

keep the showy stuff there. This makes the students in conceptual art feel like second-class citizens. The school could almost have as its motto "Don't offend!"

Musicians admitted privately that voice students could probably spend their time more usefully singing in small groups than in the choir which, though they were pressured to join it, contributed less to their professional training than to the Institute's public relations. And members of the theater faculty observed that they feared the risk involved in allowing acting or design students to experiment. As is the case in training for other professions, the pacing of learning opportunities was not simply structured by a student's formal advancement towards a degree, and an instructor's desire to provide students with learning opportunities had to be weighed against the danger a neophyte might pose to the school's image.[5] As a member of the theater faculty phrased it:

> [Theater] students know what we think of them from the amount of responsibility we've been willing to give them for a production. The way it is now, if they're good, they'll get a chance—for example, to design a set. But it's not recognized that they have a *right* to a chance. Just because a student is a graduate student, he wouldn't necessarily get a design opportunity. I have one student who got his degree and never designed a show. He was bitter about it, but we didn't feel he was ready to take on anything major. This is the way it is in most colleges. After all, why should a director, up for tenure or advancement, take a chance on a student designer? But I had hoped it would be different here—that we would take chances on a student— make them work in their weakest areas. After all, what are we doing the productions for? Just to say "Five trustees came to my show?"

In the presence of an audience whose satisfaction was crucial, the Institute could not be regarded as a refuge in which student and faculty experimentation would be freed from the constraints of the professional world. Rather than compensating for anticipated limitations in a student's post-graduate experience, Institute education began to reproduce these limitations. As one disillusioned member of the Theater School remarked:

> The whole place was to have been built around the idea of *not* doing something to please an audience. But now we're playing for the trustees—for them to come and be happy with what they see—not even for the newspaper critics. And there is too little opportunity to fail at things. When you're trying to train people, you should cast a

play in ways where people have to struggle and learn—cast it so that people can try something they might never have another opportunity to do. But if the most important thing is doing a show so that an audience can see it and will like it, then people only continue to do what they already know how to do. Now we're told that it is good for acting students to recognize that they are best at playing a certain kind of character and that they can be successful if they learn to play it fully.

RETREAT TO PROFESSIONALISM AND THE "REAL WORLD"

By the end of the Institute's second year of operation a rift had developed between the school's principal backers and its chief academic administrators. As the Institute's laity firmly disciplined its artists, cutting their budgets (which meant firing personnel) and forcing them to defer to noncollegial opinion and desire, amateurism was ritually condemned, and "professional craftsmanship" rather than "vanguardism" became the new watchword.[6]

The artists most successful in winning the confidence of the trustees explicitly recognized that protestations of professionalism served as a defensive strategy:

> The only hope is to come on professionally and tell the trustees they know nothing about your work and shouldn't presume to tell you. Your only power is in professionalism.

Not only did a professional mystique promise to provide a minimal bulwark against lay intrusion into academic affairs, but in the face of budgetary restriction, a renewed emphasis upon the traditional core of each discipline at the expense of work with ambiguous disciplinary affiliation permitted each school of the Institute to maximize its internal solidarity in the interschool struggle for scarce resources. When money was tight, musicians became reluctant to use Music School funds to support programs once touted as stimulating work "on the border between music and art." This suggests that the strength of disciplinary ties (like kinship or ethnic ones) may fluctuate with economic change—disciplinary membership becoming more exclusively defined and professional identities more rigidly claimed when competition for scarce resources encourages the development of solidary political groups with unambiguous boundaries. (If so, this may help to explain why the North American vogue for interdisciplinary studies rose during a period of prosperity and expansion in higher education and declined when that period came to an end.)

Trustees, too, proved eager to reconstitute a working relationship with the Institute's academic administrators on the basis of the artists' explicit rededication to professionalism. For them, the term resonated with the promise that students would learn "saleable" skills of service in the "real world"—a term understood to refer to a world giving normative priority to the necessity of finding employment. Even more importantly, talk of professionalism reassuringly suggested a dedication to disciplined work, seemly deportment, and a serious attitude. In affirming their commitment to it, the artists had nothing to lose except the sense of fidelity to their profession's vanguard paradigm which demanded that they work playfully, rather than "acting serious," and take an ironic view of all professionalizing activity.

Many of the Institute's members believed—as their occupational mythology required—in an inevitable and irreconcilable conflict between "conservative trustees" and "radical artists." And yet there was probably much truth in the conviction expressed by one trustee that even the Institute's most unabashed "revolutionary" would have been tolerated if he appeared to be an efficient, "responsible" administrator, assuring disciplined "productivity" in his area.

Appropriately enough for a contemporary avant-garde, the lay criticism to which Institute artists were forced to yield was ultimately a formalist one; it was more the style and organizational forms in which many of them wished to work than the ideational content of their products which had proved unacceptable to the "bourgeois" upon whom they depended. However, it was exactly in the *process* of their work rather than its outcome that the prominent aesthetic of the period located its fullest significance. And we can surmise, to take a longer historical view, that as patrons once again employ artists, rather than simply purchasing their products, the former's taste in persons and in manners, in styles of work as well as in their results, will again assume an important role in the structuring of artistic opportunity.[7] That a seventeenth-century employer looked for manners appropriate to an aristocratic household while his twentieth-century equivalent is concerned with those appropriate to a bureaucratic setting is not as important as the fact that in both cases the artist's demeanor as well as his creation is subject to scrutiny, and that support for the work requires the marketing of the worker.

NOTES

1. Michel Crozier in *The World of the Office Worker* (New York: Schocken Books, 1971), p. 104, suggests that workers in hierarchical organizations may be defending status claims when they insist that they enjoy their work: ". . . the affirmation that they like their work constitutes, for higher-level

employees, a means of affirming their superiority . . . Members of higher-level categories received as a traumatic shock the news that their colleagues in lower-level categories were really interested in their work; this was the point whose significance they made the greatest effort to minimize . . ."

2. For evidence that academic administrators in other institutions tend to view the performing arts in terms of their "public relations" function for the organization, see Nancy Sullivan, "Today's Patrons of the Arts are Colleges and Universities," *University Affairs* (Ottawa: July 1977), pp. 2-4.

3. The fear of such an inversion of status honor can be gleaned, particularly in its last sentence, from the following portion of a trustee interview printed in the school newspaper:

> The students and the trustees are the two groups that give. The administration and the faculty are on the receiving end. I mean, they've got jobs at stake. The trustees, basically, are the only ones who give. What do we get out of it? I don't even get a parking pass. The arrogance of some person [suggesting] that these trustees . . . [should] not only continue giving but ber denied participation . . . as if trustees should be seen and not heard!

4. While the concept of "vertical integration" is usually used to mean the extension of one firm's control over all facets of production, I have used it in a somewhat looser sense here.

5. A comparison could be made here with nursing education, in which the provision of learning opportunities for the student must take the safety of the patient into consideration. See Virginia L. Olesen and Elvi W. Whittaker, *The Silent Dialogue: A Study of the Social Psychology of Professional Socialization* (San Francisco: Jossey-Bass Inc., 1968), p. 114. Even without concern for a new and financially insecure school's image, the provision of performance opportunities would have taken noneducational considerations into account. For example, faculty musicians, worrying that students who were not "ready to perform publicly" could damage their teachers' reputation in professional circles, audibly reminded themselves that in "school" people had to be allowed to make mistakes but joked about scheduling performances for midnight of Christmas Eve.

6. The fact that the supreme importance of craftsmanship was increasingly asserted as the artists were forced to recognize the power of the laity, supports Becker's assertion that the art-craft distinction can best be understood in terms of the extent to which the work is designed to be "useful," and the client, customer, or employer is the final judge of its appropriateness. See Howard S. Becker, "Arts and Crafts," *American Journal of Sociology* 83 (January 1978).

7. "Good manners" appear to have been crucial in determining a seventeenth-century painter's chances of obtaining employment in the houses of the nobility. See Francis Haskell's *Patrons and Painters: A Study of the Relations Between Italian Art and Society in the Age of the Baroque* (New York: Alfred A. Knopf, 1963), p. 7.

Chapter 7

TEACHING THE UNTEACHABLE

Those old masters could really do it to
you! When you'd try to measure yourself
against them and show them what you'd
done, they would look at it, tell you it
was garbage, cross it out and say, "*This
is how it has to be done!*" Then they
would immediately do something far
better. But nobody teaches that way
now.

Composer

Professional art educators must find ways of accommodating two
widely held convictions: (1) that artistic activity is an integral part of a fully
human life and that it is therefore the art teacher's duty to encourage all
students to exercise this birth right, and (2) that art cannot really be taught.
At first glance these two views appear to contradict one another: on the one
hand, every human being is an artist and has the right to be encouraged as
such; on the other, it is impossible to *make* someone an artist, though
anyone can be taught a craft. They share the underlying assumption,
however, that artistic power is to be awakened, recognized, and disciplined
rather than directly transmitted, and together they impede a strictly
professional approach to art education.[1]

EDUCATING THE PERSON AND SHAPING THE INSTRUMENT

Once the art occupations took on ideological value as symbols of a way of life organized differently from the dominant one, participation in them could be regarded as an avenue to full personal development. As one scholar writing about artists in nineteenth-century France noted:

> Youth did not visualize themselves as painters merely in terms of the work they did standing before the easel. Their very association with this type of work seemed to be. . . . an affirmation of the mythical free individual . . .[2]

The adoption of art as a vocation has often been understood as equivalent to a "serious" commitment to self-definition—a fact reflected in the merging of the genre of the "artist-novel" with that of the novel of adolescence[3] as well as in the "inspirational" tone exhibited by much of the literature on art education. The following passage may be taken as an example of the latter:

> The arts . . . have never been more indispensable to both the individual and to society than they are today. With its accumulated insights, its disciplines, its inner conflicts, painting (or poetry, or music) provides a means for the active self-development of individuals—perhaps the only means. Given the patterns in which mass behavior, including mass education, is presently organized, art is the one vocation that keeps a space open for the individual to realize himself in knowing himself.[4]

This mythology which regards the art occupations as privileged realms of free individualism, especially since it plays an important role in recruiting young artists, provides the backdrop against which the real problems of art workers and of those who socialize art workers take on their ironic significance. Contrary to lay expectations, these occupations expose their workers to some of the hazards of the contemporary work world in their most extreme form: the molding of the work and the worker to meet shifting market demand, rapid occupational change and the early obsolescence of work skills, emotionally crippling specialization and the treatment of the worker as an instrument. Rather than serving as a refuge, milieus in which the arts are professionally practiced and learned may afford particularly virulent forms of damaging work experience. At the Institute, many teachers were uncomfortably aware of potential conflict rather than harmony between their students' personal needs and their

professional training—a recognition which made the work of teaching more difficult by increasing its moral ambiguity.

At the simplest level, this awareness could make teachers hesitant to criticize work with which students were heavily identified. As one singer explained, "You have to be very careful about discouraging students, even if they don't sound good, because you know that may be all they have in life. They may *live* to sing, and you don't dare take that away."

At a more serious level, teachers sometimes feared that the process of professional training itself would prove to be personally crippling. Members of the theater faculty, for example, worried about the impact which acting methods involving psychological brinkmanship could have upon fragile adolescent identies:

> When you're casting a play it's not your responsibility what makes the actors the kinds of persons they are. If they can expressively torture themselves, all the better. They come in, do their work and leave. But you've got a different kind of responsibility for students and it's scary. We've got some very unstable, frightened, talented kids and sometimes I think this is the worst possible environment for them. They're put through intense emotional work, their feelings are being hyped up all the time. And you're likely to find that they either become so extremely attached to you that they want to live with you or so terrified of the things you've brought out in them that they withdraw completely and won't leave the dorm. "Bringing it out in them" is our work; but I'm not sure it's good for them.

And within the Music School, some faculty spoke with disgust of the chin scars and chest indentations marking musicians who had held a violin or cello since childhood. Such occupational stigmata, they implied, were only the outward signs of a more pervasive occupational deformation. When others argued for the importance of allowing neophyte performers to devote themselves exclusively to their craft, it bears noting that even their defense of specialization drew figurative comparisons between such students and valuable "instruments":

> If this school doesn't produce really top people in every field, we have no reason for existence, and you're not going to get great performers without specialization. The musician is the same as a piece of electronic equipment—you have to look at him as a human resource. We've got one student who is close to being a master drummer—but not if he begins to spread himself too thin. It would be a crime to distract him.

But the most thoroughgoing recognition of the fact that the processes creating potentially great musicians often create very unfree human beings came from faculty who had been brought to this painful awareness by self-reflection. Even without knowing the details of a student's or colleague's life, performing artists could make rueful predictions and guesses on the basis of their own personal history. Where virtuosity requires a substantial degree of commitment at an extremely early age (for string players, for example, by the age of six or seven), such commitment must take place before a person has the capacity for truly autonomous choice, and the artistry of the adult may be scarred by the very unfree childhood social relations in which it took root. Performers swapped stories of parental ambition and emotional tyranny, talked of finding themselves heavily committed to careers they had not really chosen, and of feeling so crippled in other areas of development that there seemed little to do but lean further on what had now become their single area of competence. As one of them reflected:

> As a kid you're terrified of losing your parents' love if you don't "perform." So you spend all your time practicing and never learn to feel comfortable with girls. Until at last music is the only thing you have. It's all that you *are*. And by then *everything* is staked on it.

Gossip about a colleague's divorce, about a singer who cancelled an engagement because of hoarseness or about a pianist subject to periodic bouts of arthritis, also included knowing innuendos about "artists' widows," "sleepwalkers" who "break up" when they wake up, and "robots" trying to retool and grow limbs where they have none. (This might be dubbed the "Pinnochio theme" of those arts which demand the occupational equivalent of child marriage. The drama turns around the moment when the puppet tries to become a person, and involves the question of whether he will be able to do so without breaking up the show.)

In short, while some faculty at least gave lip service to the idea that an initiation into art was the best possible initiation into life (an idea used to help justify a professional education which had little sure market value), others knew from their own experience that professional art milieus were not necessarily ideal sites in which to prepare for life *or* to live it. As one of them warned after stating bluntly that the self-absorption required of artists makes them "dismal failures as total people," "Any student who comes to study in this field had better already be prepared for life, because this is life at one of its hardest, most ruthless, and least forgiving points." A few teachers responded to the dilemma by disclaiming any interest in fitting students for the requirements of professional careers or even in

holding them to professional levels of craftsmanship. These were the musicians who did not care if their students practiced; the printmakers who were not disturbed by sloppy prints. Among *this* group art was primarily understood as playful self-expression and opposed to a spirit of polished professionalism which they rejected as less authentic.[5] But these teachers' lack of sympathy with the school's increasingly professional goals resulted in their being among the first to leave it and their leaving incurred the eventual elimination of this radical resolution.

INNOVATIVE ART AND OBSOLESCENT ARTISTS

When you're working at the forefront of
a field it's difficult to make judgements
about people's work. It's hard to predict
how a young composer will do especially
when you know that the "nonsense" of
today could be the art of tomorrow. A
fiddle player's teacher has a much easier
time of it. He can tell a student what he
has to learn with *conviction.*

Composer

Many teachers, while unambivalent about their desire to produce professionals, believed that the qualities which made someone a true artist could not really be taught. Nevertheless, arts relying heavily upon a stable craft tradition which must be painstakingly acquired permitted them to adopt an authoritative teaching role; they had only to concentrate upon imparting workmanlike *techniques* while hoping that their students' "creative powers" would be stimulated by their own example, the magic of the scene, or even by classes focussing upon "spiritual" development. As at the Bauhaus and Black Mountain, the Institute's most popular nonmetier courses were more inspirational than scholarly, the artists' preoccupation with creative potency making them easily receptive to mystical—or even magical—systems of thought which promised to help them find and tap new sources of personal power. But arts which undergo transformation at such a rapid rate that the crafts on which they were once based appear on the verge of being abandoned altogether pose more acute problems for the art teacher.

To be a teacher in a field in which the only reliable tradition appears to be the tradition of breaking with tradition is, in a sense, to be a teacher without a field, without any unified body of theory, without any guiding standards of practice which do not erode as fast as they can be established. As one art critic phrases the problem:

Beyond the quality of the teacher, there is the problem that art changes almost from season to season in outlook, concept, and even the materials out of which it is made. If the subject being taught could be defined, the matter of whether those who teach it are first-rate or second-rate might be less important. As it is, even if the quality of an artist's work is beyond dispute, an attempt by him to encompass each new move in the art world makes him, as a teacher, in effect second-rate, since only the inventor of the new move is first-rate in relation to it. (I would not have expected to learn much about the art of Andy Warhol in a class conducted by Giacometti.) Ambitious students are apt to be aware of this situation; no matter how distinguished the creations of their artist-teacher, they regard him as inadequate to impart the latest mode popular in New York. Speaking to a university audience, Jack Tworkov, then chairman of the Art Department at Yale, observed that the students in his department . . . scarcely listened to their teachers but derived their ideas from art journals.[6]

Or, as a dean of another art school put it in moralistic rather than analytical language:

The enthusiasms with which new movements in art are embraced and the speed at which they are used up in the colleges is an indication of a speedup in studio education which bypasses historical record in favor of current values. The significance of art historical record as a force in developing really new attitudes and in the recognition of qualities and quality in art is diminishing. Artists who are teaching are trapped by the *ab initio* syndrome, which really is an abdication of their powers of influence and leadership. They can see (perhaps because of their own careful scrutiny of the past) the way the present moves young students to increasing confidence in the infallibility of their own judgements. It appears to me that in this confusion of purposes art comes off badly and students emerge from this truncated educational experience as people who are literate only in their own terms.[7]

Or, as one Institute composer phrased it, again in a somewhat moralistic tone:

The speed with which new notations emerge goes faster and faster, so that now, with practically every new composer there is a new discipline! The new notation has fragmented to the point where

many years hence one may only need to mention that there was such a thing as harmony, and most of the student's time will be spent in new notational procedures . . . But a total break with the past is a mistake and cop-out. It just means the teacher is not willing to teach what he knows to the next person and give *him* a chance.

With no stable craft tradition, without a sure sense of what core occupational skills to impart, teachers find the traditional basis of their authority as masters of a craft greatly weakened if not altogether absent. Not only do they discover that standards in their field seem to erode before they can be securely established and that there is little common agreement as to their occupation's basic skills (is it necessary to learn to draw before taking a bulldozer into the desert to do "earth-works" or to read musical notes before learning to identify different electronic wave forms?), but the very definition of who is to be called an artist and what is to be dignified as art appears hopelessly arbitrary. In other words, they are teachers of a field in which one is hard pressed to identify who one's colleagues really are. As one teacher stated wearily:

> It's one thing to whisper behind one's hand that someone isn't a real artist . . . but to be so sure of the definition of a real one that one could actually point a finger and state the case in a very loud voice?! That would be hoping for too much. If someone claims to be a tap dancer you can at least ask him to dance. But if he claims to be an artist, who knows what to ask him to do!!

Market success, though unpredictable and determined by laymen, becomes the final arbiter of colleagueship, the final validation of a product as art and of its maker as an artist. The teacher of an advanced painting seminar, talking of a man whose exhibition piece consisted of masturbating under the stage of a gallery opening in New York, paused to say quite earnestly, "I don't know whether to call him an artist . . . but I guess he is one since he exists in the art world." Facing their problem squarely and seeing it to its logical conclusion, some teachers forthrightly take as their rule of thumb that art is anything an artist makes and that anyone who "makes it" is an artist.

The question becomes how to predict what directions art students eager to "make it" should follow, and market-predicting *does* inevitably become a prominent part of the teaching role. Unable to serve as a representative and enforcer of stable occupational standards, the teacher adopts a more passive relationship to them, becomes a kind of water witch or stock market analyst passing out hunches about the route to a professional validation he is unable himself to bestow.

Furthermore, given the rapidity with which fashions in art change, even those teachers who have themselves been successful are likely to be perceived as inadequate role models. A man of thirty-five can be honored nostalgically as a master of an earlier generation, a period-piece which, however worthy for its own vintage, would be utterly useless to emulate. Even if he has successfully established himself at thirty-five or forty, he appears to have done so in a world which no longer exists—a fleeting, evanescent world which his students will not be able to enter. The rules, the shibboleths, the routes, the very gateways to full occupational participation will have so changed since his own occupational entrance that he will be as little able to guide students as the dreamer in a fairy tale is able to lead his neighbors to the miraculous palace he fell upon only the night before.

The informal, loose structure of the art world has traditionally implied a shifting scene: yesterday's ordinary neighborhood café or bar overnight becomes a message center for a national or international occupational elite, only to become at some later date an ordinary café or bar again. And certainly young artists of every generation had to decipher for themselves the current location of "the scene": it would have been useless to move to Montmartre at a time when the most important contacts and exchanges were to be found in New York.

But if in the past "the scene" has shifted from generation to generation, during the last decade the life span of a generation of artists has been greatly reduced. The entire temporal dimension of career bets and career investments has been shortened. While, for example, a nineteenth-century painter could assume that it would be at least thirty years before his work would be judged important, the outcome of a contemporary painter's occupational wager becomes apparent much earlier. As aesthetic movements succeed one another in quick succession, each introduces a new generation of rapidly aging young men. Every occupation has its own age scale: a Wall Street lawyer or senator of forty is still young; a rock star of thirty already old. Artists ambitious to make a name for themselves in art history increasingly find themselves akin to the latter. Given the short time between the casting of an occupational die and the visibility of its results, artists no longer young in the terms of their occupation's calendar find themselves unable to interest dealers or critics in investing money and professional reputation in their work.

Nor, pressed to establish themselves early, are young artists likely to feel inclined to invest their own time in the development of skills which mature only slowly and with years of practice. Eager for cues to the latest developments, knowing that they have limited time in which to make a name for themselves, they will never find their teachers young enough,

close enough to the bustling scene to convey the latest professional information. In fact, in their eyes, their teachers threaten to age as quickly as gossip or yesterday's newspaper. The less a professional segment bases its art on a slowly acquired skill and the greater its reliance upon the mystique of the most advanced technology, the less its protection against a dizzying rate of obsolescence. A master conceptual artist or an electronic composer whose instrument has been outdated by the development of a new model is divested of teaching authority more quickly than a master violinist.

Because young artists sense the urgency of devoting themselves singlemindedly to winning rapid recognition, they are likely to regard teaching as a kind of second, postretirement career—in any case, as an admission of failure to achieve the first rungs of professional success in the short period in which this might have been possible. One of the most revealing aspects of Institute social dynamics was the amount of gossip devoted to placing colleagues in generations whose time in the sun had passed. Whether unabashedly expressing glee at the opportunity to diagnose "death" and dance on a grave, or professing concern, sympathy, and proper piety for a deserving ancient of forty, the preoccupation was the same: that of collectively establishing the inevitable moment of an inevitably early occupational death.

The erosion of teaching authority is aggravated by the fact that teachers have limited powers of career sponsorship in a market which is not controlled by members of their profession. Any authority which might come from their usefulness as sponsors (as well as that rising from their function as mentors) rests on a shaky foundation. Students quickly learn that the relationships they form with their peers are likely to be far more crucial to their careers than relationships with their teachers who are, in any case, often suspected of feeling more like competitors than sponsors. A career structure which places an extremely high value upon youthfulness does indeed shift the locus of authority to the young and uninitiated.[8] As long as the clue to the newest developments is believed to lie with the last generation to enter the arena of occupational practice, teachers are easily prey to the anxious suspicion that they have more to learn from their students than the latter can learn from them.

Students adapt to the situation by regarding contact with their peers and access to tools and hardware as the principal reasons for attending art school. They use these resources as intensively as they can, accept the marginality of their teachers' role, and enjoy the relaxed, unauthoritarian atmosphere generated by the conditions I have described.[9] For the teachers of art, though, the problem of accommodation is more acute. Often feeling like mere security guards of expensive equipment, they must maintain their

morale and some form of performance in the face of the shrinking legitimacy of the teaching role.

One option available to the teacher who finds himself in this situation is to embrace it, completely abandoning all emotional investment in teaching. At the Institute, those who chose this route went into internal emigration, some claiming that by exclusively devoting themselves to their own work and setting an example of productive discipline, they fulfilled their teaching obligation as well. Such pedagogical absence could be defended with the argument that it taught students self-reliance, and one of the functions of such a philosophy was to help eliminate any conflict between teaching, on the one hand, and the exclusive pursuit of a nonpedagogical professional career on the other. Among the more cynical, teaching jobs were regarded without guilt as an attractive gig, a source of easy money for the support of the less lucrative, but more serious, aspects of their professional role.

Another tempting strategy for conserving the student public and 'he classroom scene is to become an entertainer—to substitute winning and seductive ways for the absent occupational authority. The only thing the entertainer must eschew is criticism, for as a host rather than a judge, his function is best fulfilled by lulling and amusing his clientele. As one teacher candidly told me:

> Teaching has more to do with seduction than anything else. The teacher-student relationship is very tenuous. A lot of students just won't take challenges or confront pain. So I don't tell them what to do, or criticize their work . . . I show them movies I've made, do a song and dance between each one, and try to get them to laugh—to loosen up. The most important thing is just to keep grinning. This year I've learned to grin and relax. I've slayed the dragon.

An accommodation similar to that of the entertainer in its avoidance of criticism and of any affirmation of objective standards of workmanship is that of the teacher as therapist. Maintaining that the most important task is not to distinguish good from bad work, or fertile from arid pursuits, but rather to boost students' confidence, teachers defining their role in this way regard the practice of their art as a kind of catharsis or meditation and their own function as primarily that of reassuring the student that whatever he does *is* art. One of the problems of the therapeutic approach, however, is that once the teacher ceases to represent the objective standards of a wider, impersonal authority, his power to bestow lasting reassurance and professional confidence fades.

Apart from the teacher's problem of how to preserve a minimal sense of authority and legitimacy in the face of occupational processes which

threaten to erode them, his most serious problem is that of trying to prepare students for occupational survival. Where innovation is rewarded as never before, it becomes crucial to impart an essentially academic familiarity with "everything that has been done"—not so that it might be emulated, but that its repetition might be avoided. The history of art must be known by the art student in the way a mine field must be known by a soldier who has to pick out a safe path for himself. A knowledge of "what has already been done" coupled with facility in thinking of new ideas (even if they are executed by someone else) grow in importance as basic occupational skills—certainly in comparison to a developed manual craftsmanship.

But perhaps the most crucial basic skill for a promising professional artist (even if few art schools would publicly promise to teach it) is that of aggressively hustling, conning, and, if necessary, whoring one's way to success. In fact, so close is this to being a core professional skill that if a teacher perceives its absence he may react as he would to an obvious lack of talent. Thus, a musician explains:

> Performance is enormously rewarding but also very hostile. For every job there are five hundred qualified people standing in line ready to cut your throat to get it. There are basically two ways to success. You can be well qualified and bad-mouth the competition to talk your way into a job, or you can be well qualified and sleep with the right people. When students can't push, I react as if they don't have the voice. It almost makes me angry. The fact is, the product you have to sell is yourself. Nobody wants to be pushy, but it's healthier to say "this is it. This is how I have to get it marketed," than to simper in a corner waiting to be discovered.

Or, in the equally frank words of a film maker: "I take young 'artists' (how I detest that word!) and do my best to turn them into honest whores." (This film maker *did* insist however that decent whores had their honor. Offering himself as an example he would strike a tone of mock petulance and repeat didactically, "*Sometimes* I won't do it!") The whoring need not be literal (though it sometimes is); what is essential is the possession of an aggressive belief in one's importance, a willingness to make shrewd compromises when necessary, and the ability to hustle and live by one's wits. The reaction to students who appear, in a purist way, unwilling to make any compromises is likely to be one of profound exasperation.

> If a kid tells me he 'just can't get into' a certain piece of music, I'll say "tough shit"—I have to do it every day and I can't even get into the guy I have to sit next to. They don't realize you have to go out and

pay your dues to eat, do things you don't want to do, you don't believe in. Especially in the music business, 'cause it *is* a business!

The legitimacy of conning and hustling as much as is necessary to support and develop one's work and career is strongly stressed in the occupational culture passed on to students. Lecturing about his work life to a group of students and deliberately trying to set them a useful example, a teacher is likely to stress the points in his life when he "lied his way into a social work job" in order to support his film-making or "conned" someone into giving him access to costly equipment.

The school setting itself may be perceived as dangerous in its failure to stimulate the skill of sharp hustling which will be required for survival in the outside professional world. Easy access to valued equipment or valued attention is seen as a threat which can lull students into a softness which will do them little good when they suddenly have to be warriors to survive. In faculty eyes the mark of a really promising young artist is an eagerness to drop out of the artificial protection of the school environment and to wrest a living from a Hobbesian real world. As degrees in art have little market value, the Institute's most professionally ambitious students were not likely to postpone their occupational debuts in order to earn a degree. Rather, they used the school for what it could give them and quickly moved on. Those who left and subsequently came back were regarded with a little of the disappointment a parole officer might feel before a recidivist: they were suspected of being too institutionalized to make it on the outside. They were also identified as a "problem" if they returned to use the Institute's costly equipment. For such students the "problem" was that graduation—by ending their claim on rare equipment—threatened to constitute their occupational retirement.

ABSENT AUTHORITY AND OCCUPATIONAL NONENTITY

The image of the artist as a con man and trickster is not new. The romantic tradition glorified the petty dishonesties of a Beethoven as a sign of the nobility of genius and of the dispensation from everyday morality which it rightfully enjoys. The whore, the criminal, and the immoralist have long been favored images for inverting the values of the "square" world in the name of transcendent and "higher" claims. But this earlier romanticism grew out of a posture of rebellion toward an authoritative and respectable cultural establishment which strongly defended the moral order under attack. Any current self-exaltation of the artist as a con man no longer develops in argument with authoritative defenders of morality, but merely represents an adaptive strategy for attaining conventional

success. When one artist, shrewdly recognizing the chameleonic qualities required for adaptation to a swiftly changing market, candidly quips: "What I really try to encourage in my students is a strong sense of nonentity!" this is hardly the affirmation of a defiant authenticity.

And yet, the remark raises an interesting question: how might people be socialized to such a sense of "nonentity"? If professional identities, like the identities formed during earlier stages of life, are partially shaped by an internalization of the relationship in which learning has taken place, some art teachers' strategies for managing their classes in the face of shrinking teaching authority may produce exactly the kinds of artists the contemporary market demands—artists who have never internalized a sense of objectively grounded aesthetic authority which would inhibit their rapid accommodation to changing currents of fashion. The following passages record observations made on separate occasions of an art class in which students presented work to assembled faculty for "criticism":

Session #1

Teacher: "Don't do what we suggest only 'cause we suggest it! Resist the authority shit—the older wiser artist and all that crap. We're no more *right* than you."

Same teacher about a half hour later:
 "If this is what you want to do, you'll be an artist who interests me less and less."

Student: (stammering, and wearing a facial expression which betrays his anxiety to please): "Which doesn't mean a thing to me."

Teacher: "Last year you certainly sought my opinion often!"

(Student looks flustered and remains silent.)

Session #2

A student, whose short hair and checkered sports shirt mark him an outsider to the prevalent hip subculture presents a portrait of his wife executed in a "realistic" style. It is clear that there is going to be some embarrassment in dealing with this work, less because it is bad than because it represents different aspirations than those fostered in the art school. He begins to talk about it as competently as any of the

students who have gone before him, though in the somewhat montonous tone of a person who feels isolated and afraid. Soon he is forcefully interrupted by one of the teachers: "Why are people no longer paying attention!?" The question is clearly not intended to chide the class but to call the student to account for their supposed withdrawal (a withdrawal I had not noticed but which this teacher implies is both salient and justifiable). The teacher repeats the question, turning to the class, "You stopped listening. Why did you lose interest?" And now other students try obligingly to explain the "reality" that has been presented to them: "He doesn't seem to want to change—to learn from the group." The student is again challenged to explain the meaning of the class's supposed disinterest, and is unable to say a word. In response to his defeated silence the teachers conspicuously withdraw their attention. One begins to read a book. Side conversations develop and some students leave. A few try to keep up the discussion, but since the teachers withhold their participation, most seem to be waiting with tense expectation—as if for a confession or capitulation. Finally the teacher begins again, "Do you feel close to who you really are?" The student ansers "Yes," after which the teacher continues, "If you did, you'd have been able to answer my question. There are two kinds of resistance here—one is your own magnetic anti-matter, the other is what falls in front of this picture. Now go back to the studio, pick up the goddamn instrument and get back closer to what you are.

As can be seen, a teacher may claim that his personal opinion has little objective weight, avoid giving explicit detailed directives, and yet bring considerable pressure to bear upon students—both by threatening to withdraw attention and by presenting himself as the spokesman for group opinion. Though the ideology in the name of which such pressure is applied stresses the paramount importance of individual autonomy, the teaching process itself seems to locate the authority which has been withdrawn from traditional rules and old masters in the shifting moods of the group. At a time when other aesthetic norms have lost their force, one rule remains: one must become sensitive to any sign that the audience's interest is flagging and quick to change if it is. The ultimate sanction for failure to comply with this rule is social isolation, young artists learning to fear *not* that they will be humiliated by a "master," but that they will be left behind by their peers.

An earlier avant-garde, in rebellion against their authoritative occupational fathers, created an expressive model of anarchistic individualism with which others in revolt could identify. Perhaps their

contemporary heirs, who no longer struggle against a strong older generation but learn to accommodate immediately and protean-like to shifts in fashion, deliver to us, in their strong sense of nonentity, not only a new image of the artist, but a new image of man. If in so doing they present us with the caricature of a wider alienation, this may serve us better than the illusion that art is the privileged sanctuary for an autonomy and freedom banished elsewhere.

NOTES

1. Max Weber, *Economy and Society,* Guenther Roth and Claus Wittich, eds. (New York: Bedminster Press, 1968), has discussed the problem of socialization for charismatic roles by calling attention to the contradiction between charismatic qualification, based upon "heroic or magical capacities regarded as inborn" and "rational or empirical instruction":

 > Within certain limits the transition between charismatic and rational specialized training is of course fluid. Every charismatic education includes some specialized training . . . This empirical and professional component, which is often treated as secret know-how for the sake of prestige and monopolization, increases quantitatively and in rational quality with professional differentiation and the accumulation of specialized knowledge . . . However, genuine charismatic education is the radical opposite of specialized professional training as it is espoused by bureaucracy. Weber, Op. cit., vol. 3, pp. 1143f.

2. Geraldine Pelles, *Art, Artists and Society: Origins of a Modern Dilemma* (Englewood Cliffs: Prentice-Hall, 1963), p. 19f.
3. See Beebe, *Ivory Towers and Sacred Founts: The Artist as Hero in Fiction, From Goethe to Joyce* (New York: United Press, 1964).
4. Harold Rosenberg, *The De-definition of Art* (New York: Horizon, 1972), p. 13f.
5. This approach has had its advocates elsewhere as well. The first major controversy to have taken place at the Bauhaus is said to have arisen between Gropius and Itten when the latter's commitment to spontaneity led him to refuse to correct apprentices' mistakes. See Walter Laqueur, *Weimar: A Cultural History* (New York: G.P. Putnam's Sons, 1974), p. 177f.
6. Rosenberg, Op. cit., p. 41f.
7. Andrew Ritchie, Director, *The Visual Arts in Higher Education* (New Haven: Yale University Press, 1966), p. 106.
8. For comparative purposes, see Robert K. Merton's and Harriet Zuckerman's discussion of the implications of scientific innovation for the structure of scientific careers and of scientific professions. These authors, however, focus upon the impact of innovation on the scientist's research rather than on his teaching role: Robert K. Merton and Harriet Zuckerman, "Age, Aging and Age Structure in Science," in *The Sociology of Science,* by Robert K. Merton (Chicago: University of Chicago Press), 1973, pp. 497559.
9. The democratic, easy-going unauthoritarian atmosphere of art schools has been reported elsewhere. See, for example, Mason Griff, "The Recruitment

and Socialization of Artists," in *Sociology of Art and Literature: A Reader,* edited by Milton Albrecht, James Barnett, and Mason Griff (New York: Praeger, 1970), pp. 145-59. See also Anselm Strauss, "The Art School and Its Students: A Study and an Interpretation," ibid., pp. 159-78. This atmosphere is due, however, to specific historical circumstances of the disciplines and not to any "essential" nature of art activities. For a contrast with the tone of art education in an earlier period, see Jacques Lethève, *La vie quotidienne des artistes au XIX^e siècle* (Biarritz, France: Librairie Hachette, 1968), pp. 1-99.

Chapter 8

CONCLUSION: END OF UTOPIA

If the ship is sinking, I'm not going
down holding hands!

<div align="right">Dean</div>

It was like the Gold Rush. People came
to make a fortune, but there was no
fortune to be made. So some went
broke, some left, and those who
remained just had to learn to live in a
new place.

<div align="right">Musician</div>

By 1975 Cal Arts was no longer the "scene" it had once been, and in satisfied recognition of this fact the Disney Foundation gave $14 million to the Institute as an endowment thereby finally guaranteeing its future. As some faculty observed, the school had been given a long audition by its financial backers. Before this audition was completed, the first president, the provost, three of the original deans and many faculty had either been fired or chosen to resign; a member of the Disney family had served as interim president for three years; two of the original schools (Critical Studies and Design) had been eliminated, parts of all programs cut, and the Institute's original guiding ideology definitively abandoned in favor of unambiguously stated professional goals.

Just as the Institute's first settlers colored the dream world they had been promised in the hue of their own fantasies, so each of them attended to different signs in marking the point at which the possibility of ideal artistic community had been foreclosed. Those, for example, who regarded institutionalization as the process by which a wild frontier was tamed and made uninhabitable proclaimed the school to have died within weeks of its opening. Maintaining that, whatever else their drawbacks, the Institute's first days had at least been chaotic, they watched with dismay as curriculum became formalized, course requirements established, and standard rates of matriculation encouraged. There were others whose employment alternatives made them regard the Institute as ideal long after some of their colleagues had become thoroughly disillusioned.

By early 1972 official statements about the school's future emphasized the need for a new direction, and the utopian forms of thought which had once been encouraged became increasingly tabooed. An early administrative meeting, for example, had included the following "covenant" to dream:

> Dean X: I would like to request that we keep the level of discussion at the highest level of aspiration, that we focus on what we would *like* to do—because often we delude ourselves about obstacles. What we take to be obstacles are not such; they only come from our image of institutions as they have previously existed.

> Dean Y: We've made a covenant that we'll catch one another up when we hear someone say "it would be nice *but* . . ." We have all suffered brain damage from our former association with other institutions.

Three years later, however, a colleague's plea to "dream a little" in the face of discouragement was received with marked hostility by the same people: "I could have puked," said one of them in disgust, "it was all that dreaming that got us into this mess in the first place!" And another observed: "The Disneys were the reality principle of this place and our failure was a failure of imagination, a failure of *political* imagination." Where once prestige had been awarded for daring displays of creative fancy, it was now accorded to those giving the appearance of hardheaded realism—an appearance often achieved through the rhetoric of cost accounting. In short, where people had once looked for leadership in the task of imagining possibility, they now sought help in the imagination of reality.

The major fact behind the collapse of utopianism was that "the money" necessary to guarantee the future of the school's early programs was not available; it was the effect of dwindling financial resources upon Institute social relations which played the greatest role in bringing the dream of an ideal artists' community to an end. During the initial period of fantasized plenty, human relationships had been expansive and generous, but the first effect of an impoverished institutional economy was to destroy the solidarity of those who had expected to exploit together nearly limitless resources.

The first blow to community morale came when, concerned with appeasing their financial backers, the academic administrators initiated the dismissal of one of their own number (the Dean of Critical Studies) and submitted to the trustee-ordered dismissal of another (the Provost). Subsequently, drastic cuts in the Institute's teaching budget (from $2,322,440 in 1972-73 to $1,375,000 in 1973-74) forced administrators to withdraw many of the jobs they had once bestowed and made the formally specified length of teaching contracts a salient principle of stratification in a "community" which had professed contempt for contractual forms of relationship. At this point colleagues found it difficult to trust one another, sprinkled their speech with war metaphors, and described themselves as occupants of a crowded life boat, forced to expend all their energy in defending their place and tempted to throw others overboard. Having come to the Institute in the hope of finding artistic community and a renewal of creative life, they were likely to feel at the end of three years that rather than tasting these sources of self-expansion, they had become further diminished by age and moral compromise. For moral compromise was a major preoccupation in a subculture characterized by a religious concern with purity and an Old-Testament taste for the metaphor of whoring. The following views, expressed by a musican, were shared by many:

> The only aesthetic shared by the avant-garde is that they live for their work and their vision. Both come before comfort. They are religious people in their work, and they recognize each other as brothers by their courage and their purity. Now here was supposedly an avant-garde art school, so in a way it could be considered a religious school. And we had a chance to see if the priests, when it came right down to it, were spiritual, or if instead they were just politicians, mainly concerned with staying on good terms with the powers of the realm. And they turned out to be jaded by life, and to be more impure than pure.

During the last days of my interviewing as I accompanied one of the
Institute's senior members to the place of our appointment he told me that
he felt suddenly very, very old and "bone tired." He had become aware of
his age in a new way the night before, he said, while attending a musical
comedy called "The Follies." It centered upon a reunion of old dance hall
stars and "stage door Johnnies" many years after the dance hall in which
they once worked had been razed and replaced by a parking lot:

> You keep seeing the present against the past. And you see the
> complete emptiness of these people's present lives. The former
> Johnnies are now in business, the stars are old and faded. And the
> reason I felt old was that I thought it was making a profound
> statement, and I loved it, while the young people who were there
> thought it shallow and superficial. The young people couldn't
> understand it.

When we finally sat down he was reluctant to begin the interview, calling
me a *nudnik* when I started to question him earnestly. He undoubtedly
knew that like so many others he had already conveyed indirectly, before
the interview formally began, the one thing he most wanted to say.

I, too, was caught up in the process of community disintegration. The
dean who hired me to teach in the Institute's School of Critical Studies was
the first to be divested of his position. In a community heavily based upon
personal ties, the people he had hired, like myself, quickly took on the
public status of "left overs"—a pattern which was to be repeated elsewhere
in the Institute as nodal, recruiting members of social networks departed.
When financial cutbacks encouraged administrators to draw new clear
distinctions between "artists" and dispensable "nonartist" employees, my
marginal status in this artists' community became even more pronounced,
and it was at this point that I finally began this study in earnest. Fieldwork
both required and legitimized a social distance that was in any case forced
upon me, just as it required and helped me to transcend the feelings of
mourning and anger which this enforced distance created. As I noted in the
journal I kept at the time:

> I have just been reading Laura Bohannan's account of fieldwork in
> Nigeria, *Return to Laughter*. There is no disguising it: at bottom she
> felt superior to the tribe she was observing and, as a Westerner, held a
> certain status of importance among them. Among the tribe I am
> observing, however, I have little status. In fact, I am primarily
> categorized as a member of a defeated organizational faction.
> Marginality and defeat were a public part of my identity here before I

adopted the fieldworker's role, and every now and then I feel a little demeaned as I dispassionately study people I was once invited to regard as colleagues but now regard (in comparison to me and my friends) as "winners." At such times fieldwork seems a transparent mask for impotence—my detachment only an acquiescence in the retreat forced upon me. Royal anthropology began as a ruling-class hobby, anthropological studies ultimately informing the rulers' administration. But I am one of the ruled observing the rulers. My air of dispassionate distance doesn't stem from an attempt to cultivate the virtues of aristocratic tolerance and the capacity for appreciating the "humanity" of the lower orders. Instead, I see in myself the sometimes sullen, sometimes fascinated, forcedly tolerant, but slightly demeaning careful observation which the lower classes themselves practice upon their "superiors." My very preoccupation with trying to cleanse myself of resentment marks my observation as emotionally unfree.

As the institution became increasingly factionalized and I became increasingly disturbed by the human damage I witnessed, much of my fieldwork became the mental work of struggling to position myself morally. I did not want to judge my subjects, and yet I wanted to do justice to their experience. This conflict was resolved for me in the course of an interview with a young artist who had just been fired—one described by his friends as a refugee who would now find himself on the road again. Dismissed but undefeated he needed no vindication and showed me the way to the accepting intelligence I wanted:

> In the end I still love all these people. Even the ones who have had to fire their friends and then stay on. Even the ones who sell out. I can understand their hunger to "make it." I have the same desire myself. The only reason I don't sell out is that in the end I'm too crazy emotionally. So you see, I take the easiest way out for me too. Life is too hard to expect anybody to beat it.

If fieldwork facilitates an omnipresent consciousness of community life, it also incited in me particular admiration for other members of the field situation who had achieved that quality of consciousness. The art, to use John Cage's figure of speech, of playing *both* sides of the chess game at once, of empathetically imagining the positions of *all* players in a highly factionalized institution, was one in which no group held a monopoly. I saw it as skillfully practiced among members of the secretarial staff or the Board of Trustees as among the ideologues of playfulness. And it is to *these*

artists that I am grateful for the experience of beauty discovered in their presence, a sense of beauty which was less frequently aroused in me by their "works" than—to stretch a metaphor—by the visible "grace" with which each lived his own portion of a shared life and came to his own understanding of it.

If any of the participants in the scene I have described should read this account, I trust they will understand a portraitist's gratitude toward those who have patiently opened themselves to her gaze as well as her anxiety to repay the gift with neither flattery nor caricature. Even if they do not find their own view in the picture I have drawn, I hope they will see in it a *fair* likeness and one which is not unkind.

BIBLIOGRAPHY

Aberle, David F. "A Note on Relative Deprivation Theory as applied to Millenarian and Other Cult Movements." In *Millennial Dreams in Action,* edited by Sylvia L. Thrupp, New York: Schocken Books, 1970.

Ackerman, James. "The Demise of the Avant-Garde: Notes on the Sociology of Recent American Art." *Comparative Studies in Society and History* 11 (1969).

Adler, Nathan. "The Antinomian Personality: The Hippie Character Type." *Psychiatry* 31, no. 4 (1968).

Albrecht, Milton C.; Barnett, James H.; and Griff, Mason, eds. *The Sociology of Art and Literature: A Reader.* New York: Praeger, 1970.

Alvarez, A. "Dada: Suicide as an Art." *The Savage God: A Study of Suicide.* Harmondsworth, Middlesex: Penguin, 1971.

Barron, Frank, et al, *Artists in the Making.* New York: Seminar, 1972.

Battcock, Gregory ed. *New Ideas in Art Education.* New York: E.P. Dutton, 1973.

Baumol, William J., and Bowen, William C. *Performing Arts: The Economic Dilemma.* Cambridge, Mass.: The MIT Press, 1966.

Becker, Howard. "Art as Collective Action." *American Sociological Review* 39 (December 1974).

Becker, Howard. "Arts and Crafts." *American Journal of Sociology* 83 (January 1978).

Becker, Howard. "The Professional Dance Band Musician and his Audience." *American Journal of Sociology* 57 (September 1951).

Beebe, Maurice. *Ivory Towers and Sacred Founts: The Artist as Hero in Fiction, From Goethe to Joyce.* New York: New York University Press, 1964.

Benjamin, Walter. "Theses on the Philosophy of History." *In Illumina-tions.* New York: Schocken Books, 1969.

Berger, John. *Art and Revolution: Ernst Neizvestny and the Role of the Artist in the U.S.S.R.* New York: Random House, 1969.

Bittner, Egon. "Radicalism." *International Encyclopedia of the Social Sciences.* 5, no. 13, New York: Collier-MacMillan, 1968.

Bittner, Egon. "Radicalism and the Organization of Radical Movements." *American Sociological Review* 28 (1963).

Bloom, Harold. *The Anxiety of Influence: A Theory of Poetry.* New York: Oxford University Press, 1973.

Brustein, Robert. "The Idea of Theater at Yale." *Theater Quarterly* (Winter 1971).

Burns, Joan S. *The Awkward Embrace: The Creative Artist and the Insti-tution in America.* New York: Alfred A. Knopf, 1975.

Burns, Tom, and Stalker, G.M. *The Management of Innovation.* London: Tavistock, 1961.

Burridge, Kenelm. *New Heaven, New Earth.* Oxford: Basil Blackwell, 1969.

Cabanne, Pierre. *Dialogues with Marcel Duchamp.* New York: Viking Press, 1971.

Cage, John. *A Year from Monday.* Middletown, Connecticut: Wesleyan University Press, 1969.

Canfield, F. Curtis. "The Performing Arts." *The Fine Arts and the University.* Edited by A. Whitney Griswald. New York: MacMillan, 1965.

Carpenter, Paul S. *Music: An Art and a Business.* Norman, Oklahoma: University of Oklahoma Press, 1950.

Cockburn, Alexander, and Blackburn, Robin, eds. *Student Power: Problems, Diagnosis, Action.* Baltimore: Penguin, 1969.

Colvard, Richard. "Risk Capital Philanthropy: The Ideological Defense of Innovation." In *Explorations in Social Change,* edited by George K. Zollschan and Walter Hirsch. Boston: Houghton Mifflin, 1964.

Coser, Lewis. *Men of Ideas.* New York: The Free Press, 1970.

Couch, Stephan. "Class Politics and Symphony Orchestras." *Society* 14, no. 1 (November-December 1976).

Cox, Harvey. *The Feast of Fools: A Theological Essay on Festivity and Fantasy.* Cambridge: Harvard University Press, 1969.

Crozier, Michel. *The World of the Office Worker.* New York: Schocken Books, 1971.

Dennis, Lawrence, and Jacob, Renate, eds. *The Arts in Higher Education.* San Francisco: Jossey-Bass Inc., 1968.

DiMaggio, Paul, and Hirsch, Paul M. "Production Organization in the Arts." *American Behavioral Scientist* 19, no. 6 (July-August 1976).

Douglas, Mary. *Natural Symbols: Explorations in Cosmology.* New York: Pantheon Books, 1970.

Douglas, Mary. "The Social Control of Cognition: Some Factors in Joke Perception." *Man* 3, no. 3 (September 1968).

Dubuffet, Jean. *Asphixiante Culture.* Paris: J.J. Pauvert, 1968.

Dudley, Gary. "Portable Video: The Natural Medium." *Radical Software,* no. 5. New York: Gordon and Breach, 1972.

Egbert, Donald Drew. *Social Radicalism and the Arts.* New York: Alfred Knopf, 1970.

Ellul, Jacques. *Métamorphose du bourgeois.* Paris: Calmann-Levy, 1967.

Eshelman, Clayton. "Who is the Real Enemy of Poetry?" *Los Angeles Free Press* (11 September 1970).

Etzkorn, Peter, ed. *Music and Society: The Later Writings of Paul Honigsheim.* New York: Wiley & Sons, 1973.

Evenson, Dean. "Open-ended Nervous System." *Radical Software,* no. 5. New York: Gordon Breach, 1972.

Ewen, Stewart. "Advertising as Social Production." *Radical America* 3 (May-June 1969).

Faulkner, Robert R. "Orchestra Interaction: Some Features of Communication and Authority in an Artistic Organization." *The Sociological Quarterly* 14 (Spring 1973).

Foss, Daniel. *Freak Culture: Life Style and Politics.* New York: E.P. Dutton, 1972.

Fox, Hugh. "Dick Higgins and the Something Else Press." *Arts in Society* 2, no. 2 (Summer-Fall 1974).

Freidson, Eliot. *The Profession of Medicine.* New York: Dodd, Mead and Co., 1970.

Freud, Sigmund. *On Dreams.* New York: W.W. Norton, 1952.

Frye, Northrop. *The Secular Scripture: A Study of the Structure of the Novel.* Cambridge, Mass.: Harvard University Press, 1976.

Glaser, Barney G. *Organizational Scientists: Their Professional Careers.* New York: Bobbs-Merrill, 1964.

Goodman, Mitchell, ed. *The Movement Towards a New America.* New York: Alfred Knopf, 1970.

Graña, Cesar. *Modernity and Its Discontents.* New York: Harper and Row, 1967.

Griff, Mason. "The Recruitment and Socialization of Artists." In *The Sociology of Art and Literature: A Reader,* edited by Milton Albrecht, James Barnett, and Mason Griff. New York: Praeger, 1970.

Griswald, A. Whitney, ed. *The Fine Arts and the University.* New York: Macmillan, 1965.

Haskell, Francis. *Patrons and Painters: A Study of the Relations Between Italian Art and Society in the Age of the Baroque.* New York: Vintage, 1951.

Hauser, Arnold. "The Social Status of the Renaissance Artist." *The Social History of Art* 2: 52-84. New York: Vintage, 1951.

Hightower, J.B. "Class Art to Mass Art." *Art in America.* 58:25 (Spring 1970).

Hoffman, Abbie. "Media Freaking." *Tulane Drama Review* 13, no. 4 (Summer 1969).

Hoffman, Abbie. *Revolution for the Hell of It.* New York: The Dial Press, 1968.

Hughes, Everett C. *Men and Their Work.* Glencoe, Illinois: The Free Press, 1958.

Hughes, Everett C. "The Social Drama of Work." *Mid-American Review of Sociology* 1, no. 1 (1976).

Huizinga, Johan. *Homo Ludens: A Study of the Play-Element in Culture.* New York: Roy Publishers, 1950.

Illich, Ivan. *Deschooling Society.* London: Calder & Boyars, Ltd., 1975.

Jarvie, I.C. *Movies and Society.* New York: Basic Books, 1970.

Jonas, Hans. *The Gnostic Religion: The Message of the Alien God and the Beginnings of Christianity.* Boston: Beacon Press, 1958.

Kanter, Rosabeth Moss. *Commitment and Community.* Cambridge: Harvard University Press, 1972.

Kaprow, Allan. "The Education of the Un-Artist, Part 1." *ARTnews* 70 (February 1971).

Karshan, Donald, ed. *Conceptual Art and Conceptual Aspects.* New York: New York Cultural Center, 1970.

Krause, Elliot. *The Sociology of Occupations.* Boston: Little Brown Company, 1971.

Kristeller, Paul Oskar. "The Modern System of the Arts: A Study in the History of Aesthetics." *Journal of the History of Ideas* 12 (1951), and ibid., 13 (1952).

Lacqueur, Walter. *Weimar: A Cultural History.* New York: G.P. Putnam's Sons, 1974.

Lethève, Jacques. *La vie quotidienne des artistes au XIXe siècle.* Biarritz, France: Librairie Hachette, 1968.

Lévi-Strauss, Claude. "Social Structure." In *Anthropology Today: Selections,* edited by Sol Tax. Chicago: University of Chicago Press, 1962.

Levine, Edward M. "Chicago's Art World: The Influence of Status Interests on its Social and Distribution Systems." *Urban Life and Culture* 1 (October 1972).

Lippard, Lucy ed. *Six Years: The Dematerialization of the Art Object.* New York: Praeger, 1973.

Long, Pricilla, ed. *The New Left: A Collection of Essays.* Boston: Beacon Press, 1969.

Lozano, Lee: "General Strike Piece." In *Six Years: The Dematerialization of the Art Object,* edited by Lucy Lippard. New York: Praeger, 1973.

Mahoney, Margaret, ed. *The Arts on Campus: The Necessity for Change.* Greenwich, Connecticut: New York Graphic Society, 1970.

Mallett, Serge. *La nouvelle classe ouvrière.* Paris: Editions du Seuil, 1963.

Mannheim, Karl. *Ideology and Utopia.* London: Routledge, Kegan and Paul, 1960.

Marcuse, Herbert. *Counter-revolution and Revolt.* Boston: Beacon Press, 1972.

Marcuse, Herbert. *Eros and Civilization.* Boston: Beacon Press, 1966.

Marcuse, Herbert. "Art as a Form of Reality." In *On the Future of Art,* sponsored by the Solomon R. Guggenheim Museum, New York: The Viking Press, 1970.

McCausland, Elizabeth; Harnum, Royal B.; and Vaughn, Dana P. *Art Professions in the United States.* New York: Cooper Union Art School, 1950.

McDermott, John. "Technology: The Opiate of the Intellectuals." *New York Review of Books* 13 (31 July 1969).

McDonald, Stuart, *The History and Philosophy of Art Education.* London: University of London Press, 1970.

McMullen, Roy. *Art, Affluence and Alienation: The Fine Arts Today.* London: Pall Mall Press, 1968.

Merton, Robert K., and Zuckerman, Harriet. "Age, Aging and Age Structure in Science." in *The Sociology of Science,* by Robert K. Merton. Chicago: University of Chicago Press, 1973.

Metzger, Walter. "The American Academic Profession in Hard Times: Toward an Uncertain Future." *Daedalus* 104, no. 1 (Winter 1975).

Meyer, Ursula. *Conceptual Art.* New York: Dutton, 1972.

Michaels, John A. "Artists' Ideas about Art and Their Use in Education." Final Report, Project #5-8300, *United States Department of Health, Education and Welfare,* 1967.

Mills, C. Wright. "The Cultural Apparatus." In *Power, Politics and People,* edited by I.L. Horowitz. New York: Oxford University Press, 1963.

Moore, William E. *The Professions: Roles and Rules.* New York: Russell Sage, 1970.

Morrison, Jack, ed. *The Rise of the Arts on the American Campus,* New York: McGraw-Hill, 1973.

Moulin, Raymonde. *Le Marché de la Peinture en France.* Paris: Editions de Minuit, 1967.

Oglesby, Carl, ed. *The New Left Reader*. New York: Grove Press, 1969.

Olesen, Virginia L., and Whittaker, Elvi W. *The Silent Dialogue: A Study in the Social Psychology of Professional Socialization*. San Francisco: Jossey-Bass, 1968.

Pachter, Henry M. "The Intellectuals and the State of Weimar." *Social Research* 39, no. 2 (Summer 1972).

Pelles, Geraldine. *Art, Artists and Society: Origins of a Modern Dilemma*. Englewood Cliffs: Prentice-Hall, 1963.

Peterson, Richard. "The Production of Culture: A Prolegomenon." *American Behavioral Scientist* 19, no. 6 (July-August 1976).

Peterson, Richard A. "Art and Government." *Society* 14, no. 1 (November-December 1976).

Pevsner, Nikolaus. *Academies of Art: Past and Present*. Cambridge: Cambridge University Press, 1940.

Poggioli, Renato, *The Theory of the Avant-Garde*. Cambridge: Harvard University Press, 1968.

Powdermaker, Hortense. *Hollywood the Dream Factory: An Anthropologist Looks at the Movie-makers*. Boston: Little, Brown and Co., 1950.

Quattrocchi, Angelo, and Nairn, Tom. *The Beginning of the End: France, May 1968*. London: Panther Books, 1968.

Ragon, Michel. "The Artist and Society." In *Art and Confrontation*, by Jean Cassou et al. Greenwich, Connecticut: New York Graphic Society.

Raynor, Henry. *A Social History of Music*. New York: Schocken Books, 1972.

Richter, Hans. *Dada: Art and Anti-art. New York: Harry Abrams Inc., n.d.*

Ridgeway, Sally. *"When Object Becomes Idea: The History of an Avant-Garde Art Movement."* Ph.D. dissertation, Department of Sociology, City University of New York, 1975.

Risenhoover, Morris, and Blackburn, Robert T., eds. *Artists as Professors: Conversations with Musicians, Painters, Sculptors*. Urbana: University of Illinois Press, 1976.

Ritchie, Andrew. *The Visual Arts in Higher Education*. New Haven: Yale University Press, 1966.

Rochewald, Fred C., and Gottshall, Edward M. *Commercial Art as a Business*. New York: Viking Press, 1971.

Rosenberg, Harold. *The Anxious Object: Art Today and Its Audience*. New York: Collier, 1973.

Rosenberg, Harold. *The De-definition of Art*. New York: Horizon, 1972.

Rosenberg, Harold. *The Tradition of the New*. New York: Grove Press, 1961.

Rosenberg, Harold, and Fliegel, N. *The Vanguard Artist: Portrait and Self-Portrait.* Chicago: Quadrangle, 1965.

Rossman, Michael. *Wedding Within the War.* New York: Doubleday, 1971.

Rowntree, John, and Margaret. "Youth as a Class." *Our Generation* 6, no. 1-2 (1968).

Rubin, Jerry. *Do It! Scenarios of the Revolultion.* New York: Simon and Schuster, 1970.

Ryan, Paul. "From Crucifixion to Cybernetic Acupuncture." *Radical Software,* no. 5. New York: Gordon Breach, 1972.

Schickel, Richard. *The Disney Version.* New York: Simon Schuster, 1968.

Schiller, Friedrich. *On the Aesthetic Eduction of Man.* London: Routledge and Kegan Paul, 1954.

Shahn, Ben. *The Shape of Content.* Cambridge: Harvard University Press, 1967.

Simmel, Georg. "The Adventure," In *Essays on Sociology, Philosophy and Aesthetics,* edited by Kurt H. Wolff. New York: Harper and Row, 1959.

Smigel, Erwin O. *The Wall Street Lawyer: Professional Organization Man?* Bloomington, Indiana: Indiana University Press, 1964.

Smith, Henry Nash. *Virgin Land: The American West as Symbol and Myth.* New York; Vintage, 1957.

Stein, Maurice. *The Eclipse of Community.* Princeton: Princeton University Press, 1960.

Stein, Maurice, and Miller, Larry. *Blueprint for Counter-Education.* New York: Doubleday, 1970.

Strauss, Anselm. "The Art School and its Students: A Study and Interpretation." In *The Sociology of Art and Literature,* edited by M.C. Albrecht and J.H. Barnett. New York: Praeger, 1970.

Sutherland, David Earl. "Ballet as a Career." *Society* 14, no. 1 (November/ December, 1976).

Teodori, Massimo, ed. *The New Left: A Documentary History.* New Bobbs-Merrill, 1969.

Themerson, Stefan. "Kurt Schwitters on a Time-Chart." *Typographica* 16 (1967).

Thorne, Barrie. "Professional Education in Medicine" and "Professional Education in Law." In *Education for the Professions of Medicine, Law, Theology, and Social Welfare,* by Everett C. Hughes et al. McGraw-Hill, 1973.

Thorne, Barrie. "Resisting the Draft: An Ethnography of the Draft Resistance Movement." Ph.D. dissertation, Brandeis University, May 1971.

Toffler, Alvin. *The Culture Consumers.* New York: St. Martin's Press, 1964.

Tudor, Andrew. *Images and Influence.* London: George Allen and Unwin, 1974.

Turner, Victor W. *The Ritual Process: Structure and Antistructure.* London: Routledge and Kegan Paul, 1969.

Useem, Michael. "Government Patronage of Science and Art in America." *American Behavioral Scientist* 19, no. 6 (July-August 1976)

Wallerstein, Immanuel, and Starr, Paul, eds. *The University Crisis Reader,* New York: Random House, 1971.

Weber, Max. *Economy and Society.* Edited by Guenther Roth and Claus Wittich. New York: Bedminster Press, 1968.

Weber, Max. "The Religious Foundations of Wordly Asceticism." *The Protestant Ethic and the Spirit of Capitalism.* New York: Charles Scribner's Sons, 1958.

Weber, William, *Music and the Middle Class.* London: Croom Helm, 1975.

White, Harrison, and Cynthia, *Canvasses and Careers: Institutional Change in the French Painting World.* New York: Wiley, 1965.

Willener, Alfred. *L'Image-Action de la société ou la politisation culturelle.* Paris: Editions du Seuil, 1970.

Wolf, Eric R. "Kinship, Friendship and Patron-Client Relations." In *The Social Anthropology of Complex Societies,* edited by Michael Banton. New York: Praeger, 1966.

Wolfe, Tom. *The Painted Word.* New York: Farrar, Straus and Giroux, 1975.

Wolff, Kurt H. "Culture Change in Loma: A Preliminary Research Report." In *Trying Sociology,* by Kurt H. Wolff. New York: John Wiley & Sons, 1974.

SUBJECT INDEX

Abstract Expressionism, 34

Academia: as new occupational setting for artists, 1, 97. *See also* Art, Art Schools and Academies, Artists, Arts, California Institute of the Arts, Universities

Aesthetics: as critical consciousness, 29; as fashion, 42; influence of laymen upon, 117; and social structure, XV. *See also* Art, Artists, Arts, Avant-Garde, California Institute of the Arts, Laymen, Vanguardism

Aesthetic Radicalism, 37-44; institutionalization of 40, 126; as respected professional tradition, 42

Art: academization of instruction, 2; aetiology of conventions in, XV; careers and emphasis upon youth, 137; Critical Theory of, 30; degrees, 3, 16, 140; education, 2, 103, 129-143; as "free" play, XIII; and life, 38, 117; as "liberation", 28; and market success, 135; production, XIII, XV, 4, 6; and politics, 29; and revolution, 30-37; sociological study of, XIII; teaching as post-retirement career, 137; teaching as source of employment, 3; as work, XIII. *See also* Academia, Art Schools and Academies, Artists,

Avant-Garde, California Institute of the Arts, Counter-Culture, Professionalization, Schooling, Universities, Vanguardism

"Art as a Form of Reality," 29

Art Schools and Academies: before the twentieth century, 2; in France, 2; in the United States, 2

Artists: as academics and professors, 13, 34; as "aristocrats", 114; conflicts between academic and practicing, 15; "conservative" money and "radical", 86, 127; crippling work experience of, 131; as employees, XIV, 6; guerilla, 32; as hustlers and whores, 139; as individual entrepreneurs, 6; and laymen, 11, 99, 111-127; occupational mythologies of, 122, 130; and ownership of artistic means of production, 6; as prophets, 122; professional autonomy of, 69; and "pure" research, 99; as producers of romance, 75; in-residence, 4, 13; romantic image of, XIII, 6; social integration of, 8; unemployment of, 103. *See also* Art, Arts, Avant-Garde, California Institute of the Arts, Professionalization, Schooling, Technology, Universities, Utopianism, Vanguardism

Arts: commercial and fine, 18; and crafts, 18, 129, 133; professionals and amateurs in the, 13, 112; professional education in the, 9; ritual revolt in the, 42; social marginality of the, 8; and the sociology of science, XIII; systems of work and patronage in the, XIII, 35; in universities, XIV, 1, 9, 17; work discipline in the, 115. *See also* Academia, Aesthetics, Art, Artists, California Institute of the Arts, Avant-Garde, Bohemia, Laymen, Patrons, Schooling, Utopianism, Vanguardism, Universities

Avant-Garde: aesthetics and conservativism, 40; anarchistic orientation of, 28, 44, 98; artists as "research and development men", 41; and commercial art, 41; and modernism, 28; "end" of the, 8; as occupational movement, 8, 34; and "revolutionary" activity as professional practice, 34; theater, 31. *See also* Bohemia, Professionalism, Vanguardism

Bauhaus, XIV, 34, 72, 133
Black Mountain College, XIV, 59, 72, 133
Bohemia, 7, 17, 104, 106

California: as heir of frontier mythology, 26
California, University of, 15, 55
California Institute of the Arts: Art degrees at, 3; Art School, 65, 69, 96, 118, 124; artistic vanguardism at, 44, 117; artists' view of trustees, 120; rejection of tenure concept and its consequences, 84; and counterculture, 171; creation of, 53-61; School of Critical Studies, 70, 108, 145, 147; Dance School, 115, 118; Design School, 66, 70, 145; educational philosophy at, 102; employability of graduates, 103, 116; "established vanguardism" at, 45; Film School, 66, 70, 118; Music School, 66, 69, 76, 96, 115, 118, 123-126; 131; promise of "community", 100; recruitment, 24, 45, 65, 75-79, 94; Theater School, 65, 96, 98, 124, 131; trustees as brokers, 119; trustees' views of artists, 121; as utopian art academy, XIV, 23, 26, 94, 97, 101, 147; youthfulness of its faculty, 84
California Institute of Technology, 55
Chouinard Art Institute, 53-56, 65, 84
Commercial Arts: and Fine arts, 9, 123; opposition to, 123
Communications Technology: as "revolutionary" tool, 33. *See also* Mass Communications Media, Technology
Communitarian Movement: and art, 104-107; in late 1960s, 25. *See also* Counter Culture, Millenarianism, Utopianism, Youth
Conceptual Art, 16, 124; "process" as work in, 116
Cooper Union, 6
Counter-Culture: anti-authoritarianism, 35; anarchistic orientation of, 28, 98; and Herbert Marcuse, 30. *See also* Communitarian Movement, Millenarianism, Utopianism, Youth
Critical Theory: dialectical dualism in its interpretation of art, 30

Dadaism, 31, 40, 106, 123
Danton's Death, 74
Disney Family, 54-57, 60, 66-68, 78, 86, 145
Disney Studios, 54, 68

Ecole des Beaux Arts, 2
Emile, 27

Film-making, 4, 97; and its dependency upon advanced technology, 4; decline of Hollywood industry, 97. *See also* California Institute of the Arts, Mass Communications Media, Communications Technology, Technology
Futurists, 36, 42

Gesamtkunstwerk, 15, 31, 35
Greening of America, 26
Groucho Marxists, 31

Guerilla Theater: as politics, 32. *See also* California Institute of the Arts, Theater

Higher Education: *see* California Institute of the Arts, Universities
Happenings, 34
Hollywood, 80, 97

Laymen: and artists, 69, 99, 11-127; and their influence upon aesthetics, 117. *See also* California Institute of the Arts, Professionalization
Lincoln Center, 53
Los Angeles Conservatory of Music, 53-56, 65, 84

Mass Communications Media: ' political and economic impact of, 32; and Millenarianism, 32-34. *See also* Communications Technology, Millenarianism, Technology
Means of Production: artistic, 6. *See also* Artists
Media Freaking, 32. *See also* Mass Communications Media
Millenarianism, 24, 31, 36, 96; and counter educational movement, 27; and media, 32-34; and utopian communitarianism, 24-28; and Utopianism in arts occupations, 94. *See also* Utopianism
Music Education,. 3. *See also* California Institute of the Arts
Modernist art, 74; and anarchism, 28, 34; conventions of, 37.
Modernolatry, 42

Patronage, corporate organization of, 8
Patrons: and artists, 8, 120; and brokers, 119
Play and work, 105
Professionalization: aesthetic technologies and relationship to, 5; of the arts, 5, 9, 126, 129. *See also* Artists, Arts, California Institute of the Arts, Universities
Protest Movements: and ludic spirit, 31; and romanticism, 31. *See also* Counter-Culture, Millenarianism, Utopianism, Youth
Provos, 32

Radical Software, 33
Radicalism: *See* Aesthetic Radicalism
Return to Laughter, 148
Revolution: "form" and "content" of, 37; poetic appear of, 37; as work of art, 34. *See also* Avant-Garde, Vanguardism
Romanticism: and *Gesamtkunstwerk,* 35; and image of artists, 140. *See also* Artists, Bohemia, Counter-Culture

San Francisco Actor's Workshop, 99
"Schooling": and art degrees, 3; of art education, 1; and professionalization in the arts, 3
Situationistes, 32
Surrealism, 31, 36

Technology: dependency of artists upon, 4, 6; in film making, 4; pre-industrial, 98; relationship between professionalism and, 5. *See also* California Institute of the Arts, Communications Technology, Mass Communications Media
Theater: in universities, 18. *See also* California Institute of the Arts, Guerilla Theater

Universities: art departments in, 15; and conflicts with Bohemian subculture, 17; constraints upon artists in, 12, 15; dissatisfaction of artists with, 1, 10-18; as employees of artists, 4-12; as patrons, 4; theater in, 18. *See also* Academia, Artists, Avant-Garde, California Institute of the Arts, Professionalization, Schooling, Universities, Vanguardism
Utopianism, 24, 83; communitarian, 25; in higher education, 26-28; occupational, XIV, 93; and organization of artistic production, 94; as public relations pitch, 107; and revolutionism, 25; voluntaristic, 25.

See also California Institute of the Arts, Millenarianism

Vanguardism: and anarchism, 44; of artistic process vs. product, 117; established, 45; organizational consequences of, 117; and retreat to professionalism, 126; unification of aesthetic and political, 36, 44. *See also* Avant-Garde

Western Culture: image of artists in, 6

Walt Disney Institute of the Arts, 58, 65

Work and play, 105. *See also* Artists, Avant-Garde, Bohemia, Vanguardism

Yippies, 32

Youth: culture, 24-28, 31, 36; and anti-professionalism, 107; as "social class", 24; and worship of media technology, 33. *See also* Counter-Culture, Millenarianism, Utopianism

NAME INDEX

Aberle, David F., 47(n.4)
Ackerman, James, 20(n.22)
Adler, Nathan, 49(n.34)
Albrecht, Milton, 19(n.9), 110(n.14), 144(n.9)
Alvarez, A., 51(n.57)

Barnett, James H., 19(n.9), 110(n.14), 144(n.9)
Bartók, Béla, 118
Baudelaire, Charles, 37
Baumol, William, 19(n.14), 21(n.30), 51(n.54), 61(n.2)
Beck, Julian, 35
Becker, Howard, XV(n.1), 21(n.35), 49(n.33), 128(n.6)
Beebe, Maurice, 50(n.44), 143(n.3)
Benjamin, Walter, 90(n.1)
Berger, John, 20(n.17)
Bittner, Egon, 50(n.42), 51(n.55)
Blackburn, Robert T., 19(n.12), 47(n.2)
Bloom, Harold, 109(n.7)
Bohannan, Laura, 148
Bowen, William G., 19(n.14), 21(n.30), 51(n.54), 61(n.2)
Brustein, Robert, 22(n.53)
Burridge, Kenelm, 49(n.31)

Cabanne, Pierre, 20(n.21), 50(n.45)

Cage, John, 26, 30, 47(n.6), 48(n.19-21), 149
Canfield, F. Curtis, 22(n.46)
Carmichael, Stokely, 71
Carpenter, Paul S., 19(n.7), 22(n.42)
Cassou, Jean, 50(n.38)
Clark, Royal, 56
Cockburn, Alexander, 47(n.2)
Colvard, Richard, 91(n.8)
Coser, Lewis, 48(n.13,16)
Cowley, Malcolm, 48(n.13)
Cox, Harvey, 48(n.26)
Crozier, Michel, 127(n.1)

Dennis, Lawrence, 19(n.13)
DiMaggio, Paul, XV(n.1,2)
Disney, Roy O., 56
Disney, Walt, 54-58, 60, 61(n.4), 91(n.5)
Douglas, Mary, 49(n.34), 85, 92(n.18), 109(n.8)
Dubuffet, Jean, 20(n.28)
Duchamp, Marcel, 8, 17, 40
Durkheim, Emile, 46

Egbert, Donald Drew, 20(n.22), 49(n.32), 91(n.12)
Ellul, Jacques, 20(n.19)
Eshelman, Clayton, 109(n.5,6)
Evenson, Dean, 48(n.28)

Evenson, Dudley, 48(n.12)
Ewen, Stewart, 20(n.24)

Faulkner, Robert R., 21(n.33), 92(n.14)
Flaubert, Gustave, 37
Fliegel, Norris, 19(n.10)
Foss, Daniel, 110(n.10,13,15)
Fox, Hugh, 49(n.35)
Freidson, Eliot, 22(n.47), 109(n.1)
Freire, Paolo, 47(n.11)
Freud, Sigmund, 109(n.4)

Gauguin, Paul, 94
Giacometti, Alberto, 134
Godard, Lucien, 35
Goodman, Mitchell, 47(n.2)
Gottshall, Edward M., 20(n.25)
Graña, Cesar, 50(n.40,41)
Griff, Mason, 19(n.9), 110(n.14), 143f.(n.9)
Griswald, A. Whitney, 22(n.45)
Gropius, Walter, 72, 143(n.5)

Haldemann, H. R., 65
Harnum, Royal B., 9(n.6)
Haskell, Francis, 128(n.7)
Hauser, Arnold, 21(n.36), 22(n.48)
Higgins, Dick, 49(n.35)
Hightower, J. B., 20(n.26)
Hindemith, Paul, 118
Hirsch, Paul M., XV(n.1,2), 91(n.8)
Hoffman, Abbie, 32, 48(n.15,27)
Huelsenbeck, Richard, 41
Hughes, Everett C., 19(n.15), 22(n.44, 47), 109(n.3)
Huizinga, Johan, XIII, XV(n.4)

Illich, Ivan, 18(n.1), 47(n.11), 109(n.1)

Jacob, Renate, 19(n.13)
Jagger, Mick, 71
Jonas, Hans, 48(n.18)

Kanter, Rosabeth M., 47(n.5,7,10)
Kaprow, Allan, 36, 39, 50(n.39,47)
Karshan, Donald, 22(n.49)
Krause, Elliot, 20(n.23), 109(n.1)
Kristeller, Paul Oskar, 22(n.55)

Ladd, Thornton, 56, 59

Laqueur, Walter, 143(n.5)
Leary, Timothy, 47(n.8)
Lenin, V. I., 98
Lethève, Jacques, 19(n.2,4), 144(n.9)
Levine, Edward M., 91(n.6)
Lévi-Strauss, Claude, 7, 91(n.7)
Lippard, Lucy, 22(n.49,50), 50(n.46)
Long, Pricilla, 46(n.2)
Lowry, McNeil, 17
Lozano, Lee, 50(n.46)

Mahoney, Margaret, 21(n.31), 22 (n.45)
Mallarmé, Stéphane, 94
Mallet, Serge, 19(n.16)
Mann, Thomas, 37
Mannheim, Karl, 90(n.1)
Marcuse, Herbert, XIII, XV(n.5), 28-30, 47(n.2), 48(n.17), 108
Martin, Peter, 47(n.11)
Marx, Karl, 29
Mattil, Edward L., 19(n.13), 20(n.29), 22(n.52)
McDermott, John, 109(n.1)
McDonald, William F., 19(n.8)
McLuhan, Marshall, 47(n.8)
McMullan, Roy, 51(n.48)
Merton, Robert K., 143(n.8)
Metzger, Walter, 48(n.14)
Meyer, Ursula, 21(n.37), 22(n.49,51)
Michaels, John A., 19(n.10)
Michelangelo, 16
Miller, Larry, 50(n.36)
Moore, William, 22(n.47)
Morrison, Jack, XV(n.6), 19(n.12), 109(n.9)
Moulin, Raymonde, 23, 46(n.1), 94, 109(n.2,11)
Müller, Gorgoni, 21(n.36)

Nairn, Tom, 47(n.2)

O'Doherty, Brian, 41
Oglesby, Carl, 46(n.2)
Olesen, Virginia L., 128(n.5)

Pachter, Henry M., 50(n.43)
Pelles, Geraldine, 143(n.2)
Peterson, Richard A., XV(n.1)
Pevsner, Nikolaus, 19(n.3,5)
Picasso, Pablo, 36

Poggioli, Renato, 36, 47(n.9), 49 (n.32), 50(n.37), 51(n.57), 109(n.7, 10)
Powdermaker, Hortense, 90(n.3), 91(n.10)
Price, Harrison, 56

Quattrocchi, Angelo, 47(n.2)

Ragon, Michel, 50(n.38)
Raynor, Henry, 21(n.38)
Reich, Charles, 47(n.8)
Richter, Hans, 41, 51(n.51-53,57)
Ridgeway, Sally, 22(n.49)
Risenhoover, Morris, 19(n.12)
Ritchie, Andrew, 21(n.30), 143(n.7)
Rochewald, Fred C., 20(n.25)
Rousseau, Jean-Jacques, 27
Rosenberg, Bernard, 19(n.10), 51 (n.48,50), 143(n.4,6)
Rossman, Michael, 47(n.11), 48(n.26)
Roth, Guenther, 143(n.1)
Rowntree, John, 46(n.2)
Rowntree, Margaret, 46(n.2)
Rubin, Jerry, 48(n.15)
Ryan, Paul, 48(n.29)

Saint-Simon, Henri de, 122
Scheckner, Richard, 30
Schickel, Richard, 61(n.3), 91(n.10)
Schiller, Friedrich, XIII, XV(n.3)
Schönberg, Arnold, 11
Schwitters, Kurt, 50(n.36)
Shamberg, Michael, 48(n.12)
Simmel, Georg, 92(n.19)
Smigel, Erwin O., 20(n.20), 51(n.49)
Smith, Henry Nash, 47(n.5)

Starr, Paul, 48(n.14)
Stein, Maurice, 50(n.36)
Strauss, Anselm, 110(n.14), 144(n.9)
Sullivan, Nancy, 128(n.9)
Sutherland, David Earl, 21(n.39)

Tax, Sol, 91(n.7)
Teodori, Massimo, 46(n.2)
Themerson, Stefan, 50(n.36)
Thorne, Barrie, 51(n.55), 109(n.3)
Thrupp, Sylvia L., 47(n.4)
Turner, Victor, 92(n.20)
Tworkov, Jack, 134

Useem, Michael, XV(n.6)

VanGogh, Vincent, 94, 110(n.11)
Vaughn, Dana P., 19(n.6)
Von Hagen, Lulu May, 55f., 61(n.4)

Wallerstein, Immanuel, 48(n.14)
Warhol, Andy, 134
Weber, Max, 31, 48(n.22), 143(n.1)
Webern, Anton, 96
White, Cynthia, 92(n.15)
White, Harrison, 92(n.15)
Whittaker, Elvi W., 128(n.5)
Willener, Alfred, 48(n.23-25)
Wittich, Claus, 143(n.1)
Wolfe, Tom, 22(n.51)
Wolff, Kurt H., 92(n.19)

Youngblood, Gene, 49(n.30)

Zemlinsky, Alexander van, 21(n.38)
Zollschan, George K., 91(n.8)
Zuckerman, Harriet, 143(n.8)